EYES TO SEE WHOLENESS

DEDICATION:

To my wife, Margo,

whose perceptive eyes help me see and be.

EYES TO SEE WHOLENESS
by Doug Adams
© 1995 Educational Ministries, Inc.

ISBN 1-877871-86-9
Educational Ministries, Inc.
165 Plaza Drive
Prescott, AZ 86303
800-221-0910

PREFACE

This book is designed to help us see a painting or sculpture presenting many viewpoints, many biblical texts, and many theological ideas to integrate our lives rather than illustrating only one passage. Some great art works bring together the whole biblical story to eyes which see; and this book helps us see these art works have power to bring diverse audiences together to sense a wider whole.

This book is for teachers of all age groups to inform their classes with visual arts of significance for religious studies and especially biblical and theological studies as well as liturgical and homiletical studies; and this book is for ministers and lay leaders to make worship, preaching, and education memorable by informing them with the visual arts. Over sixty percent of the population remember primarily by what they see and only twenty percent by what they hear while another twenty percent remember kinesthetically. Brought up viewing television, persons under age fifty are even more likely than their elders to be visually oriented. Therefore, it is understandable that few of those under fifty are present in classes or church worship which offer little for the eye, while many of them crowd courses and worship informed by visual arts. These chapters combine seeing, hearing, and doing to make for memorable religious studies and memorable worship, preaching, and education and to aid intergenerational learning.

Most of these art works are helpful in biblical studies; and the biblical index aids location of art works which are related to particular texts and which may be used in conjunction with lectionaries informing worship and preaching. The general index facilitates location of art works dealing with a range of theological issues. "Teaching Tips" in chapters 2 through 37 detail many methods appropriate for use with students in grade school through graduate school and with adults in continuing education. Chapters are grouped according to seasons of the church year to aid further integration of these visual arts into education and worship.

The art works as reproduced in this book will be adequate for use in many classes. Those wishing to locate and to use color slides or prints will be aided by appendix one. Those wishing to use films or videos will be aided by appendix two.

In developing this book, I appreciate the aid of Diane Apostolos-Cappadona and Audrey Englert who gave valuable editorial assistance in preparing the manuscript and Shirley Strobel who edited Harper/Collins' Church Teachers and Linda and Robert Davidson who edit Educational Ministries' Church Educator. Many of these chapters first appeared as articles in those periodicals so that teachers could test the methods with their students. From the first, I wrote those articles with the outline of this book in mind. Also my thanks are extended to the museums and artists for permission to use the illustrations included in this book.

Berkeley, California, 1995

TABLE OF CONTENT

CHAPTER 1

EYES TO SEE WHOLENESS

Art historian Leo Steinberg shows a slide of the Sistine Chapel ceiling fresco where Michelangelo's God extends a right hand toward Adam's extended left hand (Fig. 29). Steinberg then asks "What is God's other hand doing?" Although many in the audience have looked at that art work, they do not know and have to look again. Then they see God's left hand touching a child probably representing the preexistent Christ. The meaning of the work expands to express the whole sweep of the biblical story from Adam to Christ, the new Adam. (See even more biblical and theological dynamics in that art work as approached in Chapter 10.)

Visual art works often express large portions of the biblical story; but a reading of the scripture for a given day expresses only a small part of the story. Marc Chagall's Moses Before the Burning Bush (Fig. 37) presents a view encompassing thirty chapters from Exodus.[1] (See aspects of that art work discussed in Chapter 13.) The biblical story should be seen fully and not heard partially. Since visual art may present simultaneously a number of separate events or ideas, such images are able to give us a sense of wholeness while readings often give us only a part. Therefore, the visual arts are helpful in worship and education when scholars of the church year now urge us to communicate each Sunday the whole mystery of salvation rather than just separate episodes. For instance during Holy Week, we are urged to have each day's celebration embody the whole week's meaning rather than having each day portray only a different part of the story.[2] Leonardo da Vinci's The Last Supper (Fig. 1) helps us remember the whole of Jesus' crucifixion and resurrection as well as the historic event depicted and eucharistic celebration. As many of the disciples' posi-

tions in that art work are reminiscent of their own martyrdom, Leonardo reminds us of how disciples later became the body of Christ. (See the multiple communications of that art work as discussed in Chapter 2.)

In developing a sense of wholeness, the visual arts also help us to experience a fullness of theology and to avoid heresy; for "heresy is a kind of picking and choosing, a denial of the wholeness and fullness of the faith."[3] Most heresies result when people pick one valid idea but stress it to the exclusion of other valid ideas. (For an example, see theological dynamics in Rublev's icon of The Holy Trinity (Fig. 39) as explored in Chapter 14.) At a time when many persons are stressing single issues in our society and harshly judging those who disagree, the fine arts are helpful in discussions of ethics; for the distinguishing characteristic of great art is ambiguity. While propaganda may portray one person or group as completely right and the other person or group as completely wrong, great art usually reveals a flaw in the best character and a redeeming quality in the worst character.

When others think in terms of issues being black or white, artists reveal the gray areas or red or yellow or blue areas. (See such ambiguity in the ethical dynamics of works by Rembrandt van Rijn and contemporary artist Barbara Baumgarten as presented in Chapter 21.) The very word "ambiguity" comes from the Greek word for the situation faced by an army when attacked from two opposite directions at the same time so they had to give attention and energy to two opposite directions simultaneously.[4] The visual arts teach us to appreciate ambiguity as well as those with whom we disagree. Thus, the arts aid us in learning to love our enemies and to live with diversity in community. (For an example,

1

see how George Segal's The Holocaust (Figs. 4-11) allows multiple interpretation and interfaith appreciation as detailed in Chapter 3.)

The next thirty six chapters use a variety of involving methods to develop eyes to see meaningfully the visual arts in religious education for grade school children, junior and senior high school and college students, and adults. These chapters form a helpful foundation for class lectures and discussions with all age groups. In each chapter, the "Teaching Tips" detail these methods to involve the viewer's mind, body, soul, and strength. Our visual art in worship and education will be biblical not because it has biblical characters in it but because it evokes biblical character in the viewer or worshipper. John Dixon judges Barnett Newman's modern art Stations of the Cross (Fig. 14) as the most biblical work in twentieth century American art because it requires from the viewer a fullness of mind, body, soul, and strength.[5] (See discussion of that art work in Chapter 5.) If the visual art evokes our emotions but does not evoke our mind, then it is lacking. If it evokes our mind but not our emotions or body, then it is lacking. The biblical story and visual art remind us of much more that we have to bring to life. The kinesthetic method developed in many of these chapters is especially helpful in relating the biblical stories of the visual art works and the biblical character of our contemporary individual and community stories.

This book is divided into three sections reflecting three periods of the church year: "Lent through Easter and Pentecost" as times of Life-in-Christ promised and fulfilled; "Ordinary Time (Pentecost to Advent)" as times of Life-in-Christ lived out; and "Advent through Epiphany" as times of Future Life-in-Christ promised. This ordering of the church year reflects the recent recovery of liturgical understandings before the Middle Ages. Users of this book may wish to rearrange the sections to begin with advent according to the usage of the Middle Ages when the liturgical year was presented as the life of Jesus where people re-enacted episodes of Jesus' earthly life from his birth through his death, resurrection, and ascension. That life of Jesus scheme had the obvious

flaw of leaving half the year without major intentions informed by Jesus' life; for after ascension, there were six months of waiting before Jesus' reappearance as a baby. The recovery of earlier church understandings has aided reform of the church year as the church year rather than the life of Jesus year. In this recovered church year scheme, ordinary time and advent regain their eschatological character with Christmas seen as embodying the hopes for a second coming and not just a first coming.[6]

As an end time, Christmas offers a vision of what is to come. When we view a nativity scene (Figs. 80-82) within the life of Jesus year, we focus on the baby; but when we view the same scene within an eschatological church year, we see the wider social significance of a woman and child and poor shepherds raised up above a kneeling older king. Then we see blacks and whites coming together in the wisemen; and we see the nakedness of Christ resonating with the nakedness of the poor who are also lifted up as shown in the art of Chapter 27.

NOTES

[1]Stephen Breck Reid, "The Art of Marc Chagall: An Interpretation of Scripture" in Art As Religious Studies, ed. Doug Adams and Diane Apostolos-Cappadona, (New York: Crossroad, 1987), pp. 70-80.

[2]James Empereur, S.J., Worship: Exploring the Sacred, (Washington, D.C.: The Pastoral Press, 1987), pp. 190-191.

[3]Joseph P. Frary, "The Logic of Icons," Sobornost, (Winter 1972), p. 403.

[4]Leo Steinberg, "The Seven Functions of the Hands of Christ: Aspects of Leonardo's Last Supper in Art, Creativity, and the Sacred, ed. Diane Apostolos-Cappadona, (New York: Crossroad, 1984), p. 40.

[5]John Dixon, "The Bible In American Painting" in The Bible and American Arts and Letters, ed. Giles Gunn, (Philadelphia: Fortress Press, 1983), pp. 157-204.

[6]Empereur, Worship, pp. 185-204.

SECTION I

LENT THROUGH EASTER AND PENTECOST:

LIFE-IN-CHRIST PROMISED AND FULFILLED

CHAPTER 2

COMMUNION PAINTINGS AFFIRM OUR CRUCIFIXION AND RESURRECTION

The disciples appear in positions reminding us of their own crucifixion or martyrdom in Leonardo da Vinci's The Last Supper (1495-1497; Refectory, S. Maria delle Grazie, Milan). Jesus Christ' hands beckon us to participate in his crucifixion and resurrection, and in many other actions which communion helps us to remember. In more recent paintings on this subject, we see a wide variety of meaningful interpretations from William Blake's The Last Supper (1799; National Gallery of Art, Washington D.C., Fig. 2) which invites our minds to a quiet mystical union with disciples in historically correct reclining positions) to Emile Nolde's The Last Supper (1909; Nolde Foundation, Seebull, Fig. 3) which emotionally evokes our bodies to become parts of Christ's passionate action in communion).

Leonardo's mural in Milan has deteriorated to such an extent that photographs show few details distinctly. Fortunately, many other artists copied parts or all of his work so that we can focus on a most faithful reproduction - Raphael Morghen's 1800 engraving after Leonardo, The Last Supper (Fig. 1). In the classroom, we use a kinesthetic method which is simply the process of leading students to take the body positions of the different disciples and Jesus Christ so that they sense the dynamics of each figure and the whole work. In such a kinesthetic method, have the students work in teams for each figure in the art work. One student takes the position of the figure while another student compares the student position to the art work and helps adjust the positioning so it reflects all the details in the art. In large classes, more than one student may aid in arranging each figure. While the students

remain in their positions, one may interview each student who shares what he or she has learned by taking that position and what he or she senses of the other figures positioned around him or her. In a simpler form of the method for very large groups in lecture halls (or churches), students (or congregations) may be led to take the positions as best they can where they are seated.

To the immediate right of Jesus (to our left as we look at the photograph), the youthful John, who lived gracefully into old age, goes to sleep peacefully. An old balding Peter, who church tradition says was crucified upside down, extends himself horizontally toward Jesus and appears as close to being upended as possible while still being visible above the table. The shadowy figure of Judas leans away from Jesus and clutches a money bag in his right hand. Further to Jesus' right (and our left), Andrew holds up both hands so that his arms and hands diagonally form an X reminiscent of his crucifixion diagonally. To this day we call such an X-shaped cross the St. Andrew's cross. In front of Andrew, Peter's right hand holds a knife pointing toward Bartholomew, who church tradition says was martyred by flaying.

While those disciples to Jesus' right are crowded together and display cramped hand gestures, many of the disciples to his left (our right) have much elbow room and demonstrate expansive gestures. James' arms extend horizontally to form a cross with his upright torso. To his right, Thomas' disembodied head appears (an allusion to a method of martyrdom which Paul reportedly shared); and to the other side, Philip's hands point to his own heart, the remov-

al of which was another method of martyrdom.

Resurrection as well as crucifixion are indicated in the art work. Thomas' right hand points heavenward as do the palms of the three disciples to the far left of Christ (at our right). Jesus' own hands are in the posture of the resurrected Christ in a vision of the Last Judgment: i.e. one palm is down and one up. In Leonardo's work, Jesus' hands reverse the usual positions and have the right palm pointed down and the left palm pointed up. Such a reversal was required for reasons art historian Leo Steinberg explains:

> When Leonardo embarked on the painting, Montorfano' fresco of the Crucifix-ion, completed in 1495, already occupied the wall opposite. And there, on the south wall, the right side of Christ turns, as required, toward the Madonna and the Good Thief. The direction of bless-edness was thus prefixed for the entire refectory. In conformity with Christ's own inclination, the longitudinal hall was, as it were, oriented laterally to its pulpit, eastward, and to what lay beyond its east wall -- the graveyard and church.[1]

So Christ' upward left palm bids the worshippers in the church and the dead in the graveyard to rise. Steinberg notes seven functions of Jesus' hands that illumine the significance of his life, death, and resurrection related to communion:

> (1) Christ spreads his hands to express willing surrender; (2) the gesture accuses the traitor; (3) it contours Christ's shape so as to allude to the Trinity; (4) both hands together, pointing to bread and wine, evoke the sacrament of communion; (5) the open hand, defining the radius of the church dome, extends the promise of life to their sleeping dead; (6) the palms, alternatively prone and uplifting, prefigure the Judge of the Second Coming.[2]

A seventh function opens the painting to the viewer and includes us more fully in the action. As Jesus' body and arms move forward, they are extended by the very walls of the hall in which originally viewers sat to dine. So his arms and the walls embrace the viewer in simultaneous actions of crucifixion and resurrection.

Taking the positions in Blake's The Last Supper, students recline on the floor in a manner typical of first-century dining. Instead of being animated into action by Jesus as in Leonardo's work, several of the disciples in Blake's painting seem to be in postures of meditation or contemplation. The well ordered disciples and the ample empty central space invite our minds to peaceful reflection and mystical union. In contrast, Nolde's The Last Supper requires that students who embody it crowd together and focus on the hands of Christ which hold the cup at the center of the painting. The bold strokes of paint in this expressionist work evoke both our emotions and a tactile sense of the body.

Art historian Joshua Taylor has helped us see how works, such as that of Blake, can be characterized as "unitive" because they make us oblivious to ourselves and other persons as our minds are drawn beyond distinctions into perfect union. Taylor detailed how works such as Nolde's can be categorized as "communitive" because they make us aware of ourselves and others as distinct bodily individuals with whom we can relate but can never become one. We usually associate the unitive style of art with contemplation and the communitive style of art with action. Both forms are religious; but they correspond to different understandings of religion.[3]

"Unitive" corresponds to the Eastern religious concern for unity with eternal ideas and absorption into immortality and oneness. "Communitive" corresponds to a western religious concern for community and resurrection of the body, with each individual persisting as a distinct part in the world. The communitive style of the paintings by Leonardo and Nolde resonates with Paul's conception that Christ's disciples are part of the body of Christ but individual members of it. (I Corinthians 12:27).

In the many ways detailed in this chapter, the art works bring our lives into relation with biblical, historical, theological, and liturgical understandings. The following teaching tips may aid the development of those understandings.

TEACHING TIPS

1. Lead class members in assuming the positions of the figures in each of the three paintings and discuss the differences which the students feel in these three different conceptions of the last supper.

2. Using several different translations of the Bible, lead the class in reading the different accounts related to the last supper (Matthew 26:17-30; Mark 14:12-26; Luke 22:7-38; John chapters 13-17; and I Corinthians 11:23-26). Discuss which scriptures inform which paintings; and discuss what later church traditions, theological teachings, and liturgical practices are reflected in them.

3. Lead the class members to create their own visual presentations of the last supper. First, have them try different physical positions and take photographs of each arrangement. If you take Polaroid photos, then you may immediately discuss the meanings of each arrangement and try variations to share additional meanings.

Some arrangements may emphasize how we are all parts of one body in Christ. Other arrangements may emphasize how Christ and his followers sacrifice themselves for others. Other arrangements may emphasize how we are to become servants and not masters of others.

4. To Leonardo's work, compare and contrast the insights embodied in the works which class members have created.

NOTES

[1] Leo Steinberg, "The Seven Functions of the Hands of Christ: Aspects of Leonardo's Last Supper," Art, Creativity, and the Sacred, ed. Diane Apostolos-Cappadona, (New York: Crossroad, 1984), p.50.

[2] Ibid., p. 55.

[3] Doug Adams, "Theological Expressions Through Visual Arts Forms," Art, Creativity, and the Sacred, p. 313.

CHAPTER 3

SACRIFICE, CRUCIFIXION, AND HOPE IN SEGAL'S "THE HOLOCAUST"

George Segal's The Holocaust (1984; The Legion of Honor Museum, San Francisco, Figs. 4-11) resonates with several of the subjects of sacrifice in the Hebrew and Christian scriptures as well as hope in the face of twentieth century inhumanity. Therefore, it is an appropriate image to view as we approach the lenten season and Good Friday. Using a kinesthetic method of replicating the body positions of the human figures in the sculpture, students become aware of the ambiguities expressed in the work of art so they can both remember and transcend interpretations associated with their earlier experience of the subject matter.

George Segal's The Holocaust contains ten life-size white bronze bodies lying on the ground with an eleventh solitary figure standing at a barb wire fence. Use the photographs to guide eleven students to reassemble the sculpture, each one assuming the position of a different one of the figures. Such an assemblage allows each student to experience simultaneously that one figure's internal sense and external awareness of the other presences in the total work.

When first viewing the sculpture from above, the viewer sees a full bodied young couple at one's right and the figure of a heavy set man and boy at one's left. When assuming the positions of the sculpture, the female student who depicted one part of the young couple reported that her head and shoulders rested on his right rib cage and make her aware of his breathing. She also discovered a partially eaten apple in her left hand. While she sensed no one else in the sculpture, her partner's left arm rested on the abdomen of the central figure. Her partner was quite aware of the central figure's breathing, although he saw only that central figure's right hand. As the students began to consider the relations of Adam and Eve to The Holocaust and came to see the central figure as God, they were cautioned to await the reports of the other figures before developing a full interpretation.

Those taking the positions of the older man and the young boy reported that they saw only each other. The placement of the man's left hand over the right side of the boy's face obscured the boy's vision of the action. The boy's hands were tightly drawn up behind his back as if they were bound. At first, the viewers reported that the man seemed to be protecting the boy or shielding him from seeing anything troubling. As the student more fully embodied that man, he realized his right hand was in the shape of a fist which was separated from the boy's head only by the central figure's intervening left arm. That arm was all he knew of the central figure. From this kinesthetic experience, students came to interpret the central figure as God's angel and began associating Abraham's intended sacrifice of Isaac with The Holocaust. Only later did they read Jane Dillenberger's study of Segal's earlier representations of this theme: In Memory of May 4, 1970, Kent State: Abraham and Isaac, (1978; Princeton University Chapel, Princeton, Fig. 55); and Abraham's Sacrifice, (1973; The Mann Auditorium, Tel Aviv) as discussed in chapter 19.[1]

How are we to understand these familiar biblical subjects in this new configuration entitled The Holocaust? One student remembered that the word "holocaust" is associated with the word "sacrifice" in the Hebrew scriptures. Those who embodied the central figure and one of

those in the heap of figures found themselves in the cruciform positions. The figure at the right foot of the central figure remembered similar positions in crucifixion or deposition scenes of Christ. Those who looked at the sculpture from above or from the other side of the fence observed that the whole work is in a cruciform shape with a long vertical line composed of Abraham/Isaac, the central figure, the figure at the central figure's right leg, and the solitary figure standing at the fence. The horizontal line is composed of the heap of bodies, the central figure, and Eve.

Urged to consider alternative interpretations, other students noted that the whole work formed a star of David. Some remembered that many well fed persons were gassed on arrival at concentration camps before they would have become emaciated; so all of the bodies could be included in a death camp scenario. This holocaust could be interpreted, then, through the idea of sacrifice as presented in the Abraham and Isaac story. Or the central figure who can be interpreted as a crucified Christ could also be seen as creation or nature itself as I suggested by a comparison to The Scream (1983, National Gallery, Oslo) by Edvard Munch (1863-1944). Munch noted, "I listened to the Great Infinite Cry of Nature."[2] The central body's flaccid phallus is the most prominent display of genitals in the sculpture. Many of the other figures' genitals are not at all visible or even indicated. Such a display could support an interpretation of the central figure as a genesis of life or an embodiment of nature.

The student standing at the barb wire fence with his back to all the others said that he felt lonely and more dead than alive. He was the only isolated figure in the sculpture; for all the rest touched or were touched by at least one other person. When compared to his isolation, the figures on the ground appeared more interactive. Their interrelation defied the horror of the historical event of the Holocaust. On the ground, all of the figures' heads pointed inward toward the central figure establishing a strong sense of total relationship that diminished if they turned around in the opposite direction with their heads far away from the central figure. (Such a reversal of position increased the sense of exposure and vulnerability.)

The student embodying Eve felt very much alive. Eve's sensuality contributed to the sense of lively survival as Segal acknowledges:

She is an ample, earthly figure, suggesting nature's abundance even in death, a Persephone image of renewal."I became as interested in Eve's sensuality as anything else," Segal stated in an interview. "It has to do with survival."[3]

In the heap of bodies, the student who embodied the cruciform figure sensed that he was being propelled upward. On top of the heap, another student sensed her body thrust upward as in a dive or her arms and hands extended upward in prayer or blessing. As the students assumed the positions of figures in the sculpture, the central figure reported that he felt an increasing responsibility for each individual and for the group as a whole.

When they first came to The Holocaust, many students saw only the horror of death. However, after embodying some of the figures, they saw many more details and sensed some relationships that witness to life. Life or death may be interpreted as predominating. Multiple interpretations of The Holocaust are possible as one may begin the analysis with the sacrificial aspects of the Abraham and Isaac event or the creative dimensions of Adam and Eve. The central figure may be interpreted in many ways: as God, as God's angel, as Christ, or as an embodiment of nature.[4] In the overall composition, one may see a cruciform or star of David. Christian Scriptures are evoked as well as Hebrew Scriptures.

TEACHING TIPS

1. Place a blanket on the floor on which the students recreate this sculpture. Reassemble the Segal sculpture by having the members of your class take the positions of the different figures shown in the photographs of The Holocaust.

2. Ask each person what he or she senses (sees or feels) of others; discuss which figures are the most alive or the least alive.

3. Remove the central figure; and ask the

others how they feel with the central figure gone. Then discuss how we would feel with Jesus or God gone, and how the disciples may have felt after Jesus died on Friday.

4. Similarly, remove the Isaac figure and ask Abraham how he feels; and remove the Eve figure and ask Adam how he feels. Discuss how we feel at the loss of a family member who dies or goes away.

5. Have class members imagine and perhaps draw how they would each make a sculpture linking modern-day suffering or sacrifices with historic holocausts and crucifixion.

6. Discuss how touching, reaching out to others, and expressing our feelings help us live with suffering.

NOTES

[1]Jane Dillenberger, "George Segal's Abraham and Isaac: Some Iconographic Reflections" in Art, Creativity, and the Sacred, ed. Diane Apostolos-Cappadona (New York: Crossroad, 1984) pp.105-124.

[2]Munch spoke about his own painting, The Scream, which bears comparison with the central figure in The Holocaust.

[3]Sam Hunter and Don Hawthorne, George Segal (New York: Rizzoli, 1984), p. 122.

[4]In my February 20, 1988 interview of Segal, he acknowledged that he had the cruciform in mind when approaching the sculpture from the direction of the person at the foot of the central figure. However, that is just one of the multiple interpretations depending on which way the sculpture is approached. Søren Kierkegaard's Fear and Trembling inspired Segal with the idea of multiple approaches. In that book, there are four different scenarios of what could have been going through the mind of Abraham on the way to sacrifice Isaac at Mt. Moriah. (Cf. Doug Adams, Transcendence With the Human Body in Art: George Segal, Stephen De Staebler, Jasper Johns, and Christo (New York: Crossroad, 1991), pp. 13-44.)

SURVEYING THE CROSS THROUGH PAINTINGS AND HYMNS

Pianist Artur Rubinstein injured his hand before a major evening performance. He walked onto the stage and told the audience of the injury, but said he would play the best he could. Having played one of the finest concerts of his career, he was greeted after the performance with many saying "we will hope to hear you when you are better."

Expectations affect what we hear or see. People had come to hear the great Artur Rubinstein and anticipated being on the edge of their seats ready to give attention to his every piece. When he told them about his injury, they sat back in their seats, did not expect much, and heard little. Similarly, we often gain much when listening to a preacher whose excellence we anticipate; for we bring energy to listening. We may gain little from listening to a preacher whom we assume is dull - in our inattentiveness we miss his or her fine points.

Music may set a mood and so affect our expectations of what we see. Playing several different musical selections gives us several expectations leading us to see different facets of an art work. For example, if we look at Georgia O'Keeffe's Black Cross, New Mexico (1929; The Art Institute of Chicago, Chicago, Fig. 12) while singing the hymn "Were You There When They Crucified My Lord," we may tremble as we see the huge cross which confronts us - seeing nothing but that looming black shape. However if we sing the hymn "We've a Story To Tell to the Nations," we may notice the horizontal lines of yellow and red on the horizon beneath the cross beam. We are heartened when we hear the words "for the darkness shall turn to dawning." (A color print of that painting is available in many books on O'Keeffe at local libraries or in many sizes inexpensively from The Museum Shop of the Art Institute of Chicago, 111 South Michigan Avenue, Chicago, Illinois 60603. Credit card orders may be placed between 10:30 a.m. and 4p.m. Central Standard Time Wednesday through Saturday at 312-443-3535.)

If we sing the line "it glows with peace and joy" from the hymn "In the Cross of Christ I Glory," we may see how luminous is the black of the cross. The frontality of the cross may comfort us as it evokes a sense of commitment or engagement or unsettle us as it confronts us. Frontality may engage us personally for reasons further explored in discussions of Stephen De Staebler's sculptures (chapters 31 and 37), an Orthodox mosaic of Pantocrator - Christ as Judge - or Barnett Newman's Fourteen Stations of the Cross (chapter 5).

In such frontality, there is an engagement or commitment like our conversation with one person at a dining table or our other moments of intimacy face to face. In such encounters, there are possibilities for the full range of emotions from painful arguing to pleasurable lovemaking. Frontal moments are not bland. Other lines from the hymn "In The Cross of Christ I Glory" may evoke those feelings associated with frontal art: "Bane and blessing, pain and pleasure, By the cross are sanctified."

What additional facets of O'Keeffe's painting do we see when we sing other hymns such as "When I Survey The Wondrous Cross" or "Christ The Lord Is Risen Today" or "Take Up Thy Cross"? When we sing these different hymns, what do we see in the other art work

featured in this chapter, Louise Nevelson's <u>Cross of the Good Shepherd</u> (1976; Erol Beker Chapel of St. Peter's Lutheran Church, New York, Fig. 13).

Nevelson's <u>Cross of the Good Shepherd</u> and other art works transform common wood fragments into glorious creations. Originally she gathered pieces of wood discarded in streets or dumps. She would assemble these together and paint them the same color such as all white or all black. The act of turning the discarded common pieces into a wondrous whole art work resonates with the transforming action of Jesus who took the common and the discarded, and made them into one body as a community reconciling all to God. Colossians 1:19-20 affirms that "Through Christ, God chose to reconcile the whole universe to God's self, making peace through the shedding of Christ's blood upon the cross - to reconcile all things whether on earth or in heaven"

The chapel features several of Nevelson's works besides this particular cross: there is another cross as well as three large wall reliefs referring to the Trinity; an assemblage of twelve square boxes of "found" wooden objects referring to the Apostles; and an entrance relief representing the wheat and grapes of Eucharist. Asked whether she felt any conflict between her Jewish upbringing and her crafting of crosses and other Christian imagery, Nevelson noted that a neighboring synagogue served as the location for the cornerstone ceremony for the church. "If we're having their dedication in a synagogue, that's enough. We've broken barriers on both sides with this and we hope to break more."[1]

In the art of both O'Keeffe and Nevelson, the cross is not a subject matter which stands out over against the world. Instead, the cross affirms the world. The O'Keeffe cross seems as much an element of nature as the mountains. Its massiveness and color bespeak its earthiness. The Nevelson cross is built of wooden fragments which seem as if they could be found in any common lumber yard or construction site along a city street. The O'Keeffe work resonates with the southwest landscape and its Catholic Spanish traditions. The Nevelson work resonates with New York City and its buildings. These works visually reconcile heaven and earth.

TEACHING TIPS

1. Lead the students in singing each of the hymns mentioned in the article as they look at the Georgia O'Keeffe painting. After each hymn, discuss which features of the painting the students noticed as they sang the hymn.

2. Discuss how the frontal presentation of the cross evokes a sense of engagement or confrontation. Ask the class members where they have such frontal moments of engagement or confrontation in their own lives.

3. Repeat the process of singing some of the hymns, looking at the Nevelson cross, and discussing what students see.

4. Discuss how Nevelson created many of her art works out of "found" objects, how reconciliation takes place in both Nevelson and O'Keeffe works, and how such reconciliation resonates with the reconciliation discussed in Colossians 1:19-20.

5. The week before this class session, ask students to look for small discarded wooden pieces throughout your community. Have them bring the pieces to this class session and make a cross while discussing where each piece was found.

NOTES

[1]Grace Glueck, "White on White: Louise Nevelson's 'Gift to the Universe'," <u>New York Times</u>, October 22, 1976.

CHAPTER 5

NEWMAN'S "STATIONS OF THE CROSS" EVOKE BIBLICAL CHARACTER

Of Barnett Newman's Stations of the Cross (1958-1966; National Gallery of Art, Washington D.C.), art historian John Dixon concludes, "They are profoundly biblical paintings, perhaps the profoundest ever achieved in this country."[1] His conclusion about their quality was confirmed when these fourteen abstract expressionist paintings were purchased for permanent display in the east wing of the National Gallery of Art. For reasons we will detail in this chapter, an art work may be judged as biblical because it evokes biblical character in the viewer rather than portraying biblical characters.

Looking at the first panel in Newman's Stations of the Cross (Fig. 14) and at his sculpture Broken Obelisk (1963-1967; Rothko Chapel, Houston, Fig.15) helps us experience the redemptive qualities of suffering. The artist did not create the fourteen panels to correspond to the conventional fourteen different stations of the cross from Jesus being condemned, through his crucifixion, and to his entombment. Instead, Newman's canvases expressed suffering which he considered a continuous agony rather than separate episodes. These art works are appropriate for study during lent and holy week or whenever we contemplate the significance of Christ's crucifixion.

Consider the ways in which a person's sharing of his or her brokenness may communicate hope or healing to others. Henry Nouwen has called this dynamic the wounded healer. Thomas Woodward observes this dynamic frequently as his disabled clowns, such as cerebral palsied Lydell, minister to others in hospitals:

A nurse tells the story, "We had this patient who had just had both legs amputated. He was a young man: and he was what you'd call terminally depressed. He wouldn't do anything to help himself. For him, life was over. Then, all of a sudden into his room wheeled this guy with cerebral palsy who's got a funny hat and clown make-up painted on his face; he can't speak and he can't gesture, but he smiles and makes friendly noises deep in his throat. For two, maybe five minutes the two men just look at one another. Then the clown was wheeled out into the hall and into another room. Our patient was shocked. He said, 'Here I am, feeling like my life is over and here is this guy who's got much less than I have, sitting there in his wheel chair, smiling and trying to lift me up. My life is not over — it may be just beginning.'"[2]

Newman's works confront us much as Lydell confronted that hospital patient. These art works are broken. The top of the inverted Obelisk is broken; and the zips of black paint down the canvas are jagged. Their very brokenness and jaggedness engage us and makes us aware of our own bodily nature and finitude. Joshua Taylor saw in such art works a "will to fellowship" or a "communitive" style that makes us aware of our own individuality and our relationships. A communitive art work "makes us sense that a person with a body painted this image and makes us aware of ourselves as distinct bodily individuals who can relate with others but never totally become one with them."[3]

If we take a straight edged piece of paper and cover the top of the sculpture so that it no longer appears broken, we sense how the "perfect" obelisk no longer makes us aware of our own body, finitude, or individuality. As we face an idealized perfect form, we become one with it. In such perfect shapes, Taylor saw a "will to form" or a "unitive" style. A unitive art work "makes us oblivious to persons as we are drawn beyond into perfect unity."[4]

Newman's works confront us not only because of their brokenness but also because of their frontality - they face us. This frontal quality is evidenced by the Pantocrator (11th century; Monastery, Daphni, Fig. 16) - the resurrected Christ as judge in the dome of many Greek Orthodox churches. With the vertical black zip at the left balanced by the rough vertical black zips at the right, Newman's first painting in the Stations of the Cross faces the viewer and does not allow the viewer to imagine passing through the canvas unengaged. As noted in chapter four, the frontal quality engages us like a conversation with one other person we face at a dinner table. Such frontal engagement is unlike the milling around at a typical cocktail party where we stand at oblique angles to others and talk with them in an uncommitted way as we may look for someone better. (Of the artists included in this book, Stephen De Staebler most fully develops and discusses the commitments embodied in frontality as chapters 31 and 37 reveal.)

There are, however, different experiences within frontal conversation. While the Pantocrator stresses the divinity of Christ dictating to the viewer, Newman's Stations of the Cross engage us in a two way conversation stressing the humanity of Jesus. The size and placement of these paintings facilitate this two-way conversation. Each individual canvas of the Stations of the Cross provides the shape in which a human figure could stand erect - a height to accommodate most men and women (seventy-eight inches) and a width of a person with arms extended (sixty inches).[5] The very verticality of the canvas causes the viewer to straighten up to attention whereas horizontal art works often invite us to relax.

While some artists' works evoke our emo-tions and other artists' works evoke our intellect, Newman's works evoke both our emotion and intellect fully. It is such evocation of the viewer's full personhood which caused John Dixon to call Newman's works profoundly biblical:

> Newman's require the spectator to think about them. In thought we are more than simple experiences, however spiritual. We have to mobilize our deepest individuality, an individuality that is profoundly biblical. The intelligence is too bound to a richly emotional experience to be pure enlightenment rationality. The experience is too bound to intelligent thought to be gnostic. The paintings, in short, compel a distinctly biblical personality as a condition of their response.[6]

Biblical faith affirms the body and mind together as good and created by God. In Luke 10:27, we hear a summary of desirable biblical character: "love the Lord your God with all your heart, with all your soul, with all your strength, and with all your mind; and your neighbour as yourself." (Similar passages are found in Deuteronomy 6:5 and Leviticus 19:18.) We may judge an art work as biblical in spirit when it evokes our fullness of heart, soul, strength, and mind in love of God and of others.

TEACHING TIPS

1. Look at Broken Obelisk and then place a straight edged piece of paper over the top to cut off the broken section and make it look unbroken. Ask class members to share how they feel when seeing something broken and then something unbroken. To which do they give more attention? Ask them to remember when they or someone else had a broken leg or broken arm; and discuss how other people treated the broken person compared to how they usually treated that person when he or she was not broken.

2. There are three casts of Broken Obelisk: one at the Museum of Modern Art in New York, a second on the Seattle campus of the University of Washington, and a third (pictured in this book) outside the Rothko Chapel in Houston.

This latter one was dedicated to Martin Luther King. How does martyrdom increase the influence of the person murdered? Consider the power of Christ crucified, the disciples martyred, Martin Luther King or John Kennedy killed. Consider Paul's repeated observation that God was reconciling the world through Christ on the cross.

3. While pointing out the frontality of the first panel of Station of the Cross, discuss the difference between a committed conversation facing someone at dinner or elsewhere in contrast to the uncommitted chatter at a party where we do not talk with others face to face but are looking beyond them for someone better. Discuss what attention and energy of heart, soul, strength, and mind we should give in prayer and work with God and others.

NOTES

[1] John Dixon, "The Bible In American Painting," The Bible and American Arts and Letters, ed., Giles Gunn, (Philadelphia: Fortress Press, 1983), p. 179.

[2] Thomas Woodward, "Clown and Gown," Modern Liturgy, Vol. 8, No. 5 (November, 85), p.6.

[3] Doug Adams, "Theological Expressions Through Visual Art Forms," Art, Creativity, and the Sacred, ed. Diane Apostolos-Cappadona, (New York: Crossroad, 1984), p. 313.

[4] Ibid.

[5] Jane Dillenberger, Secular Art With Sacred Themes, (Nashville: Abingdon, 1969).

[6] John Dixon, op.cit., p. 178.

BIRTH, DEATH, AND REBIRTH THROUGH PIETÀS

Several pietàs depict not only the death of Jesus but also his birth from Mary and his rebirth in resurrection. Such works project a sense of the whole biblical story, not just one episode. By referring to both death and life, these works permit remembrance of a full range of experiences in human lives and help us to see ourselves as parts of the body of Christ.

Visual art works which are not idealized may function like Henry Nouwen's "wounded healer" discussed in Chapter 5. As we tell stories about our problems, other persons are able to face their own problems; so too, art works revealing brokenness or incompleteness allow us to face our own mortal finite condition and to empathize with other's problems. In contrast, artist Stephen De Staebler observes the negative effects of idealizing the body in art; for it glorifies youth and does not make for graceful aging as our bodies look less and less like the idealized forms as we grow beyond adolescence.1 Thus, Paul's writing that "we were reconciled to God by the death of his Son" (Romans 5:10) can be understood as the crucifixion having the power of reconciliation when Christ is visualized as truly wounded. A glorified image of Christ is distant from the human condition and leaves many viewers distant from God.

Michelangelo's different renditions of the Pietà show changes in his perceptions from the ideal to reality. His earliest Pietà (1500; Basilica Church of St. Peter, Vatican City, Fig. 17), commonly called the Roman Pietà because it is near Rome, depicts an idealized adult male body of Christ in his mother's lap. There is more life than death in this body whose joints remain supple and whose arteries pulse in anticipation of resurrection. By denying rigor mortis, he seems more asleep than dead.

The image of Jesus in his mother's lap relates to hundreds of other art works of Jesus as a baby in his mother's lap. This reminder of Jesus' birth in humble conditions portrays Mary with the shoulders, hips, and other enlarged body parts which some art historians have characterized as a "washer woman" in order to accommodate a full grown man in her lap. Successfully placing a good sized man in a woman's lap, the artist has created an immense Mary in The Roman Pietà.[2]

As Michelangelo aged, he became dissatisfied with his earlier Pietàs as less truthful to the conditions of aging and suffering. With a growing appreciation for the power of suffering love, Michelangelo created The Rondanini Pietà (1564; Castello Sforesca, Milan, Fig. 18) where the standing Christ figure buckles at the knees and collapses back into the standing body of his mother.3 The upper halves of the two bodies merge partially as both figures face forward with the heads and eyes looking down toward their left. Much of the work shows a roughness with little of the smooth surface evident in his early Pietàs. The mother's left arm in front of his left shoulder presses his body into her own and seems to keep him from falling. That merging of bodies symbolizes that Jesus was born from Mary's body and that all believers as members of the church become parts of the body of Christ as Mary is often seen as the symbol of the church.

California artist Stephen De Staebler has recently created a Pietà commissioned by Jane Blaffer Owen (1989; The Roofless Church, New Harmony, Indiana, Fig. 19) which resonates with Michelangelo's Rondanini Pietà. However, De

Staebler's standing figures merge by overlapping at the sides rather than front and back; and so only two legs are visible below. Christ's left leg recedes and appears to have suffered; but Mary's right leg moves forward in resurrection. The head of the Christ emerges at the level of the mother's left breast. His head at her breast and the merging of the bodies remind us that he was born of Mary. Above the mother's head emerges an ambiguous shape which could be a nimbus, flame, or an as-yet-unrealized form into which the bodies are being transformed. Resurrection as well as crucifixion are evident in this work. Mary is once again seen as a symbol of the church which is also considered to be the resurrected body of Christ. Like Michelangelo's last sculpture, De Staebler's Pietà seems like a work-in-progress; but De Staebler's work offers more of resurrection, albeit in an ambiguous form in which we may see many different possibilities.[4]

On the reconciling effect of De Staebler's Pietà, Jane Blaffer Owen wrote:

> Not long ago a woman I did not know burst into tears when she saw our Pietà. She had little, if any, experience of art, but she told me the story of the recent loss of a son. Then I spoke of the death of my daughter Carol. Two strangers grew very close in that moment, and closer to the Mother of God than either of them had been before.[5]

TEACHING TIPS

1. Give each student four blank 3" X 5" cards; and ask each student to use two of them to write down brief descriptions of two happy experiences in his or her life (one on each card). Then have each student use the other two cards to write down brief descriptions of two sad experiences in his or her life (one on each card).

2. Then ask the students to look at the three Pietàs in this chapter. (Have the three pictures placed on three separate tables or at three separate sides of a table.) Instruct the students to place each of their four cards by the art work which most closely expresses the emotion described on that card.

3. As a whole class, discuss the different emotions each of the sculptures embody by having students share the happy or sad stories they have placed by each art work. (Discuss all the cards placed by one art work before going on to discuss all the cards placed by the second art work and then the third art work.)

4. Then share with the class how episodes of Jesus' birth, death, and resurrection are expressed in each art work and the dynamics of the wounded healer and Romans 5:10.

NOTES

[1]Doug Adams, Transcendence with the Human Body in Art (New York: Crossroad, 1991) p. 55.

[2]See Leo Steinberg, "The Erotic Metaphors of Love and Birth in Michelangelo's Pietàs" in Studies in Erotic Art, ed. Theodore Bowie and Cornelia V. Christenson (New York: Basic Books, 1970), pp. 231-338.

[3]Michelangelo's views of suffering love are explored in Nicholas Piediscalzi's "From Overwhelming Power To Suffering Love: Tracing Transformations in Michelangelo's Art and Theology," Art As Religious Studies, ed. Adams and Apostolos-Cappadona, (New York: Crossroad, 1987), pp. 117-130.

[4]Some of De Staebler's other works are seen and discussed in Doug Adams, "Informing Religious Studies with Contemporary and Earlier Visual Arts Portraying the Human Body" also in Art As Religious Studies, pp. 190-201; and many are reproduced in Adams' Transcendence With the Human Body in Art, op.cit., pp. 45-84.

[5]Ibid, p. 84.

CHAPTER 7

SEEING JOB FALL AND RISE IN OUR LIVES

The following method could be used with many different biblical stories to help the members of the class or congregation see the relationship between their lives and a Bible story. In this case, we illumine the falls and rises in our lives through the Book of Job. The method may be used simply in a one-time class session; or it may be used at an intergenerational gathering (such as an after potluck program) to begin the creation of a dance or mime which could subsequently be fully developed for sharing in a church worship service several weeks later. The method could be enriched by the accompanying art works. As the entire chapter details the method, there is no need for the usual list of teaching tips.

Everyone is clustered into groups of four or five people. The teacher either asks or tells the students about Job's condition at the beginning of the book of Job. We learn that Job was wealthy and healthy. He had family and friends who respected his opinions. He had a positive close relationship to God. In sum, he had a sense of well-being. Then, everyone is asked to remember one time in each of their lives when they had a feeling of well-being. With that one time in his or her mind, each person is asked to think of a word which expresses that sense of well-being. Then everyone is asked to take physical positions to express the words they have chosen. I usually have everyone say or sing a five-fold Amen during which time they may try out several different positions of their own choosing; but at the end of the five fold Amen, each person freezes (as if a sculpture) in one of the positions he or she has tried.

While everyone maintains their positions, they look in the direction of the teacher who goes around the room tapping each person on a shoulder as a cue for each to speak out the word

of well-being which the position embodied. Polaroid photographs and slides of the positions may be taken for later use in discussion or in development of a mime or dance on the theme of Job. The slides could later be projected by rear view projection as a backdrop for the presentation of the developed mime or dance in worship or at other church gatherings. After photos have been taken, the teacher may invite people to relax and share the time in their lives when they have experienced Job in well-being. This discussion could be in the whole group or in the groupings of four or five people; for shy persons may feel more comfortable sharing in a group of just four or five. By cutting off the discussion after several persons speak, one may avoid forcing everyone to speak. The teacher tells everyone to remember the position they took as their "number one" position.

Using the same method detailed above, each person develops a "number two" position to express when he or she experienced the sense of loss Job had during the middle of the Book of Job. Job lost wealth, family, and health: he developed boils on his skin. He no longer sensed God's presence. Three people lectured to him with less than helpful advice. His wife urged him to "curse God and die." After developing the "number two" position, it may be helpful to look at the positions of the bodies in William Blake's Illustrations for the Book of Job,[1] especially number 10, "The Just Upright Man is laughed to scorn" (Fig. 20). People could be asked to indicate which figure in that art work is expressive of their "number two" position. There could be further discussion about losses in our lives and how they affect our body positions: slumped shoulders, contracted torso, bowed head, or even total collapse on the floor or into a chair.

Using the same method which helped generate position "number one" and position "number two," each person develops a "number three" position to express the time when he or she experienced the sense of recovery Job felt at the end of the Book of Job. They may focus on what happened to draw them up from the depths of despair expressed in their "number two" position. Was it someone they encountered, a book, a moment of prayer, a retreat, or a new challenge? This "number three" position may focus on a time at the beginning of the recovery or when recovery was more developed. (Some Biblical scholars see the original ending of the book of Job at the point where Job is restored to conversation with God before the verses where his wealth, health, and family were fully restored.) Discussions of such restoration may be enhanced by looking at Blake's fourteenth illustration for the Book of Job: "When the morning Stars sang together, & all the Sons of God shouted for joy" (Fig. 21). People may indicate which one of the body positions in that art work expresses their recovery from the despair of "number two" position and their move into "number three" position.

When everyone has developed their three positions relating their lives to the book of Job (Job in well-being, Job at a time of loss, and Job in recovery), then they are led in singing or saying fifteen Amens. During the first five Amens, they move into their "number one" position. During the next five Amens, they move into their "number two" position. During the final five Amens, they move into their "number three" position. Repeat that pattern two more times with half the group watching the other half each time. Then discuss what people have learned about moving from well-being to loss to recovery. While the people are saying or singing the fifteen Amens and moving into their three positions, the teacher (or other persons skilled in dance or mime) may circulate among the people to mirror what they see, i.e., the teacher, mime, or dancer imitates with his or her own body what other people are doing. After repeating such a process so the teacher, mime, or dancer is able to mirror most of those in the class, then the people sit down and say or sing fifteen

Amens during which time the teacher, mime, or dancer reenacts the body positions they have seen. (During first five Amens, the "number one" positions are shown; during the second five Amens, the "number two" positions are shown; and during the final five Amens, the "number three" positions are shown.)

Then the teacher asks how many people saw each of their positions reflected in the reenactments and how many did not see their positions reflected. This is especially important to do if a dance or mime is to be developed for sharing in a later worship service; for in this way, all of the people's positions may be included. Different people react with different body positions to the same feeling; and different people have different feelings in response to the same event. It is easy to miss a less dramatic gesture which is nonetheless important to include. The recovery of Job may be embodied by the obviously joyful positions of those four figures whose arms are raised above their heads at the top of the art work or by the more restrained but relaxed kneeling figures below. Having three or four dancers involved in mirroring back the positions will help capture the full range of people's expressions.

When the reenactment is shared in class or when the mime or dance of Job is shared in worship later, the people will see that mime or dance not as something alien imported into worship but rather as a meaningful extension of their own bodies. This method has been used to increase people's meaningful relationship with many different Biblical stories. One selects three or more different moments of feeling in the story and then leads the people to develop body positions for each feeling. For instance with the story of Abraham and Isaac, the first may be Abraham's feeling when God tells him to kill his son Isaac (i.e., to kill his future or his hope). The second may be Isaac's feeling later in the story when he may sense that his father is about to kill him. The third may be when the angel of God stays Abraham's hand and Isaac lives. With the story of Miriam, the first position may reflect her feelings when leading the people's celebrational dance at the Exodus. The second position may reflect her feelings when she

contracted leprosy and Moses ordered her to be left in the desert. The third position may reflect her feelings when the people forced Moses to change his mind and keep her. Exploring such stories with this movement method allows people to integrate the falls and rises of their lives with the Biblical stories and to sense God in more aspects of their lives.

NOTES

[1]An extensive discussion of Blake's illustrations for the Book of Job is Kathleen Raine, The Human Face of God: William Blake and the Book of Job (London: Thames and Hudson, 1982). A brief psychological approach is found in Edward F. Edinger, Encounter with the Self: A Jungian Commentary on William Blake's Illustrations of the Book of Job (Toronto: Inner City Books, 1986).

REMEMBERING OUR EXODUS AND RESURRECTION AT EVERY DOORWAY

How many doorways do you pass through in one day? In making a list through the week, my students counted passing through doorways over two hundred times. Some doors they opened or closed several times a day: bedroom doors, closet doors, bathroom doors, front doors, back doors, and car doors. Some doorways were usually already open as they passed through: doorways to the kitchen, the living room, the dining room, and the family room. They passed through doorways at a grocery store, a bank, a post office, a shop, and a gas station. At school, there were many doors to open and close. At home there were also doors to kitchen cabinets and the refrigerator.

Passing through a doorway, opening or closing a door, and seeing a door are frequent experiences in our daily lives. Visual art and religious ritual connect the doorway to our memory of God and Christ; and so, we may remember what they have done for us whenever we see a door or pass through a doorway. The doorway may communicate our connection to God in Christ and so encourage us and remind us to give thanks.

In Judaism, the doorway is a reminder of the Exodus experience. Attached to the front doorpost of a Jewish home is a mezuzah, a slender case containing on a parchment scroll the texts from Deuteronomy 6:4-9 and 11:13-21. The first text includes the words "Hear, O Israel, the Lord is our God, one Lord, and you must love the Lord your God with all your heart and soul and strength." The text goes on to instruct the believer to remember the commandments and "speak of them indoors and out of doors, when you lie down and when you rise....; write them up on the doorposts of your houses"

In entering or exiting through the doorway, people touch the mezuzah to remember all that God has done for them. As Exodus chapter 12 verses 7 and 22 recount, doorposts were marked with the blood of a male lamb at the time of the first passover which protected the Israelites and initiated the Exodus from Egypt. So, everytime we walk through an exit, we may remember the Exodus experience and that the Lord brought us out of Egypt.

In Jewish visual art, the doorway becomes a highly religious symbol. Ann Honig Nadel titles one of her contemporary lifesized doorway sculptures Soul Catcher (1985; private collection, Fig. 22). Made of bronze and standing almost seven feet tall and over four feet wide, the doorway is a threshold to thought about the transcendent, about what lies beyond us in time and space. The art invites us to take a step beyond where we are and to pass through to new possibilities. The doorway is open and not closed.

At the center of a vast program of visual art in the third century Jewish synagogue at Dura-Europa in northern Syria, there is the Torah niche where scrolls of Genesis through Deuteronomy were placed (Fig. 23) The Torah niche's shape is the same as doors of the Jerusalem Temple painted above the niche. The people were to remember God's Temple (the place of sacrifice) and their connection to the whole Jewish experience every time they read the Torah. To the right of the Temple doors is a painting of the altar on which Isaac lies. Abraham stands with his back to us. The distant figure by the tent is Sarah. Caught in a thicket is a male lamb to be used in sacrifice (instead of Isaac) as noted in Genesis 22:13. The doors and

the sacrifice of the male lamb also remind the viewer of the Exodus.[1]

To the left of the Temple doors is painted a menorah, the candelabrum used in Jewish worship and noted in Exodus 25:31-40. This symbol relates to the doors and the Exodus as art historian Jo Milgrom discusses. She notes that the menorah in art often appears by the door and that it originates from the tree of light and tree of life imagery which in turn originates from the God of light in near eastern culture where the seven flames rise from the God's arms and head.[2] The menorah reminds us of God "who wrapped himself in light as a robe" (Psalm 104:2).

In Christian art, Christ is often placed in what appears to be a doorway which looks very like the Torah niche or Temple door. One rendering of <u>Christ</u> (Fig. 24) in the late eighth century <u>Book of Kells</u> is surrounded by a shape reminiscent of a doorway. In the Gospel of John, we may remember that Jesus is likened to a door: "I am the door of the sheep" (John 10:7); and "I am the door, anyone who comes into the fold through me shall be safe." (John 10:9) Similarly in the Epistle of James 5:9, it is written "there stands the Judge at the door." Christ resurrected as judge is linked to the door. As the logos, Christ becomes the new Torah in the niche. His right hand touches the Bible. He has become the Word. Above him are two peacocks heralding the new day just as such birds' calls waken people at the dawning of a morning. The writers of the four gospels appear below him to the right and the left.

Two classroom projects may help students make the connection between Christ and every doorway. In one project, students create mezuzahs and place in them not only the traditional texts from Deuteronomy but also those passages from the Gospel of John likening Christ to the door. Then they place the mezuzahs by the doors in their own homes. In the second project, students take slides of the many doors in their lives (doors in their homes, doors at schools, doors at the library, doors at movie theaters, at grocery stores, at post offices, at places parents work, etc.) Then together the class creates a slide show including all the slides along with a sound track tape recording of the scripture passages mentioned in this article. Such a slide show could then be shared with other classes or with the whole church in worship or at a family night potluck. An alternative is to have the students take photographs instead of slides and then create together a large collage poster of those photographs with the Biblical passages printed or written over or around the photographs. That poster could then be placed at the entrance of the church worship space on a Sunday when the children are in worship with their families.

TEACHING TIPS

1. At the class session a week earlier, you give the students this assignment: "Keep a list of all the doors you open or shut and doorways you pass through during this coming week at home, at school, and throughout the community." Discuss with them the references to and meanings of doors and doorways in the Bible and in art as included in this chapter. Students could make mezuzahs with those Bibical texts in them and take them home to place them by their doors.

2. At the subsequent class session, discuss the many different doors the students have noted on their lists throughout that previous week. At that session, also organize a plan for securing slides (or photographs) of those doors and doorways. Have students plan to photograph some of the doors open and some closed; and have them and their family members and friends in the pictures of doors.

3. At a later class session (it may need to be two weeks later to have all the slides or photographs developed), create the collage with the photographs and the Biblical passages (or the slide show with the tape recording of those Biblical passages).

4. If you have only one or two weeks to give to the project, then ask students to bring in the slides (or photographs) along with their lists to the first full class session on this topic. If it is a large class, you could limit each student to just a few slides (or photographs). You could substitute the drawing of the doorways for making slides and photographs if you wish to do the whole experience in one class session.)

NOTES

1. See Joseph Gutmann, ed., <u>The Dura-Europos Synagogue: A Re-evaluation (1932-1972)</u> (Missoula: Scholars Press, 1973).

2. Jo Milgrom, "The Tree of Light Springs From the Threshold," <u>Art As Religious Studies</u>, ed. Doug Adams and Diane Apostolos-Cappadona (New York: Crossroad, 1987), pp. 58-69.

"SLEEPING AND RESTING STILL" THROUGH JESUS' AGONY AND RESURRECTION

"Sleeping and resting still?" Jesus asks his three closest disciples when they have gone asleep for the third time in the Garden of Gethsemane on the night in which he is betrayed. (Mark 14:41) Andrea Mantegna portrays The Agony In The Garden (mid 15th century; National Gallery, London, Fig. 25) with Peter, James, and John asleep in the immediate foreground as Jesus prays on the rock above while his enemies in the background come to take him. The disciples appear very foolish; for at this climax, they are asleep with their heads laid back. All three look as if they are snoring peacefully; and John has his mouth very open.

Jesus' satirical rebuke of the sleeping disciples is expressed in images not only of his agony in the garden but also of the resurrection. In the foreground, three of the four soldiers are shown asleep at the moment of Christ rising from the tomb, represented by a sarcophagus in Piero della Francesca, The Resurrection (c. 1462-64; Palazzo Communale, Sansepolcro, Fig. 26). At our right, the fourth soldier leans back amazed at the resurrection. At the moment of the best news for the world, three are asleep and do not see it. Those three remind us of the three disciples who slept a few days before in the garden and who later will not believe the good news of resurrection even when Mary Magdalene tells them. In the background, we see a garden which relates not only to the garden by the tomb of his resurrection but also to the garden where the disciples slept and to the garden where Adam and Eve fell. Most disciples are sleeping and resting still that first Easter morn and are no more faithful than the soldiers who slumber through the most momentous event in history.

There is good news in remembering that the disciples slept through Jesus' agony and his resurrection. Like his disciples, we sleep when we should be awake to the agonies and resurrections in our own time. The number three is significant: the three disciples sleep three times in the Garden of Gethsemane paralleling the three times Peter will deny him. If leading disciples such as Peter sleep, then there is hope for anyone no matter what has been done or left undone. In discussing each of the following art works with students in a class, invite a sharing of the agonies and resurrections they have slept through these days.

In The Agony In The Garden, there are symbolized many agonies and joys from the whole biblical story, not just Gethsemane. In the far right background is a palm tree reminiscent of a few days earlier (Palm Sunday) when the multitudes greeted Jesus on his entrance into Jerusalem. Rabbits are evident along the road to our right and on the rocks to our left. Rabbits are associated with lust and the fall as well as resurrection and abundant new life. Thus, the joys at the beginning and end of Holy Week are present. The cross held by the angels and the trees remind us of Good Friday crucifixion.

The painting portrays even larger sweeps of the Biblical story since the tree suggests the fall of Adam and Eve who lived in that other garden. The new Adam undoes the damage of Adam's fall through his crucifixion and resurrection. Humanity's earlier sins are evidenced by the ziggurat-like mountain which resembles the Tower of Babel. The black bird in the tree's upper branches and the white dove in the foreground bring to mind the Noah story of the flood which destroyed the sinful but lifted up the ark of Noah who sent forth a black bird which did not return and then later a white dove

23

which returned with an olive leaf revealing that the flood had receded.

In the Berthold Missal Last Supper (c. 1225; Pierpont Morgan Library, New York, Fig. 27) John leans against Jesus' chest. This sleeping figure of John has at least three significations: this favorite disciple will be among those who go to sleep through Jesus' agony in the garden later that night; John will be the only disciple to avoid martyrdom and die in his sleep in old age; and Jesus is the new David and true king of Israel, for David loved his Jonathan too.)

In the Resurrection, the frontal presentation of the Christ figure engages us as if in a conversation. He seems to ask, "Do you see?" While those soldiers representing the powers of the earth fail to see, Jesus rises above them. This painting asserts that he is the true Lord, the true ruler, and that the soldiers and the empire they represent are subordinate to him. His upraised banner with the cross symbolizes that he has conquered the powers of death.

Jesus' left foot is on top of the tomb so that his left knee is much higher than his right knee. This position relates to a liturgical pose in worship: i.e., genuflection where the lower left leg is vertical while the lower right leg is horizontal on the ground. This identification between the body posture of the resurrected Christ in the art work with the contemporary worshippers in the congregation affirms that the church members are the body of Christ and the continuing resurrection in the world. In the Berthold Missal Last Supper other liturgical gestures of prayer or blessing are depicted by Jesus and some of the disciples. In these incarnational ways, we see ourselves as both the body of Christ and the disciples when we pray.

TEACHING TIPS

1. Looking at the art works, ask the class to identify each object and its connection to other episodes in the life of Jesus and in other biblical stories from Genesis through the Gospels. Share with them this chapter's insights about such objects after the students have shared their own insights.

2. Read aloud Mark 14:37-41 and discuss the significance of the sleeping figures in each of the art works.

3. After explaining how the body positions in the art works are identical to the body positions taken by worshippers in historic or contemporary worship, invite the students to take some of those body positions.

4. With the aid of newspapers and magazines, have the students cut out headlines, photographs, and stories which they believe are contemporary agonies to which we or others are asleep. With students, assemble those clippings into a collage entitled The Agony in the Garden Today.

5. Similarly, have the students clip out what they believe are contemporary resurrections to which we or others are asleep. Lead the students in assembling those clippings into a collage entitled The Resurrection Today.

CHAPTER 10

RESURRECTION IN MICHELANGELO'S ART AND OUR EXPECTATIONS

As visitors crowd into the Sistine Chapel, they expect to see a work over the high altar called The Last Judgment (1541: Sistine Chapel, Vatican City). Therefore, they interpret the central Christ figure's hands as engaged in wrathful gestures (Fig. 28). How would that interpretation change if the visitors knew that the work's original title was Resurrection and that those hands are in the positions of consecration and benediction for the mass? Our expectations strongly affect what we see. Having students assume the bodily positions within Michelangelo's work helps them transform their initial expectations and experience a sense of bodily resurrection.

To assume the position of the Christ figure's legs, one begins with the right leg in a kneeling position with the right knee on the floor. The lower left leg is vertical; and the sole of the left foot is flat on the floor with toes pointed directly forward. One achieves the position of the Christ by beginning to raise the right leg while maintaining the position of the left leg. One turns the torso slightly to the left with the head facing down and slightly to the left. With fingers bent slightly, the lower left arm and palm are held parallel to the floor in the front of the mid-torso. The right arm is raised so the elbow is on a level with the head while the open right palm faces forward slightly in front, above, and to the right of the head.

Some priests who took this position in my class reported a remembrance of celebrating the mass with hands in those positions at moments of consecration or benediction when the priest looks off to the side to read the appropriate texts. The position of Christ's legs reminded them of one rising from a kneeling position which many remembered at the consecration in

the mass. They had not yet read of the painting's original title (Resurrection) or art historian Leo Steinberg's interpretation of the hands as blessing.[1] Ambiguous understandings are appropriate for a fresco positioned above the altar of a mass which invites the viewers to partake the eucharist to their blessing or damning depending on what they expect. Expectations strongly affect what the viewer experiences.

This kinesthetic method transforms our vision of another work in the Sistine Chapel. Most viewers of The Creation of Adam (c. 1511; Sistine Chapel, Vatican City, Fig. 29) focus on where God extends a right hand toward Adam's left hand. Steinberg asks, "What is God's other hand doing?" Then we see God's left arm embracing a female figure (who is identified variously as the pre-existent Eve, or the pre-existent Mary, or Sophia [Wisdom or Holy Spirit]); and his left hand rests on the shoulder of a baby boy (the pre-existent Christ, the Logos). The meaning of the whole work expands to express the sweep of the biblical story from Adam to the new Adam: the good news - good news not communicated if we focus on God's right hand alone.

Visual arts have the possibilities to express a whole sweep of the biblical story whereas the readings of scripture for a given day express only parts of the story. A painting may present simultaneously a number of separate events within one context to give us a sense of wholeness. In our time of liturgical renewal when each worship service is to remind us of the whole biblical story rather than just separate episodes from the life of Jesus, the visual arts raise our vision to wider horizons to help us remember what happened before and after any one episode.

Ted Gill reports that this fresco was the

favorite of theologian Emil Brunner because God and Adam are not touching and so express the eternal vis-a-vis: they have persistent distinct personalities who may communicate but never merge at the expense of individuation. For Brunner, Christianity values individual personalities and communion while some eastern religions value that union which leaves no separate space for individuality. Care for the individual personality is reflected in Christian concern for "resurrection of the body" instead of eastern religions' "immortality of soul" which Gill pejoratively styles as "sucking everyone into a universal mush of divinity."[2]

In assuming the figural positions found in The Creation of Adam, the participants increasingly realize God the Father's reliance on others. He is supported from below by several smaller figures as well as by his left arm which goes around the female figure. Some students developed an understanding of the Trinity in this act of creation as the Father God is in relation to the Son and the female figure who could be seen as the Holy Spirit. A complex understanding of the whole company of heaven is developed. Cooperation in creation is stressed as all work together.

To increase the understanding of the resurrection, one may explore the fall segment of Michelangelo's Temptation and Expulsion (c. 1511: Sistine Chapel, Vatican City, Fig. 30). In that work, there is also a kind of cooperation but with divided intentions. In assuming the position of Adam, one stands keeping the knees somewhat bent with the right foot stepping straight forward toward the surface of the fresco while the right knee is turned in somewhat toward the left. For the upper left thigh to appear as it does behind Eve's head and for his groin to be as visible as it is, the hidden left foot must be placed substantially to the left but not too far into the background. The upper torso is turned sharply to the left so that most of the back is exposed. Both arms are extended at head level with the left hand clutching the tree limb in the background and the right hand pointing toward the serpent in the foreground. The head faces the direction of the right hand. In this position, a body experiences a tremendous

tension. There is substantial ambiguity as to which direction this body is going; it is on the brink of falling. Such kinesthetic insights add to the students' understanding of whether this Adam knows what he is doing and sees that he is choosing between two or more directions. His precarious position contrasts with both the stability of the Christ figure (the new Adam) in The Last Judgment/Resurrection and the support of the God the Father figure in The Creation of Adam.

To assume the position of Eve, one sits with knees bent sharply and feet drawn up just below the buttocks. The upper torso turns somewhat to the left with that left arm extended high above the head and toward the serpent. Eve's head turns sharply to face the left hand. The right hand is close to the right rib cage and pelvic area. By taking these positions, one realizes the acute tension in Eve's body.

Through this kinesthetic method, tensions and intentions become evident which would be missed by a relaxed sedentary viewer. Some dynamics of creation and fall and resurrection are felt through interaction with Michelangelo's frescos; and we realize how the body informs our relationships with others.

TEACHING TIPS

1. Lead the class members in assuming the positions of the figures in different Michelangelo frescos.

2. With The Creation of Adam, discuss what cooperation and attention are present in the act of creation; and discuss what cooperation and attention are needed in other acts of creation (staging a play or musical, making a scientific discovery, raising a family). Discuss the importance of letting the creation go and not trying to shape it further (whether it is an art work or ones son or daughter).

3. With the Temptation and Expulsion, discuss what tensions are felt by those in the act of disobeying.

4. With the Last Judgment/Resurrection, discuss how our expectations affect our experiences with family members, at school, at work. Read the parable of the workers in the vineyard (Matthew 20:1-16) and discuss how rising

expectations affect our judgments.

NOTES

[1]Leo Steinberg, "Michelangelo's 'Last Judgment' as Merciful Heresy," <u>Art In America</u>, (November-December 1975) pp. 49-63. Cf. Marcia Hall, "Michelangelo's Last Judgement: Resurrection of the Body and Predestination," <u>Art Bulletin</u>, 58 (March 1976) pp. 85-92.
[2]Doug Adams, "Insights from Three Perspectives on the Religious and Aesthetic Imagination," <u>Seedbed</u> (June 1975) pp. 1-3.

CHAPTER 11

BECOMING THE BODY OF CHRIST IN RESURRECTED COMMUNION

The broken bread and the glass of wine are the most substantial visual elements in Salvador Dali's The Sacrament of the Last Supper (1955; National Gallery of Art, Washington D.C., Fig. 31). As we focus on those elements, the actual image of the body of Jesus seems to fade away. From the lake in the background, boats are visible through the torso and left arm of Jesus. Such boats may remind us of his later resurrected appearances to the disciples at the Sea of Galilee. The large torso which rises above the scene signifying resurrection and ascension simultaneously images the crucifixion through the extended arms. Those arms also seem to embrace or bless the disciples below who are the members of the Body of Christ.

In asking class members to list the possible allusions to biblical episodes which occur to them as they view Dali's The Sacrament of the Last Supper, they name not only the foregoing possibilities but also the transfiguration of which the mountains and light around Jesus remind them. The stillness of the lake reminds others of Jesus' walking on the water and calming of the storm. One student observed that the glass of wine placed in front of Jesus' right side made a visual association with the wound from the crucifixion. The visual art of communion helps us to remember the whole biblical story rather than just one episode.

Paul Tillich was critical of Dali's sentimental rendering of Jesus (which Tillich called "kitsch," "a beautifying naturalism").[1] The figure of Jesus does not command our attention which is visually drawn to the bread and wine; and the lines of the table cloth then extend our vision toward Jesus. The light and Jesus' right hand draw our attention upward to the torso looming above. That torso's extended arms with palms down direct our attention toward the group of disciples below. So we see the connections between the bread and wine, and the disciples as the body of Christ.

In western Christianity, communion has often been understood as a historic remembrance of the Last Supper. Such a limited understanding makes communion a somber occasion as at the time of the Last Supper the people still face the crucifixion of Jesus on Good Friday. Since Vatican II, the Catholic and Protestant churches have rediscovered a celebrative communion closer to earlier church understandings. In Eastern Orthodox Christianity, communion has been celebrated not only as a remembrance of the historic Last Supper but also as the communion experiences at the post-resurrection events at Emmaus and at the Sea of Galilee.[2] A resurrected communion encourages joyfulness emphasizing each communicant as a part of the glorified body of Christ.

In both painting and engraving, Rembrandt van Rijn created art which expresses dynamics of the resurrected communion described in Luke's account of the Emmaus story. In Luke 24:13-35, Christ's followers recognized him not when he interpreted the scriptures but only when "he took the bread and blessed, and broke it, and gave it to them." We see that event in Rembrandt's etching and drypoint Christ At Emmaus (mid 17th century; National Gallery of Art, Washington D.C., Fig. 32) where the Christ holds in each hand a portion of the broken bread and extends his hands toward disciples on either side of him. The pieces of bread are almost indistinguishable from the shape of his hands and arms; and as in the Dali work, the cup is placed before Christ's right side in proximity to his wound.

Rembrandt's art leads us to see the connection between the biblical Supper at Emmaus and our communion in worship. Like an altar in a raised chancel area, the table is set on a platform. Like a baldachino which hovers over the altar in many churches, a cloth canopy defines the space of the table. Christ's two followers hold their hands in prayer positions which church leaders frequently assume at an altar: the standing disciple to Christ's right folds his hands in prayer while the disciple to Christ's left holds his arms up and out in the manner of a benediction or blessing. At the time of Rembrandt, even lay persons frequently prayed with their hands and arms raised in that biblical manner. Three floorboards run from the foreground toward the table so as to make a further connection between the viewer and the Christ.

Some artistic devices similar to Rembrandt's are evident in other artists' works which help connect the present viewer, the biblical accounts of communion, and later church practices of communion. As Rembrandt's floorboards connect the viewer with the scene, we see in Dali's work a stripe of golden color moving from background to foreground across each end of the table so as to embrace the viewer. We may remember how Christ's hands in Morghen's engraving of Leonardo's Last Supper reached out toward the viewer (Fig. 1). As Rembrandt's figures take positions reminiscent of Protestant ministers leading worship, so Dali's disciples appear in the kneeling posture of a pre-Vatican II Roman Catholic priest at the communion table during the consecration of the elements.

Two methods help viewers see the multiple meanings of each body position or gesture in these art works. In the first method, have them look at Rembrandt's full art work and discuss the meaning of the hand gestures of each character. The viewers will interpret the followers' gestures as startled physical reactions to their recognition of the central dinner companion as the resurrected Christ. Then place a piece of paper over the Christ figure so as to remove him from view and discuss the meaning of the hand gestures of the remaining figures who now appear to be at an altar for communion. The viewers then probably will interpret the gestures as postures of prayer, blessing, or benediction.

In the second method which builds on the kinesthetic method, three class members assume the positions of the three characters in the full Rembrandt art work. They and other viewers discuss the meaning of their hand gestures. Then have the central Christ figure leave the scene; and ask the remaining two figures and other viewers to discuss the new meaning of their hand gestures in this changed context. One may use the same two methods with the Dali work and involve more class members.

Removing the Christ figure from both art works helps the class members to sense not only multiple meanings of Dali's and Rembrandt's works but also significant dynamics in the biblical stories. At the Last Supper, Jesus was present but spoke of his impending departure which will leave the disciples as the body of Christ. Later that night, he was taken from the disciples. In the Emmaus road story, Jesus disappears from the scene.

TEACHING TIPS

1. Discuss which biblical stories each art work helps us remember. Then read those stories aloud to see other possible connections between the work and the biblical accounts: the Last Supper and the later scene at the Mount of Olives (Matthew 26: 17-46); the Emmaus road meal (Luke 24:13-35); the meal at the Sea of Galilee (John 21); the Christ appearing to disciples in Jerusalem and blessing them at Bethany (Luke 24:36-53); and whatever other passages the class members suggest.

2. Lead the class in the two methods described so they see and discuss the multiple meanings of the body gestures of the Rembrandt work and Dali work.

3. Lead the class to list each art works' details which recall worship and communion services in their churches and in churches of other traditions. Discuss how each art work helps us understand communion and ourselves as the body of Christ. Read and discuss Paul's account of the Last Supper and his understanding of church members as the resurrected body of Christ (1 Corinthians 11:23-26; and 1 Corinthians 12:12-27).

NOTES

[1]Paul Tillich, <u>On Art and Architecture</u>, ed. by Jane and John Dillenberger, (New York: Crossroad, 1987), pp. xvi and 133.

[2]Nicholas Zernov details how the Orthodox Christian liturgy remembers a wide range of biblical accounts including the last supper, the meals with the resurrected Christ at Emmaus and the Sea of Galilee, and the ascension: <u>Orthodox Encounter</u>, (London: James Clarke & Co., 1961), pp. 62-69.

CHAPTER 12

SEEING MULTIPLE MEANINGS
OF CHRIST IN ISAAC

Showing side by side two or three art works with the same Biblical subject allows the students to see meaningful similarities and differences. For instance, a comparison of three art works on the theme of Abraham's sacrifice of Isaac reveals not only how the artists emphasize different moments of the Genesis 22 story but also how they relate the story meaningfully to their own times or theologies. Because both Jews and Christians have seen the sacrifice of Isaac and the sacrifice of Christ as illumining each other, art works on Isaac express multiple meanings of Christ.

Lead the students in making a list of the persons and objects in the Biblical story. In reading Genesis 22, we note the presence of God, Abraham, Isaac, two servants, the angel of God, an ass, a ram in the thicket, a mountain, a knife, an altar, wood, and a fire. Then look at each art work and list the persons and objects in each separately. In Rembrandt's Sacrifice of Abraham (1635; Hermitage, St. Petersburg, Fig. 33), we see Abraham, Isaac on a pile of wood, the angel, and the knife. In Jack Levine's Sacrifice of Isaac (1974, private collection, Fig. 34), we see Abraham, Isaac, and the knife; but no angel stays the hand, although one may interpret some sketchy shapes to be forming some tiny figures to the left of Abraham's head.

In Chagall's The Sacrifice of Isaac (1935; Musée National Message Biblique Marc Chagall, Nice, Fig. 35) we see all of those persons and objects plus a bush with a very small ram under it and a person to the left; and in the upper right background, we see other persons and a man carrying a cross. Above and to the left of the blue angel is a white angel. Some of those additional figures are mentioned in Midrash, Jewish commentary on scripture; for in one

passage of Midrash, Isaac carrying wood up the mountain is compared to a man carrying the cross, an allusion to Jesus.

The 1974 Jack Levine etching shows Abraham's left hand raised with the knife ready to sacrifice Isaac. There is no obvious angel about to intervene to save Isaac. At that moment, it appears Isaac will be sacrificed. In the early 1970s, the memory of killings in Vietnam and the threat of nuclear war still hung as a sword of Damocles imperiling any hopeful human future. The word sacrifice and the word Holocaust are related in Biblical Hebrew so that this Levine etching brings to mind the memory of the World War II Holocaust when millions of Jews and others were not spared but were killed.

The positioning of the body of Isaac both in Levine's work and in Rembrandt's work is similar to the body position of Christ on the lap of Mary in many Pietà sculptures and paintings. So, these works (and Chagall's work with a man carrying a cross in the background) remind us of Jesus who was killed.

In Chagall's work, the figure of Abraham looks away from Isaac and up toward the angel so that we sense Isaac will be spared. In Rembrandt's work, the angel grasps Abraham's hand which drops the knife so that it will not slit Isaac's throat. The knife is falling toward the lower part of Isaac's body; and so, we may remember that circumcision rather than child sacrifice was a sign of covenant with God.

Comparing the right and left halves in each art work yields other meaningful insights. Levine's Abraham holding the knife in his left hand is unusual and signals a more ominous act than in Rembrandt's or Chagall's works; for the left is "sinistre" or "gauche" in foreign languages and is associated with the sinister or the damned

in art where the blessed are to Christ's right and the damned to his left in last judgment works. Similarly, the angel and the light are to Abraham's right in the Rembrandt work while darkness is to Abraham's left.

The darkness of Abraham's eyes in both the Levine and the Rembrandt works may communicate sadness. Detailing one of four different ways Abraham could have felt in response to God's command to kill Isaac, nineteenth century theologian Søren Kierkegaard wrote that even after Isaac was spared, Abraham would be sad:

> From that day Abraham grew old, he could not forget that God had demanded this of him. Isaac prospered as before, but Abraham's eyes were darkened and he knew joy no more. (Fear and Trembling and Sickness Unto Death, New York, Doubleday, 1954, p.28.)

Kierkegaard imagines three other possible reactions by Abraham and Isaac. In one scenario, Abraham considers telling Isaac that the sacrifice is Abraham's idea but that God does not will the sacrifice, so Isaac will not lose faith in God. In another scenario, Isaac never talked to anyone about what had happened on that mountain; and Isaac lost his faith. It may be noted in the Biblical text that while Abarham went down the mountain to return home with the servants, Isaac is not mentioned as accompanying Abraham; and we may well imagine that Isaac would not again accompany his father up or down any more mountains of sacrifice. Jews and Christians do tell the stories about sacrifice; and telling such stories keeps faith alive.

Ask each student to pick out which of the three art works he or she finds most meaningful; and then have students discuss which works they have picked and why they find them meaningful. Discuss which of the works relate to our own lives or to the events going on in the world.

To help students link their own lives with the Abraham and Isaac story, one may use the mime/dance method fully detailed in chapter 7 on "Seeing Job Rise and Fall in Our Own Lives." Each student is asked to pick three times in his or her life: l) when all was going well within the family much as Isaac thought all was going well when he and Abraham set off from home on the trip to Mt. Moriah to offer a sacrifice; 2) when there was conflict between parent and student and the future looked bleak much as Isaac's future looked bleak when Abraham bound Isaac on the altar and was about to kill him; and 3) when the hope of a future was restored much as when the angel spared Isaac's life. Students discuss each of those three times; and they may embody those times by using the mime/dance method.

An alternative is to use the torn paper method developed by Jo Milgrom and fully described in chapter thirty on "Embracing Tensions Between Generations." Each student picks a different colored paper for each character or object from Genesis 22 that he or she decides to include in an art work. Each student then creates his or her own art work by tearing the papers into the forms representing the characters or objects and placing them in relation to each other on a piece of white paper. Students then discuss the meanings of the art works they have created.

TEACHING TIPS

1. Lead the students in reading aloud Genesis 22:1-19 and have the students make a list of all the characters and objects in the story.

2. Have the students look at the art works and list which characters and objects are in each.

3. After each student has selected the art work which is most meaningful to him or her, have the class discuss their selections and why they made them.

4. Use the mime/dance method or the torn paper method to help students relate their lives to the story of Abraham and Isaac.

LIGHT INTERRELATES STORIES OF MOSES AND JESUS

The Gospels of Matthew and Mark emphasize the importance of Jesus by presenting him as the new Moses. At the birth of each man, the secular rulers order the death of Jewish male children; for they fear their own reigns will be overthrown. Both Moses and Jesus spend time in Egypt; and both later experience the wilderness before undertaking their missions. As Moses parts the waters so people safely reach the other side of a sea, Jesus stills the waters so the boats reach the other side of a sea. As the sea drowns Pharaoh's army, so the sea drowns the pigs into which the demon called "legion" enters with Jesus' permission; and "legion" was the designation of a Roman army. As Moses feeds the people in the wilderness, Jesus feeds the people in the wilderness.

As Moses receives the Ten Commandments on the Mountain, Jesus gives the Sermon on the Mount. Moses leads the twelve tribes as Jesus leads the twelve disciples; and as the priestly tribe of Levi does not count as a real tribe and has no future land, so Judas does not count as a real disciple and has no future. Moses is associated with the Passover Seder meal as Jesus is associated with the institution of Communion. Moses strikes the rock while Jesus curses the fig tree; and there are many other similarities as noted in Edward Hobbs' work, The Gospel of Mark and the Exodus (University of Chicago, 1958). While Moses sees the promised land from a hill top, he dies before the people enter that land as Jesus dies on a hill before the kingdom comes or before the church is organized.

Visual art helps us see many parallels between Moses and Jesus. The symbol of light is prominent in some of those parallels. Both Moses and Jesus are transfigured in light by

mountain top experiences of God. As the burning bush is symbolic of God's presence in the Moses story, so the star is symbolic of God's presence in Jesus' birth. As Moses and his people are led by God's presence known by a cloud during the day and a fire in the cloud at night, the wisemen are led by a star to Jesus.

In religions of the near east long before Judaism or Christianity, light was associated with God. Jo Milgrom has shown how the menorah, the candelabra in Jewish ritual, originates from the God of light pictured at the center of an Akkadian cylinder seal dating from 2800 B.C.E.: The Sun God Ascending Between Two Mountains (c. 2800 B.C.E.; The Pierpont Morgan Library, New York, Fig. 36). Rays of sunlight rise from the shoulders and horizontally held arms of the sun god much as the candle holders rise in the menorah. Light continues to be associated with God's presence in stories about Moses and Jesus where "rays of light came from the face of Moses" (Exodus 34:35) and where Jesus is called "the light of the world" (John 8:12).

Compare Marc Chagall's Moses Before the Burning Bush (n.d.; Musée National Message Biblique Marc Chagall, Nice, Fig. 37) and Mathias Grünewald's Resurrection detail of the Isenheim Altarpiece (1515; Musee d'Unterlinden, Colmar, Fig. 38). In Chagall's work, a circle of red and gold light in the upper center surrounds an angel with upraised arms at the top of the burning bush. In Grünewald's work, a circle of red and gold light suffuses the risen Christ with upraised arms above the tomb. Chagall's painting presents Moses twice: at the right he appears in white with rays of white light coming from his head as he was described after the Mount Sinai experience of receiving

the law; and at the left he is portrayed with a golden colored face, golden rays of light above his head, and a blue body.

When that blue body is examined, we find it is composed of hundreds of people. We are led to see the people of Israel as the body of Moses much as Christians talk of the followers of Jesus in the church as the body of Christ. Below the Moses figure is a diagonal white cloud shape which represents the foam of the sea which covers many red figures below who represent the drowning Egyptian army; and that cloud like shape may also allude to the cloud of God's presence which was at the Exodus and which later led the people in the wilderness. In his chapter "The Art of Marc Chagall" in Art As Religious Studies (Crossroad, 1987), Stephen Reid identifies many more of the shapes and colors in Chagall's work.

Theologian Paul Tillich called Grünewald's Resurrection the only great art work on that subject. He explained why he made that judgment:

> It is because Mathias Grünewald is able to show the Resurrection as a transformation of the finite into the infinite, symbolized by the sun in which the body of Christ disappears. Now this is a tremendous insight. Very often in the Resurrection pictures, Christ simply returns into the world of bodies, trees, souls, and other human beings and talks with them, as if nothing had happened before. Now this is not Resurrection. (Paul Tillich, On Art and Architecture, Crossroad, 1987, p. 117.)

In the Grünewald work and in other representations of resurrection (as in Piero della Francesca work discussed in Chapter 9) we often see the soldiers reacting in different ways symbolic of different persons' reactions to Christ. Some continue to sleep and so are unaware of the event; others are upset and seem to reject Christ while others look interested to see what is happening.

The associations of the son of God with the sun are reflected in the timing of Christmas, when days have begun to grow longer with more sunlight each day after we have passed through days with the most hours of darkness at the winter solstice. The decorating of Christmas trees and homes with strings of electric lightbulbs and the lighting of Advent candles in church are continuations of Biblical, historical, and theological associations of Christ and light. Similarly the resurrection at Easter is associated with the time of year when we have begun to have more hours of light than of darkness after the spring equinox. Historically in confirmation, those confirmed were presented with light symbolizing that they, as the body of Christ, were to be the light of the world.

TEACHING TIPS

1. With students looking at the paintings in this chapter, ask them to list all the objects and shapes in each painting and then discuss similarities between the two art works in terms of objects and shapes. If you obtain color versions of these in books on those artists from a library, then students may also discuss similarities in colors.

2. Read aloud each scripture passage from Exodus and from the Gospels which relate to details in the art works, and have the students stop you each time they see how such Biblical references are evident in the art works: e.g. Exodus 3:2-11; Exodus 13:20-22; Exodus 14:21-28; Exodus 34:29-33; Matthew 17:1-5; Matthew 28:1-4; and John 8:12.

3. With students, make a list of parallels between details in the life of Moses and in the life of Jesus as noted by this chapter; and discuss how our understanding of Jesus is enriched by associating him as the new Moses. How do our understandings of Baptism increase when we see it associated with the Exodus experience of passing through the waters and moving from slavery to freedom? How do our understandings of communion increase when we see it associated with the Exodus experience of the passover meal?

4. After considering how light represents God in the stories and art works of Moses or Jesus, discuss how light is used in the decorations and celebrations of Christmas at homes and church. Students may then create a mural showing how light appears throughout their lives

and ways their lives or the lives of others may be the light of the world. (Have magazines available so that students may find many depictions of ways light appears in daily life and may use some of those depictions in creating collage parts of the mural.)

SECTION II

ORDINARY TIME
(FROM PENTECOST TO ADVENT)

LIFE-IN-CHRIST LIVED OUT

ICONS REVERSE PERSPECTIVE AS PARABLES OF GOD'S COMMUNITY

G. K. Chesterton was fond of saying, "You must stand on your head to see the world correctly; for it is upside down." Through a renaissance perspective, we viewers of art stand supreme at the center of a universe; for other objects and persons appear smaller in a painting's background further from us and larger in the foreground nearer us. Through reverse and multiple perspectives found in byzantine icons, we viewers are put in a different place; for persons and objects appear smaller in the foreground and larger in the middle ground or background. From this more modest place, we see how to reshape our thinking and to relate meaningfully in God's community.

The shift from a renaissance perspective to the icons' reverse perspective is similar to the shift in thinking invited by Jesus' parables. Before hearing the parable of the Good Samaritan, a man self-centeredly asks "What shall I do to inherit eternal life?" In conversation with Jesus, the man begins to shift his focus away from himself by asking "Who is my neighbor?" By the end of the parable, the man does not speak of himself but speaks only of "the one who showed mercy" on another person. (Luke 10:25-37)

Reverse and multiple perspectives reveal the theologies of Orthodox Christian icons and El Greco's art. Although some scholars have described how such perspectives informed the development of cubism and other techniques in modern art, this discussion prepares us to appreciate much modern art as expressing theological values.[1] Considering visual art works as theological expressions is normative practice in Eastern Orthodox Christian churches where paintings and words are both affirmed as co-equal ways of communicating The Word.

Andrei Rublev's icon of The Holy Trinity (1411; Tetreyekov Gallery, Moscow, Fig. 39) is called the icon of icons and the highest statement of theology in the Russian Orthodox Church. Created around 1411, this icon portrays the three angels of Genesis 18:1-8. While that story speaks of Abraham's hospitality to strangers, Orthodox Christian tradition treated the three angels as prefigurations of the Trinity and the meal as communion. Icons based on that biblical text explored the theological dynamics of the Trinity and the communion which both model how we are to live in community with God and others.

In an unknown artist's slightly earlier version of this same theme, Old Testament Trinity (1410; Russian Museum, St. Petersburg, Fig. 40), we easily see the reverse perspective as the central angel behind the table is larger than the two angels seated closer to us at the sides of the table. In the foreground, diminutive images of Abraham and Sarah serve the meal. In Rublev's version, the central figure, although further away from us, is only subtly larger than the two angels closer to us while Abraham and Sarah have been eliminated.

Like the subtle cubism in many of Paul Cezanne's still-life paintings of fruit on a table, Rublev's work allows us to see multiple perspectives simultaneously further undermining our normal sense of stability from one central fixed point. We see the table top as if we were looking down on it at the same time that we see its front and bottom as if we were standing in front or below it. Similarly, we see the cup simultaneously from the top and from the front.

This combination of reverse and multiple perspectives disorients the viewer and causes a slight dizziness. As historical theologian Marga-

ret Miles notes, "a person grasps God's transcendence by the perception of an image that dizzies and before which her or his breath is taken away."[2] Such an experience unsettles us and shows us that we are not the center of the world. For Christians, transcendence begins when we sense the other which is beyond us and makes us aware of our finitude.

Having made us aware of the limitations of any one fixed viewpoint, Rublev's icon invites us to move into more dynamic relationships within a community. Such dynamics become evident when we try to fix our attention on just one of the three figures portrayed. This fixation is impossible to maintain; for all of the figures are looking away from themselves and calling attention to the others as their eyes, heads, and bodies incline toward others. If one focuses on the figure to our left, he is looking toward the figure to our right while that figure is looking back toward the figure on our left.

Similarly the coloration of the garments results in our eyes being drawn from one figure to another. (A color print of this icon is readily available as it is reproduced in The Encyclopedia Britannica article on "Russian Art" and in many books on icons.) The blue of the tunic on the figure to our left is relatively faint; whereas the blue is more intense in the tunic on our right and is most intense in the central figure's outer garment. The central figure looks to the one at our left to keep our attention moving.

The halos behind each head resonate with each other and draw our attention from one to the other. The overlapping wings of each figure make us aware of the others. The white color of the halos stands out in the color prints of the work and attracts attention.

Healthy relationships in community are modelled by the avoidance of a fixation on any one other person. Those dynamics are also designed to avoid theological heresy which "is a kind of picking and choosing, a denial of the wholeness and fullness of the faith."[3] Most heresies result when people emphasize one valid doctrine to the exclusion of other valid doctrines. Such a preoccupation with any one figure in the Trinity is prevented by the dynamics in Rublev's icon.

While different interpreters see the central figure as either God or Christ, they see the figure on our right as the Holy Spirit. All three figures appear taller than the average person. They would evidently be nine or ten heads high if they were standing, whereas the average person is six or seven heads high. That seeming "distortion" is how persons appear when they are far above us. (Invite some students to lie on the floor looking up at your standing figure; and they will see your head far away and smaller than if they were looking at you face to face.)

This elongation of the figures is an aspect of multiple perspectives characteristic of icons and also evident in El Greco's paintings. For example, the kneeling Francis would be ten heads high if he were standing in St. Francis (c. 1590-1604; The Art Institute of Chicago, Chicago, Fig. 41). In his native Crete, El Greco learned the dynamics of icons such as the reverse perspective evident in St. Francis where the book's far edge is longer than its near edge and where the far leg of the crucifix is longer than the near leg. From El Greco, many modern artists have learned reverse and multiple perspectives which present theological dimensions in modern art.

TEACHING TIPS

1. Ask class members to try to focus exclusively on any one of the three figures in Rublev's The Holy Trinity and discuss what makes such fixation impossible. Discuss the problems which result in personal relationships when we spend all our attention on just one person and ignore others. Also discuss the distortions which result from making too much of one doctrine of Christian faith and ignoring other doctrines of Christian faith.

2. Ask class members to look for examples of reverse and multiple perspectives in the paintings and then discuss how such perspectives are like parables in changing how we think. Consider ways such reversed perspectives would change the structure of questions we ask. Change "What is happening to me?" to "What is God doing through me in the world?" Change "Who am I?" to "Who are we?" Change "What should I do?" to "Who is helping others and showing us to do likewise?" With those transformed questions we shift attention from our-

selves to others and sense greater intention in living.

3. Position students in different parts of the room at different levels and then have each report what he or she sees (or have each draw what he or she sees). In one large drawing, use a different color pencil or crayon to draw what each student reports seeing. Then discuss some ethical or moral issue or political issue and write down the different views of each person. Share a biblical story and have each student write down or draw the features of the story which are memorable or most important; and then share such stories or drawings and later discuss how the viewpoints of others add to our insights and understandings.

NOTES

[1]Robert Byron and David Talbot Rice, The Birth of Western Painting, (New York: Hacker Art Books, 1968).

[2]Margaret Miles, Image as Insight: Visual Understanding in Western Christianity and Secular Culture, (Boston: Beacon Press, 1985), p. 32.

[3]Joseph P. Frary, "The Logic of Icons," Sobornost, (Winter 1972), p. 403.

CHAPTER 15

PILGRIMAGE TOWARD COMMUNITY WITH CHRISTO'S "RUNNING FENCE"

Contemporary artists increasingly create their works in settings outside museums; so, we are required to make a pilgrimage to see art. In our pilgrimage to see such works as well as in the process to create them, we become aware of the communities which sustain us. Often taken for granted or ignored, our sense of community is re-defined and strengthened by such works of art. In such a pilgrimage, we become aware of our limitations and of our need for others.

A major example of such process art was The Running Fence, Sonoma and Marin Counties, California (1972-76, figs. 42-44) created in 1976 by the New York based artist Christo. Stretched over twenty-four and-a-half miles across Marin and Sonoma counties in northern California for two weeks, the artwork was made of white nylon, eighteen-feet high and suspended by steel cables. The work began east of Highway 101 and ran west for many miles until dipping into the Pacific Ocean.

This art work's theological import occurs at several levels. The viewer's finitude was stressed by the over twenty-four mile size; for the whole work could not be seen from any one place. Required to drive and periodically to walk on a day-long trip to view much of the fence, one became more conscious of one's own body. Becoming aware of one's own finitude is a major step toward becoming aware of God. As we realize that we are creatures who are dependent upon what is beyond our control, then we become aware of the Creator who shapes us and sustains us.

In a museum, we may be able to pretend that we are in control and can see everything. However trying to see a work of process art such as Running Fence makes us aware of exactly how limited we are as human beings. Since the fence ran across dozens of jurisdictions including numerous privately owned ranches, the viewer was made aware of the different political entities (with their varied territorial policies for approaching the fence). Further, one became acquainted with a number of ranchers some of whom did not allow one to cross their land to view the fence as it ran down a gully or behind a barn. Another dimension of human finitude was made evident when we were surprised as the artwork appeared from behind a hill or out of a previously unnoticed valley. When we are surprised, we realize that we are not all knowing.

Building the artwork revealed the interrelations of many distinct communities. In process art, seeing these interrelations is part of the art experience. As they tried to support or oppose the fence's construction, many persons realized for the first time not only the different political jurisdictions in which they lived but also the different views held by their neighbors. The litigation over the fence made evident the profiles of different persons and groups in the communities. The several years of planning required for the completion of this project resulted in the recognition of the individual characteristics of the many ranchers and political jurisdictions as different settlements were made with each of them. For instance, breaks in the fence were designed to accommodate the primary travel routes in each ranch or political jurisdiction. This accommodation required that every rancher and every community realize explicitly the routes they traveled regularly (something they had otherwise only tacitly known).

Using Joshua Taylor's terms detailed in

chapters 2 and 5, I call such a work of art spiritually "communitive." The artwork occasioned the awareness of one's own body and finitude as well as the recognition of other distinct individuals and groups. However the Running Fence did more than make us aware of the distinct personalities of these communities; it also brought together individuals who would otherwise have remained unknown to each other. Even after the fence had been down for many years, one cannot walk or drive along that stretch of northern California without remembering the wider possibilities for fellowship that Running Fence revealed.

My wife and I made the pilgrimage to Running Fence with Jane Daggett Dillenberger, Harry Corcoran, and John Dillenberger. Of course, we took many slides and photographs. William Sloan Coffin, former pastor of Riverside Church in New York, says that when we arrive in heaven, God will not greet us like an accountant with a ledger book of rights and wrongs in hand. Instead, God will say, "Let's see the slides." Many people tire of seeing the slides and films which neighbors have taken of their trips; but God is interested in the journeys of each of us.

In your church school class, discuss with students the questions raised in "Teaching Tips" to imagine creating a Running Fence in your community. Bring along a map of the town, city, or county and surrounding area. On that map have students draw the main ways in which they move. Where do they spend most of their time coming and going? At the previous class session, you may ask them to begin paying attention to where they come and go during the week.

Looking at the four gospels, what do they indicate about where Jesus spent most of his time coming and going? In Luke's Gospel, he crossed over into Samaria where Jews did not go. He spent time with persons whom many religious leaders of his day avoided. What new patterns of coming and going should we explore in our lives in light of the ways Jesus moves in the gospels?

Crossing or breaking down barriers which divide persons is an important aspect not only of Jesus' ministry but also of Christo's art. In my interviews with Christo and his wife Jeanne-Claude, they expressed puzzlement that most critics have missed the religious and political significance of their work. He dropped his last name Javacheff so as to emphasize his first name: Christo.[1]

Many of his early art projects were natural or man-made objects which he wrapped in white colored fabric. Wrapped Coastline, Little Bay, Australia (1969; Fig. 45) and Wrapped Kunsthalle, Bern, Switzerland (1968; Fig. 46) are like prayers of thanksgiving helping people see earth as gift. A wrapped object implies a gift and a giver who wrapped it: i.e., God as creator of the earth for us. Such wrapped works emphasize the mystery of creation and the finitude of the viewer who cannot see exactly what is inside the wrapping. As masks sometimes reveal as well as conceal, the wrappings call our explicit attention to shapes which before we had noticed only tacitly.

The wrappings also may remind us of the shroud and resurrection of Christ as Dominique Laporte pointed out.[2] While the size of the projects and the number of persons wanting to view them no longer make it practical to have the works up for just three days, more recent works have been planned for as long as three weeks (such as the umbrellas project discussed in Chapter 24). The Running Fence relates to the wrapped works; for although it is not like the wrapping paper, it is like the ribbon around a package. Jeanne-Claude has called the fence a "ribbon of light."

The Running Fence's political meanings are also often overlooked. Its forerunner was the orange (rust-like) colored Valley-Curtain, Grand Hogback, Rifle, Colorado (1971-72) which was a parody of the Iron Curtain as the twenty-four and-a-half mile The Running Fence was a parody of the Berlin Wall which was twenty-four kilometers long. Valley Curtain was placed in a valley where Christo knew the winds would rip it to pieces in a brief time. Far earlier than most other persons, the Bulgarian born Christo was certain Communism would collapse. At the same time that he conceived Valley-Curtain and The Running Fence, Christo also conceived of

Wrapped Reischstag, Berlin (1971-1995) which could not be completed until Germany was reunited and that parliament building by the Berlin Wall could be wrapped.

TEACHING TIPS

1. If you were going to create a Running Fence in your town or city or county, where would you have it run?

2. What would your Running Fence reveal about the ways you travel most often? Where do you spend most of your time traveling?

3. What do such patterns reveal about what and whom you value and do not value? Where do you rarely go and who lives there?

4. With a map of the town or county before you, have each student mark the routes he or she travels most often. (Have each person use a different colored crayon.) Which parts of the map are unknown areas with respect to who lives there? Does your Running Fence take you to hospitals, jails, retirement homes?

5. How would we change where we come and go in light of where Jesus comes and goes in the gospels?

6. As another project, wrap some object in the room early in the class session and then unwrap it toward the end of the class. A white sheet could be used to wrap a large object. Discuss how wrapping and unwrapping a familiar object help us see it afresh and how Christo's wrapped works or his ribbon of light, The Running Fence, help us understand the world as a gift from God.

NOTES

[1] Doug Adams, "Christo's The Running Fence: Wider Communities and the Earth," chapter 4 in Transcendence with the Human Body in Art, pp. 120-148.

[2] Dominique G. Laporte, Christo, trans. Abby Pollak (New York: Pantheon Books, 1988), p. 67.

CHAPTER 16

RELATING BIBLICAL PASSAGES AND OUR LIVES IN "PANELS OF LOVE"

Eleven paintings form a twenty foot tall cross entitled Panels of Love (1988; artist's collection, Fig. 47) by Timothy Grummon. He asked each of his family members and close friends to select a biblical passage for him to explore as a basis for each of the paintings. The vertical line of the cross is formed by the five paintings suggested by family members; and the horizontal cross bar is formed by the six paintings suggested by close friends. Grummon writes, "The Panels of Love is a celebration of family and friends and my recognition of their ability to love."[1]

Creating the eleven paintings throughout 1988, three years after he had been diagnosed as having ARC (AIDS-Related Complex), Grummon writes, "my decision to become an artist and the ongoing spirit of faith of my parents have allowed me to rekindle the life force within"[2] The eleven paintings have been assembled as a cross in many churches throughout Timothy's home town of San Diego, Pacific School of Religion's Chapel in Berkeley, and Grace Cathedral in San Francisco. The cross can be disassembled so that the panels can be exhibited as a series in galleries.

In all of the paintings, the one constant is the color gold. Grummon notes, "Not only is gold healing and soothing, it was also chosen to represent the color of love. Love expresses a state of being, and it is also a causative: love causes things to happen; it motivates and inspires in ways which defy rational, scientific thought."[3] The color gold is also common to all the mosaics and icons of Eastern Orthodox Christian churches and underlies even dark colors or shadows so that a celestial radiance pervades everything. A Greek word for gold (chruseos) and its variation in a person's name

such as John Chrysostom, the fourth century leader of the church in Constantinople, resonate with the word for Christ (Christos).

Entitled Lily of the Field, Panel 1 is at the bottom of the cross. The flourishing reddish-orange lily, based on Matthew 6:28-29, was selected by Grummon's brother and sister-in-law. The earth tones of the lily and the brown hills below suggest human connection to the land and how it supports us. The vertical golden shape to our right in Panel 1 flows up into the Ark of Energy, Panel 2, which is based on Genesis 4:9. This passage was chosen by his sister who gave a resounding "Yes" to the question "Am I my brother's keeper?"

In Panel 2, a curving abstract presentation of Judaism's Ark of the Covenant cradles or shelters an orb which symbolizes the human need for support. A temple structure allocates plenty of space within for the ark and orb. Giving a person space to grow is important to the artist. Grummon appreciates his sister's support which he says "deals not with direct assistance, but rather with providing an individual with the opportunity to become self-supporting."[4] He represented development and expansion of the individual's capabilities by having the four colors in the orb flow out of the sheltered temple, toward the viewer, then across the bottom, up the side of this panel, and into the panel above it.

House, Prairie, and Tree, Panel 3, is based on Psalm 23 suggested by the artist's mother. He asked which of that psalm's verses were most meaningful to her; and she identified verses with images of nature. So, he created the art work featuring a central landscape with an abstract tree since his mother takes delight in planting trees. To our left, a path meanders up

to the door of the house of the Lord.

The artist then created the panels of the horizontal crossbar. One friend chose Psalm 118:24 for Panel 4, Rejoice, Fine Bird, to our far left. A beautiful bird flies across the panel as the sun rises imaging the text, "This is the day which the Lord has made, let us rejoice and be glad in it." The artist writes that he repeats that phrase over and over again each morning to inspire himself to rise, rejoice, and avoid the paralysis of depression to which his illness easily leads.

Next he created Tears and Butterflies Passing Through, Panel 5, which was based on a friend's selection of Matthew 2:16-18. This work depicts the tears in response to the deaths of innocent children whether by Herod's attempt to kill Jesus or by AIDS in our own day. This text includes a quotation from Jeremiah 31:15 in which Rachel weeps for her children who were no more. The artist abstracted the weeping head; for all human beings, male and female, grieve. As a color associated with grief, black surrounds or touches everything in the panel. Symbolic of resurrection, butterflies are often obscured by the grief.

To our far right is Panel 6, Together in a Spacious Place, based on Psalm 66:12. Hope is affirmed without denying the reality of disasters: "we went through fire and through water; yet you have brought us forth to a spacious place." The two flying birds express that hope and relate to a couple the artist knew, one of whom had died of AIDS. The colors of pinks, lavenders, and grays refer to the gay tradition; for Adolph Hitler required gays to wear pink triangles much as he required Jews to wear the star of David.

Just to the left of Panel 6, Stones Without Motion, Panel 7, is based on the story in John 8:3-11 of the woman taken in adultery. Two stones are suspended in the air above a woman; but the stones are motionless.; No one threw a stone when Jesus said "Let him who is without sin among you be the first to throw a stone at her." In the background, the sun rises on a new day.

The final four panels were conceived in relation to one another. The central panel Faith, Hope, and Love is based on Grummon's own scriptural selection (1 Corinthians 13:4-7 and 13) which affirms the centrality of love which is patient and kind, and not insistent on its own way. To our left is Living in Bounty which is based on Psalm 27.13; and to our right is Strength of Heart which visualized Song of Solomon 8:6-7. A fence runs across all three of these panels with a gateway in each. The artist writes, "The time arrives when a person states, 'This is what I believe or disbelieve.' On saying this, one has stepped through the gate into the future."[5]

The top panel, Through the Heaven Rocks expresses Psalm 121:1-2 suggested by Grummon's father: "I lift up my eyes to the hills. From whence does my help come? My help comes from the Lord, who made heaven and earth." The dove descends from above and represents not only God's Spirit but also God's peace; for the artist's father has spent a lifetime working for world peace.

TEACHING TIPS

1. Discuss how Panels of Love relates Biblical passages, the artist's relatives and friends, and the issues of our day.

2. Select one issue of our day (such as peace or some other mission such as saving the environment or feeding the hungry) and ask each class member to select a scripture which he or she finds meaningful and which relates to the issue. Be sure that you select a scripture also.

3. Then have each student work on creating a painting or drawing to express the scripture he or she has chosen and its relation with the issue. (You may have many magazines and newspapers available so persons may create a collage from such materials rather than doing a painting or drawing.) When you begin, give each student a piece of cardboard or stiff paper of similar size on which to create his or her work.

4. Assemble the finished art works in the shape of a cross on the wall or attach them to a cross made of wood which may be placed in a base so as to stand in the classroom or in a place of worship.

5. An alternative assignment is to create a cross with one panel expressing the favorite

scripture of each class member. A longer term project is for each student to create a complete cross of several panels as Timothy Grummon did with each panel based on a scripture suggested by the student's family member or friend.

NOTES

[1]Timothy Walters Grummon, Panels of Love: Paintings and Reflections, (San Diego: Los Hombres Press, 1990) p. iv.
[2]Ibid., p. iii.
[3]Ibid., p. iv
[4]Ibid., p. 20.
[5]Ibid.

CHAPTER 17

FOCUSING ON OTHERS' FAITH THROUGH CHRIST'S MIRACLES

To the surprise of many viewers, Jesus often is not the center of visual attention in art works portraying his miracles. For instance, in Jan van Hemessen's Arise, Take Up Thy Bed, and Walk (mid-16th century; National Gallery of Art, Washington D.C., Fig. 48) the healed man fills the foreground. It is difficult even to see the tiny figure of Jesus in the background in the midst of many other figures in the doorway. In Jacques Callot's engraving of Jesus and Saint Peter on the Water (early 17th century; National Gallery of Art, Washington D.C., Fig. 49) the sinking Peter is at the center of focus while Jesus is off to his right. Jesus is drably dressed and off to one side in The Marriage at Cana (late 15th century; National Gallery of Art, Washington D.C., Fig. 50) by The Master of the Retable of the Reyes Catolicos.

Why do the artists portray Jesus so modestly in their art works while they give central attention to others? Study of the gospels reveals that the artists are faithful to those accounts which emphasize Jesus' focus on others and their faith. Study of such art may help us focus on others rather than being preoccupied with ourselves. Thinking beyond ourselves is the beginning of creative health and growth.

New Testament scholar James Breech notes that college students frequently try to find themselves in every parable and miracle. I heard him say to one class, "Some of these stories are not about you; they are about other people. There are other people in the world."[1] A sign of maturity is to move beyond preoccupation with ourselves and to focus on others and clearly see them and their gifts. Such maturity allows creative accomplishments; for as often observed, a person may accomplish much if he or she does not mind who gets the credit.

Often when a person is healed in the gospels, Jesus is reported to have said, "your faith has made you well." Jesus does not take credit for the event but concentrates instead on the person and his or her faith as in the healing of the woman with a flow of blood (Mark 5:34) and blind Bartimaeus (Mark 10:52). Similarly, the story of the paralytic minimizes Jesus' glory and stresses the faith of those who come for healing. Mark's Gospel says, "When Jesus saw their faith," and so shifts attention to the paralytic. (Mark 2:5)

This story does not shower reverential attention on Jesus. Instead he was probably showered with dust and dirty debris and perhaps insects when the roof above him was removed while he was in the midst of teaching. The noise as well as the dirt of such roof removal does not glorify Jesus' teaching but disrupts it. In other miracle stories, Jesus attempts to minimize his own glory by telling people not to tell anyone that he has healed them (Mark 1:44 and Mark 5:43).[2]

There is another way in which the biblical accounts and the art works direct our attention away from Jesus and toward others and their faith: the moment of performing the miracle does not receive the attention which instead is given to a later moment of the healed person acting. For instance, in the Jan van Hemessen painting, we do not see Jesus touching the paralytic; but we see the paralytic carrying his bedding at some distance away from the house where he was healed. Similarly, in The Marriage at Cana, we do not see Jesus turning the water into wine; but we see the wine being conveyed to the governor of the feast who according to the text praises the bridegroom not Jesus: "Every man serves the good wine first, and when men

have drunk freely, then the poor wine; but you have kept the good wine until now" (John 2:10).

The governor's judgment is mistaken with respect to the provider of the wine and perhaps as to the quality of the wine. As governor of the feast, he would have been drinking the original wine before it ran out; and so, it is unlikely that later he would be in any condition to distinguish much about wine quality. (cf. Giotto's rendering of the governor of the feast as drunk in Chapter 34.) Reliable wine tasters do not drink the wine; for swallowing even a small amount diminishes ability to discriminate among wines. The quality of the wine is further questionable because of its source. The servants knew that the wine was drawn from the jugs used for Jewish purification rites (John 2:6 and 9). The 20 to 30 gallon size of each jug was large enough to accommodate bathing for a human body. The servants may have thought of this wine as a first century equivalent of bathtub gin.

The number of jugs underscores the question of its imperfection; for seven is the number of perfection as six is the number of imperfection. Jesus' miracle itself is minimized further in the art by the small size of the six jugs in the foreground. Each 20 to 30 gallon jug equals four to six cases of wine. Six jugs would equal 120 to 180 gallons or 48 to 72 cases of wine which if piled up together would form across the room a wall so tall that we could not see anything else. The artist wants us to see much more.

In the painting, there are many references to the whole biblical story from Jesus' birth to death as well as before and after those events. A white sculpture at the top of the room portrays Moses holding the tablet of the ten commandments reminding us of the biblical stories from the Hebrew scriptures. In the backroom, the meal being eaten may be identified as a Passover. The angels in the upper right and the bed below them at the center are frequently visible in representations of the annunciation to Mary before Jesus was born. On the wall to the right are tree and cross motifs which remind us of Jesus' death. On the edge of the table cloth, additional small crosses appear among the words from the Latin translation of angel Gabriel's announcement to Mary: "Hail, Mary, full of grace." One may use the same methods discussed in chapter 11 to see how the table becomes a communion altar and the hand gestures become liturgical prayer and blessing; so, the painting refers to later church worship long after Jesus' earthly life.

The impending removal of Jesus is foreshadowed by the endings in many miracle stories where there are negative reactions to Jesus rather than positive affirmations we might expect.In Mark 2:5-7, Jesus forgives the paralytic's sin and the scribes say, "It is blasphemy!" In Mark 3:5-6, Jesus heals the man with the withered hand; and "the Pharisees went out, and immediately held counsel with the Herodians against him, how to destroy him." In Mark 3:21-22, Jesus has healed many; but "when his friends heard of it, they went out to seize him, for they said, 'He is beside himself'; and the scribes who came down from Jerusalem said, 'He is possessed by Beelzebul, and by the prince of demons he casts out the demons.'" In Mark 5:17 after he healed the man possessed of a demon, "they began to beg Jesus to depart from their neighborhood."

The miracle stories are good news for those who have been asked to leave town and for those who have been criticized. If Jesus had always been praised, other people who try to follow him would be easily discouraged by criticism. In light of Luke 17:17-18 where only one out of ten lepers returned to thank Jesus, we should not be discouraged when few people thank us. Similarly in the portrayal of Peter's fear and lack of faith which results in his sinking into the water (Matthew 14:30), we may take heart. If the disciples had been perfect in their faith, there would be little hope for the rest of us to be disciples; for we know our own lack of faith.

In classes, we have held a reunion of the nine lepers who did not say thank you to Jesus. Some class members become those lepers whom the teacher then interviews as to why they did not return to thank Jesus. Other class members are equipped with sets of score cards numbered one through ten; and after they hear each excuse, they raise up their score cards much as in the Olympics. A ten from each judge would be

the highest rating; but the only excuse I have seen achieve tens from all judges was the following:

> As Jesus told me to do, I first went to show myself to the priests at the temple. Then I came back to thank Jesus but he was gone. In looking for Jesus, I finally ran into Peter and asked, "Where is Jesus." Peter responded. "I don't know any Jesus."

With disciples such as Peter, there is hope that we and all others may be disciples.

TEACHING TIPS

1. With each art work, ask class members to look and see which moment in the biblical story the artist is portraying.

2. Discuss why the art works and the biblical accounts focus on the person healed rather than on Jesus.

3. With The Marriage at Cana, ask class members to list all the other biblical stories remembered by looking at the details in the painting. To guide this process, focus on each detail and ask them what it brings to mind from biblical stories.

4. Discuss how Peter's lack of faith and the people's negative reactions to Jesus' miracles are good news and encourage us to be disciples and to see how others (no matter how unfaithful) may be disciples. Invite students to share times they have been criticized when they should have been praised.

5. Enact the reunion of the lepers with some class members being the lepers and others scoring the excuses as described in this chapter. Then discuss times we have not been thanked when we have given to others.

NOTES

[1] I heard Breech make that choice comment when I was his guest lecturer at York University on January 7, 1980. Breech is a leading scholar on Jesus' parables with works such as The Silence of Jesus (Philadelphia: Fortress, 1983).

[2] For further insights into the miracle stories, study Robert M. Fowler's Loaves and Fishes: The Function of the Feeding Stories in the Gospel of Mark, (Atlanta: Scholars Press, 1981; and Jonathan Z. Smith's "Good News Is No News: Aretology and Gospel" and many other articles in Christianity, Judaism, and Other Greco-Roman Cults, ed. Jacob Neusner, (Leiden: E. J. Brill, 1975).

CHAPTER 18

EVERYDAY SACRAMENTAL INVOLVEMENT THROUGH IMPRESSIONISM

One of the best teachers in my experience was American History Professor Anne Scott. Her favorite art was French Impressionist painting. We explore in this chapter how her classroom skills and her interest in Impressionism shed light on how to involve others in teaching and how to deepen understanding of sacraments. In class, she rarely lectured and usually directed questions to students so that we became much more involved in her class than in most other classes. Years later I asked her how she learned to become such a good teacher. Her response is helpful to potential teachers who fear that they cannot teach because they have questions but few answers to share.

Early in her career, she had become president of a statewide woman's organization about whose business matters she knew very little. Called upon to lecture about the organization at chapters around the state, she soon learned that many in the audience knew a great deal about the organization. So, when she was asked questions about the organization, she would ask the audience to respond. Audience members not only became involved in answering questions but were far more interested as a result. People enjoy talking themselves more than listening to lectures.

Similarly, people enjoy an Impressionist painting which invites their involvement. There is usually a space in which the viewer may imagine walking or sitting. The viewer feels at home in the painting because the subject matter is an everyday scene in a park, by a river, at the beach, or in a restaurant. Impressionist paintings contrast with the paintings which preceded them. Earlier nineteenth century works featured dramatic historical scenes often populated by famous people. It is easier to imagine ourselves with the ordinary people in everyday Impressionist scenes.

In Edgar Degas' The Glass of Absinthe (1876; Musée d'Orsay, Paris, Fig. 51) there is room at the tables for us; and the man and woman at another table are informally dressed so that we may come as we are without worrying about being out of place. The characters' loneliness is emphasized by their looking away from each other; so, we do not feel we would interrupt any conversation if we entered. In fact, the work seems incomplete unless we do enter; and the couple look as if they need someone to help them converse again. Their feet open out toward us. If those feet were turned toward each other or if the woman faced toward the man, we might feel we should not enter the space.

There is space for us on a bench with the two children in Camille Pissarro's The Corner of Hermitage Garden (1877; Musée d'Orsay, Paris, Fig. 52). There is plenty of room for us to enter the scene and to stroll over towards the flower beds or along the yard. If plants filled the foreground, then we could not easily imagine entering the scene. If there were three formally dressed people filling the bench, we might feel less welcome. As it is, there is nothing to inhibit us from walking into the painting.

We may stroll even further into Auguste Renoir's Seine at Argenteuil (1873; Musée d'Orsay, Paris, Fig. 53). Trails and open areas stretch out to our right along the river as it extends to the horizon. Impressionist painting invited viewers to go to the countryside, the beach, or other outdoor settings which had not previously been such popular destinations. In paintings by Claude Monet, there is plenty of space on the beach, along the river bank, or in the boat for a few more people. There are

unobstructed roads or rivers extending into the distance and bidding us to travel. The people in the scenes are not extraordinary but look like people we meet everyday. The subjects are usually common ones such as flowers, ponds, lawns, rivers, beaches, or haystacks.

How do such Impressionist paintings relate to religion as they do not have religious subjects? Precisely because they do not have special religious subject matter, Impressionist paintings resonate with Jesus' parables which rarely have any religious figures and instead include everyday, seemingly secular subjects such as family quarrels (The Prodigal Son), economic issues around salaries or debts (The Workers in the Vineyard and The Unjust Steward), and meals (The Banquet parables). Most of the characters are workers, brothers, or servants; and the few religious figures are not admirable (a priest who does not help or a pharisee whose prayer is prideful).

Similarly, Jesus' disciples are drawn from the ranks of fishermen, tax collectors, and others of no particularly distinguished status; and all the prophets in Old Testament are lay people and not priests. Since such characters are not distinguished by superior education, wealth, or perfection in any other ways, we see ourselves as having possibilities to be in the ranks of the disciples or prophets.

Because most of Jesus' parables have no endings, they do not tell us what to think but rather invite us to think. As New Testament scholar James Breech notes, when there are no endings there are no final judgments; and all the characters could still change.[1] Such lack of endings invites us to imagine many possibilities of what may happen next. At the end of the Prodigal Son story, the elder brother is arguing with the father outside the party. Will the brothers reconcile or quarrel? At the end of the Good Samaritan story, we do not know whether the beaten man will live or die; and if he lives, how will he respond to the knowledge that a Samaritan helped him? Such incomplete stories continue to involve us much more than a story which has been completed (as any writer of a soap opera on television knows).

Having no endings, Jesus' parables honor the capacities of the listener to imagine. When the disciples asked Jesus what a parable meant, he usually said nothing, told them another parable, or asked them a question rather than giving them an answer. Like my teacher Anne Scott or like an Impressionist painting, Jesus' stories and questions open up space for the listener to become responsible to think and to answer.

Eastern Orthodox Christian scholar Nicholas Zernov reminded me that Impressionist Painting occurred when there was a major renewal of sacramental appreciation in worship.[2] That nineteenth-century renewal stressed the greater involvement for the congregation in worship much as Impressionist art opened space for the viewer to enter and become involved. Common everyday elements are stressed both in the art and in the sacramental renewal where more frequent communion with common daily bread reminds us of God whenever we break bread through the week. God is to be found not just in the extraordinary major events carried out by famous people but also in the common daily moments of our lives.

TEACHING TIPS

1. Invite students to imagine where they may enter and sit and move around in the art works. Ask them how the spaces and common objects or people in the art works make the paintings inviting for them to enter and feel at home. Ask them to imagine other ways the paintings could have been done to be less inviting or more inviting.

2. Discuss how Jesus' parables are like Impressionist paintings in opening space for involvement of our imaginations by having everyday persons and common events and no endings. Ask them to imagine several different endings to one of the following parables: Good Samaritan, Luke 10:30-35; Prodigal Son, Luke 15:11-32; or Unjust Steward, Luke 16:1-8). Ask them to imagine other ways that parable could have been told to make it less inviting or more inviting for our imagination.

3. Discuss ways in which worship may become more like Impressionist paintings or Jesus' parables by allowing more places for our participation.

NOTES

[1] James Breech, The Silence of Jesus (Philadelphia: Fortress Press, 1983).
[2] He had mentioned that when I took courses from him and reminded me or it in later correspondence: Letter from Nicholas Zernov to Doug Adams, October 15, 1967.

CHAPTER 19

LIVING WITH WOUNDED FAMILIES

Biblical stories present many families with wounded relationships. If such stories had described perfect family relations, it would be more difficult to live with our own imperfect families. These familial conflicts described in the Bible make our family problems liveable.

For example, the first man and woman, Adam and Eve, irresponsibly blamed each other for their own sin. The first brothers reveal the opposite of brotherly love when Cain kills Abel. Later, Jacob stole his brother Esau's birthright; and Joseph's brothers sold him into slavery. Abraham's families had conflicts with each other as his sons (Ishmael and Isaac born of different mothers) clashed. Moses had conflicts with both his brother Aaron and his sister Miriam.

Ruth and Naomi stand out as one of the few positive family relationships; and they relate in a broken family where Ruth's husband has died. Ruth as a foreigner and daughter-in-law was more helpful than any of Naomi's Israelite family.

New Testament stories continue to narrate family problems. Jesus' parable of the father with two sons (Luke 15:11-32) ends with the brothers unreconciled as the elder brother and father argue in the courtyard while the younger brother stays at the party apparently without noticing nor caring about the absence of the father or the elder brother who was not even invited to the party. In another parable of two sons (Matthew 21:28-32), one son promises to obey his father but then fails to do so while the other son defies his father but then later obeys.

Jesus' relationships with his own family (including his mother) are not the expected material for Mother's Day sermons. When a messenger brings news that Jesus' mother and

brothers are outside asking to speak with him, Jesus does not rush out to greet them but rather asks, "Who is my mother and who are my brothers?" and says his disciples are his family, "For whoever does the will of my Father in heaven is my brother, and sister, and mother." (Matthew 12:46-50). He continues teaching and never greets Mary and his brothers.

Other encounters between Jesus and his mother are similarly abrasive. At the wedding at Cana (John 2:1-5), Mary tells him that the wine has run out; but Jesus responds, "What is that to me woman, my time has not yet come." (If my mother asked me to take out the garbage and I responded, "What is that to me woman, my time has not yet come," she would probably respond, "Your time is closer than you think!") Jesus supplied over one hundred and twenty gallons of wine to which we can only imagine Mary's response (which might have been that he had overdone it).

The disciples prove to be less than a model family as jealousies arise among them, as one betrays Jesus, and as another denies him three times. Even after his resurrection, his disciples do not believe each other. Much later Paul says that Peter is to be condemned for failing to live up to his promises (Galatians 2: 11).

Thank God for disciples such as these; for so we see that we (with all our failings) can be disciples. Thank God for such Biblical stories of imperfect family relations, for so we do not despair over any of our rough family relationships or church conflicts.

Contemporary American sculptor George Segal offers visual insights into several relationships in the Biblical stories of Abraham and his families. In Abraham's Farewell To Ishmael (1987; private collection, Fig. 54), Segal shows

Abraham's tender embrace of Ishmael, his son by Sarah's servant Hagar who served as a surrogate for the barren Sarah. The positions of Abraham's arms embracing Ishmael are echoed in the ways Hagar's arms go around her own body (reminding us that Abraham once embraced Hagar tenderly). Each right forearm is diagonally positioned with the hand embracing a left shoulder: Abraham's hand embraces Ishmael's shoulder while Hagar's hand embraces her own shoulder. Abraham's and Hagar's left forearms are parallel to the ground with fingers spread in an open position to embrace a side: Abraham's hand embraces Ishmael's side and Hagar's hand embraces her own side.

As if presiding over the departure of Ishmael and Hager, the hooded figure of Sarah stands ominously in the background. If the viewer stands further to the left, Sarah appears to come between Abraham and Ishmael to our left and Hagar to our right. Indeed, Sarah did come between Abraham and Hagar as Sarah insisted that Hagar and Ishmael be thrown out into the desert so they would present no threat to Isaac's inheritance (Genesis 21:9-10).

Such an art work speaks deeply to the dimensions of family life many people experience. In many families, there are half-brothers or half-sisters born of different mothers but of the same father or of different fathers but the same mother. Even between children of the same parents, there are often divisive concerns over who inherits what; and such concerns may damage family relationships years before either parent dies. Many children experience a parent delighting more in one child than in another child even when the parent tries to love both equally. Many husbands, wives, and children have experienced the separation when a divorce occurs or even when a child simply leaves home. Others know the experience of another person coming between themselves and someone else with whom they had once had a meaningful relationship.

There are other episodes of Abraham's life with Sarah which are less than exemplary. Pretending that Sarah is his sister and not his wife when they go into Egypt, Abraham thinks Pharaoh takes the beautiful women like Sarah into his harem and would kill any known husband. Having gained much cattle from that deception, Abraham repeats it again with King Abimelech.

As scripture scholar James Sanders often says, "Biblical stories are not models for morality but mirrors for identity." Precisely because biblical figures' lives have rough edges, we are able to identify with them. Similarly, Jesus' sufferings on the Cross speak to our sufferings.

Segal sculpted another episode from Abraham's life which speaks to tensions between parents and children. In 1978, Segal completed Abraham and Isaac: In Memory of May 4, 1970, Kent State (Fig. 55) after he was commissioned to do a memorial about the national guard killing of four Kent State University students who were protesting the American bombing of Cambodia during the Vietnam War. The sculpture not only portrays the moment when Abraham was about to sacrifice Isaac (Genesis 22) but also (because the Isaac is sculpted as a college-aged young man) reminds us of the generation gap which pitted so many anti-war college students against their parents who supported the Vietnam war.

In the Biblical story, the angel of God saved Isaac's life from the knife which Segal shows Abraham holding in his right hand. Segal's sculpture was rejected by Kent State and now stands outside the Princeton University Chapel.

TIPS FOR TEACHERS

1. Have each student pick one of the characters in the art works or in the Biblical texts about Abraham.

2. Discuss each art work and each Biblical text by having each student share what he or she is doing and feeling as a character in that art work or text. Then students may be asked where such stories and feelings intersect their own family relationships.

3. The role playing discussion may be enhanced if the teacher becomes a Phil Donahue style interviewer and interviews students who are Abraham, Sarah, Hagar, Ishmael, Isaac, Pharaoh, and any other characters the students have become. Others in the class may be invited to be the studio audience and to ask questions of

the characters. Characters may be asked to question each other.

4. Have the students read the Abraham stories before class to make the best use of class time: Genesis chapters 12 through 22 but especially chapters 12, 16, 17, 21, and 22.

CHAPTER 20

CHOOSING A CROSS TO FOLLOW CHRIST

Each gospel expresses a different facet of the Christian faith and is helpful at different times in our lives. Mark's so-called gospel of the cross relates Christ to our times of suffering, Luke's gospel of social concern relates Christ to our times of social action to extend justice for all, and John's gospel of glory relates Christ to our times of celebration from a baptism to a wedding to frequent table fellowship.

Similarly, different art works dealing with the cross express different facets of the Christian faith. Some show Christ's suffering at crucifixion while some depict his concern for others including his enemies or the anticipation of his glory at resurrection. In our personal consideration of which cross is most meaningful at this time, we reveal our present needs and goals.

Consider the three art works which illustrate this chapter and select the one you find most meaningful. Why is that work more meaningful to you than either of the other two? At other times of your life, would one of the other art works have been more meaningful? Which art work would be most meaningful when you experience the death of a close friend? Which would be most meaningful when you are reaching out to help others? Which would be most meaningful when you celebrate a joyful event?

The detail of Mathias Grünewald's The Crucifixion from the Isenheim Altarpiece (c.1515; Musée d'Unterlinden, Colmar, Fig. 56) features a depiction of Christ typical of northern European art which stresses the realism of physical suffering. Crucifixion is far more common in the art of northern Europe than in southern Europe. Grünewald painted Christ with the painful skin condition of many patients who were suffering in the hospital whose chapel commissioned this art work; so, worshippers could see that Christ identified with their condition. A heaviness pervades the painting as Christ's body slumps and is surrounded by a dark foreboding sky. When we are suffering, this image may help us realize that we are not alone. Twentieth century theologian Paul Tillich praised this work: "I believe it is the greatest German picture ever painted, and it shows you that expressionism is by no means a modern invention."[1]

The detail of Raphael's The Crucified Christ (early 16th century; National Gallery, London, Fig.57) shows a Christ typical of southern European art which emphasized the idealized human body. This glorified body expresses resurrection more than crucifixion. Christ has overcome death. Death has no power. The figure on the cross seems to stand forth with arms raised in victory. A bright blue sky suffuses the scene with lightness. Such art expresses a spirit congenial for celebration.

The Grünewald and the Raphael works were both painted in the early sixteenth century. A hundred years earlier, Master of Saint Veronica created an illumination of The Crucifixion (c. 1400-1410; J. Paul Getty Museum, Malibu, Fig. 58) which incorporated gestures used in the worship of his day. Christ's gesture is still familiar in our day. The hands of Christ are raised in benediction towards us. His arms and hands of blessing are above the heads of all those at the foot of the cross. His blessing falls on both the women who have faithfully followed him and on the soldier who has crucified him. He embraces all within the art work and all who view it. His embrace would stretch our conception of who is included in Christ's concern.

In preparation for a class, gather photo-

55

graphs of many art works showing crosses and crucifixions. There are three accompanying this chapter. Works by Georgia O'Keeffe and Louise Nevelson appear in chapter 4; two works by Barnett Newman appear in chapter 5; and there are two cruciforms within George Segal's work in chapter 3. Other examples may be gathered by bringing to class a few art books from the church library or a school or public library.

Open those books to eight or nine works showing the cross or crucifixion so they are visible to the students sitting around the table. Ask each student to look at each art work and to choose the one which he or she finds most meaningful. (If you have a large number of students, place the art works on several different tables and ask the students to move around the room to view all the art works before each student chooses one work he or she finds most meaningful. Students could be instructed to sit down at the table where they find the most meaningful work (or to stand by that table).

Students could take turns describing the features of the art works they have chosen and why they are meaningful. (If several students have chosen the same work, there is opportunity for small group discussion about that work.) Later, students may be asked why they did not choose some of the other art works, especially those which no one selected.

After students have chosen their crosses and discussed why they made their choices, the teacher or one of the students could read aloud Mark 8:34 (and following verses) about how we must take up our cross and follow Christ. Ask each student to consider what it means to take up the cross each has chosen. What does each cross suggest is involved in following Christ?

Then students could be invited to imagine what painting or collage or sculpture of the cross they might create which would even more fully express following Christ in our day. They could simply describe what they imagine or they could make it with materials provided in the classroom. (Such works could be created by collage from magazines or newspapers which students or the teacher have brought.)

TEACHING TIPS

1. Place on a classroom table or tables many different examples of art works featuring the cross or crucifixion which are in this chapter, other chapters in this book, or other art books from the church or local library.

2. Ask each student to look at all the art works and select the one which is most meaningful to him or her. Then lead a discussion in which students share details of the art works they have chosen and why they are meaningful.

3. Share scriptures which speak of the cross and consider which texts relate to which art works. The following are possibilities: Mark 8:34; I Corinthians 1:18; Galatians 6:14; Colossians 1:20. What does each art work suggest is involved in following Christ?

4. Invite students to imagine even more adequate art works they could create to embody the scripture about taking up a cross and following Christ. Either discuss those imagined possibilities or actually create them through collage from magazines and newspapers or other materials.

NOTES

[1] Paul Tillich, On Art and Architecture, ed. John and Jane Dillenberger, (New York: Crossroad, 1987), p. 99.

CHAPTER 21

BLACK, WHITE, AND GRAY
IN THE REIGN OF GOD

The colorization of black and white movies domesticates them, for most of us see the everyday world in color but dream in black and white. Many movie directors choose to film in black and white when they wish us to glimpse the extraordinary nature of eternal concerns. Similarly, a number of artists concerned with the mystery of God create in black, white, and gray. For example, we examined in chapter five Barnett Newman's fourteen abstract paintings entitled Stations of the Cross (now permanently displayed at the National Gallery of Art); and one may think of Ad Reinhardt's series of black cross paintings begun with a work for Thomas Merton's meditation. In this chapter, we focus on black and white and gray drawings and quilts by contemporary artist Barbara Dee Baumgarten and the use of shadows in a painting by Rembrandt.

Baumgarten uses gray as well as black and white to suggest the ethical insight of ambiguity so that we do not slip into brittle ideology where everything is seen as black or white. Great art and literature reveal flaws in the best of characters and redeeming qualities in the worst. In contrast, many television shows give us the "good guys" versus the "bad guys"; the right wear white and the wrong wear black not only in old-time western films but also in George Lucas films such as Star Wars. Such thinking may lead to racist character judgments based on color alone, reason enough to look for a more profound vision.

The gray color introduces a complexity into art forms because there are so many shades of gray. It is much more difficult to match a gray than it is to match other colors, as many persons looking for materials have learned. Such wide varieties in gray require us to look more closely than we normally do. Similarly, in the New Testament, Jesus leads us to look more closely and appreciate other persons as individuals whom we should approach with our care and not our categories.

Baumgarten's Two Praying at Temple (1984; private collection, Fig. 59), a 15" square drawing done in pen, ink and wash, illumines the parable of the Pharisee and the Tax Collector (Luke 18:9-14). In this drawing, as in many of her other works, a black-and-white checkerboard motif is the background she uses to suggest that ethics are often pursued as an adversary argument where both sides assume that one is right and the other wrong - that one must win and the other lose. Such a way of thinking characterizes this particular Pharisee who righteously stated his case to distinguish himself sharply from the tax collector: "God, I thank Thee that I am not like other men."

The Pharisee is portrayed with an upraised black and white fist, whereas the tax collector is gray with the imploring hand of a beggar who asks, "God, be merciful to me, a sinner." Baumgarten writes that the Pharisee's raised fist is a symbol of power and unshakable determination, while the tax collector's "reaching hand contains the urge to stretch and touch one's companion to bridge the gap between the speaker and listener. It is a vulnerable gesture of love."[1] In the church, gray calls us to be penitent and not prideful, as do the gray ashes which we place on our foreheads on Wednesday at the beginning of Lent.

In the 6 1/2 foot square quilt entitled Wom-

an (1985; private collection, Fig. 60), Baumgarten illumines the text about the woman taken in adultery (John 8:2-12). The black and white checkerboard characterizes the thinking of those who would quickly categorize, judge, and attempt to destroy this woman. On the contrary, the woman who is faceless, submits in a kneeling posture which does not neatly fit into the square categories. Her gray colored form is transparent as she has nothing further to hide.

The solid gray around her is intended by the artist to suggest the hand of God reaching down to hold the woman. The gray of God's hand is highly textured and conveys something of God's strength and perseverance. The artist writes, "I love the texture of the hand of God: it yells to be touched. The creation was hard labor. It was a great struggle to push the quilt through my sewing machine. It took strength, perseverance and patience."[2]

To the woman's upper right is a raised hand that reminds us of the Pharisee's fist from the artist's earlier work; in this case the fist appears eager to throw a stone. To her middle right, an extended hand reminds us of the artist's earlier rendering of the tax collector.

God's affirmation of the woman is stressed by the very medium of quilting which has in this country usually been a woman's art form. Major art museum exhibitions of quilts have now affirmed many women as artists, whereas previously quilts were relegated to craft museums. Since The Whitney Museum of American Art's show of quilts in 1972, many other museums have recognized the renaissance of quilting with exhibitions at the Smithsonian in Washington, D.C., the Denver Museum, and the Oakland Museum in California. Artist Judy Chicago organized hundreds of women to create dozens of quilts exploring ethical issues around giving birth, as she reported in her amply illustrated book The Birth Project.[3]

Gray expresses our finitude and the mystery of God who is so much more than we can ever clearly understand. English theologians saw the Word of God as "the light whose clarity takes all shadows away." Continental reformers, such as Luther and Calvin, interpreted the Word of God as possessing more mystery, "the light that shines into our darkness without dispelling all the shadows," as John Dillenberger has noted.[4] In a similar manner, while the English portraits of many kings and queens follow English theology and eliminate all shadows, Rembrandt's art works express the reformers' continental theology in utilizing grays to help us experience the mystery of God as shadows permeate even Head of Christ (17th century; The Metropolitan Museum of Art, New York, Fig. 61) attributed to Rembrandt.

TEACHING TIPS

1. While class members examine the art works with black and white checkerboard backgrounds, ask them to share how they feel when playing checkers or chess. Lead them to reflect on tension that builds in any adversary game where one person or group will win and the other lose.

2. Ask class members to reflect on times when they have acted powerfully and self-righteously, like the raised fist in the art works or the judgmental character in biblical stories of "The Pharisee and the Tax Collector" and "The Woman Taken in Adultery."

3. While class members look at Woman, invite them to reflect on the gray areas in ethical debates on capital punishment, abortion, and other complex sexual and social issues. Remind them that capital punishment by stoning would have ended the life of the woman taken in adultery if Jesus had not spoken.

4. Invite class members to reflect in silence on their own sins which should keep them from casting stones at others.

5. Ask class members to recall what quilts are in their own families and the affirmations they bring to mind. How are those affirming memories like the affirmation the woman must have felt when Jesus saved her from being stoned or like the affirmation of the tax collector when he prayed in the temple?

NOTES

[1]Barbara Dee Baumgarten, <u>Life is Not Black and White: Quilting as a Theological Medium</u>, (Unpublished M.A. thesis, Pacific School of Religion, 1986), p. 51.

[2]Baumgarten, p. 69.

[3]Judy Chicago, <u>The Birth Project</u>, (New York: Doubleday and Co., 1985).

[4]John Dillenberger, <u>Visual Art and Christianity in America: the Colonial Period Through the Nineteenth Century</u>, (Chico: Scholars Press, 1984), p. 9.

CHAPTER 22

ART AFFIRMS TIMES TO MOURN AND TO DANCE

Look at the painting Madame Cezanne (late 19th century; The Metropolitan Museum, New York, Fig. 62) by Paul Cezanne and guess what age she was when he painted this work. Make that determination of her age before you read the rest of this chapter.

When you ask students in your class to determine the age of Cezanne's wife in the painting, ask them to remain silent and simply raise their hand when you call out an age within 5 years of what they have guessed. Then say "20" and pause for some students to raise their hands, then "30," then "40," then "50," then "60" and finally "70." Some will judge she is in her twenties or thirties; but others will judge she is in her fifties or older. Place a piece of paper over the left half of the painting so that her figure is cut down the middle leaving visible only the eye and hand and side of her body next to the billowing curtain in the background. That side appears young (a full cheek and a full fleshy hand). Adding to that side's vitality, the hand holds a fresh flower; and the curtain is full and curvaceous. Noticing some of those details, a person would identify the woman as young.

Shift the paper to cover what you have been seeing and to reveal the other side of the woman. The sunken face and the bony hand on that side suggest a much older woman; and only partly visible in the background, the rectangular shaped frame of a painting or a window adds a harsh line quite unlike the curvaceous curtain on the other side. Noticing those details, a person would identify the woman as old.

Cezanne knew his wife when she was young and when she was old. His painting is not a snap shot of his wife at one period of her life. Madame Cezanne includes aspects from both her youth and her older age. Such inclusions affirm both periods of her life.

A visual art work may portray simultaneously different times of life and so prevent us from seeing life in terms of "either/or." Instead the visual arts offer us a fuller view of life in terms of "both/and." Many ethical and theological problems arise when we view them with a snap shot approach which does not do justice to the complexity of both what has taken place earlier and what will take place later.

Religious commitments involve a sense of history including the changing conditions we face in the past, present, and future. For instance, in marriage vows, the bride and groom are traditionally asked to continue their commitment to each other "in sickness and in health, for richer and poorer." In Ecclesiastes 3:1-8, we learn that life has many seasons including "a time to mourn and a time to dance"; and we may have faith in God through all those times.

In Edouard Manet's Christ (19th century; Legion of Honor Museum, San Francisco, Fig. 63), we see two different phases of Jesus' life. With this figure, use the method demonstrated earlier with Madame Cezanne. One side of his body has a strong raised shoulder and full chest; and that half of his face has a full mouth and an eye focused intensely. That side of his body and face is full of life. As you move a paper to cover that lively side of Christ's face and to reveal the other side, you see a lowered shoulder, a sunken chest, and a face with little if any mouth and a somewhat dilated eye rolled heavenward. That side of Christ appears more dead than alive.

In this one painting, we have portrayed both the life and death of Christ. It is important to keep both aspects together and not to remember only the life or the death. In the Biblical texts

60

and in communion rites, we are asked to remember Christ's life _and_ death. Remembering both his life and death allows us to affirm the different phases of our own lives which invite each of us to mourn and to dance at different times.

Using this method with René Magritte's The Therapeutist (1967; Hirshhorn Museum, Washington D.C., Fig. 64), we see that one side of the figure with a cane appears to be upright while the side with the bag appears to be sagging. The arm and leg on one side appear alert; and the shoe on that side appears relatively new. The arm and leg on the other side appear flaccid; and the shoe on that side appears well worn. On closer inspection, one sees that the handle of the bag is broken off. We may associate one side with vigorous younger age and the other side with declining older age.

A sleek bird outside the cage is on the alert half of the figure while a gaunt bird inside the cage is on the sagging half of the figure. One may ask whether the function of the healer (the therapeutist) is opening the cage door and allowing a prime bird freedom to be outside the cage or is accustoming an older bird to live inside the cage. This sculpture may affirm both options.

Initially, we see only a few details of the many features in a painting or sculpture. Based on those few details, we leap to a judgment about the age of Cezanne's wife or the condition of Manet's Christ or the meaning of Magritte's sculpture. Then we often fail to see other details which may conflict with our initial view. This method of looking first at one side and then at the other helps us see more details and the complexity of each art work.

Our own expectations are probably revealed in how we see some details and not others. If we told our students that we were about to show them a painting of Cezanne's wife when she was a young woman, I imagine most of them would see her youthful details. If we told them it was a painting when she was old, they would see her aging details. (If one student spoke out too quickly what age he or she judged Madame Cezanne to be, then others might see her that way.) Similarly, if we told students that we were about to show them a painting of Christ near death, I imagine they would see those lifeless details; but if we told them that it was a painting of Christ in meditation, they would see the more lively details. Manet's painting probably was a study for his larger 1865 painting Christ Mocked (The Art Institute of Chicago). We should not too quickly interpret one work in terms of the other; for the artist's intentions may have changed. Even related art works may differ in important respects.

When we expose students to an art work without giving them any expectations, then their responses reveal some of the expectations they carry with them. To help the students recognize how their habitual expectations affect how they see and do not see details in a painting may help them take time to see more complexity in art works and in other persons. Appreciating such complexity allows affirmation of more times in our lives which God gives to us.

TEACHING TIPS

1. Give students pencils and pieces of paper; and ask all of them to write down simultaneously the age of Madame Cezanne when Cezanne created his painting of her. Then have the students share their estimates of her age; and using the method explained in this chapter, explore the different details of the painting.

2. Using the same method, explore Manet's Christ; and then explore Magritte's The Therapeutist.

3. Discuss how what we see is affected by our expectations and reveals our expectations.

4. Discuss how appreciating greater complexity allows us to affirm more times of our lives. Relate these observations to the mention of sickness and health in marriage vows, life and death in communion rites, and times to mourn and to dance (and other contrasts) in Ecclesiastes 3:1-8.

CHAPTER 23

FACING THE CAIN IN OURSELVES

In creating the eighteen masks for the exhibition "Faces of Cain" (figs. 65, 66, 67, and 68) by shaping most them from her own face, Joan Carter reveals not only sources of problems in social ethics but also some steps toward solutions. In our interview, she notes that "Cain serves as a symbol, a metaphor, a vehicle for exploration into that which drives individuals to hate, bloodshed, war and ultimately self-destruction." In discussing ethical problems, we often point to other people as the source of problems and so avoid our own responsibility and evoke a defensive reaction from the others; but by facing the Cain in ourselves through her masks, we act confessionally as a step toward taking responsibility for the problems.

Her process was to meditate on the Biblical story of Cain killing his brother Abel and the episodes before and after that event (Genesis 4). She also read Elie Wiesel's commentaries on that Biblical story. Then with a hair net or shower cap covering her hair, she coated her face with vaseline (being careful to coat especially eye brows and eye lashes) and applied to her face cut strips of plaster cast material (which may be obtained at any medical supply store and then dipped in water just before applying). The plaster cast hardens in twenty minutes; so, she removed it from her face before it hardened completely and then crafted details while it was still flexible.

Joan Carter shared that the closed mouth in many of the masks "reflects in visible terms the emotional state, the scream that is swallowed, the coverup that occurs through silence." To be silent in the face of killing is an assent to the evil. In most of the masks, the mouths appear accustomed to not speaking; for there is no strain in the closed lips. In contrast, one of the figures with long golden colored hair has lips which reflect some tension not at ease with saying nothing and perhaps on the verge of speaking. The artist comments, "That one speaks to me; but I don't know what it says." The long hair is made of raffia, a synthetic straw.

Where the mouth is open, the Cain mask embodies Abel's blood crying out from the earth as in Genesis 4:10 where God says "What have you done? Hark! Your brother's blood that has been shed is crying out to me from the ground." She notes that "what gets buried inside is too painful and too powerful to keep in; and the mouth opens (almost an involuntary opening)." The open mouth in a few masks of Cain reveals how interrelated Cain and Abel are. Elie Wiesel's commentary on this scripture notes that Cain and Abel are linked as we are with all other humans; so, "Every murder is a suicide: Cain killed Cain in Abel." Recognizing that Cain's anger resulted from Abel's sacrifice being accepted by God while Cain's sacrifice was rejected, we may appreciate Wiesel's comment that "We were responsible for one another ...Abel and I ... Neither of us was entirely guilty or totally innocent; we were both, each in our own way, indifferent to the other."

As Abel did nothing to reconcile Cain after Cain's sacrifice was rejected, so we are insensitive to others in many ways besides physically attacking them. Joan Carter notes contemporary expressions of the Cain story in our lives:

Once we begin to explore the Cainness in each one of ourselves, we begin to see that it was not just an act back at the beginning of time; but we see it as a strain that has carried through in many ways: crime in the cities and also the way we pass one another on the high-

way. There is an aggressive anger that emerges at every turn which says that Cain is close to the surface and thinly covered over with niceties.

The eyes are closed in most of the masks. We often close our eyes to our own potential for evil; and we do not want to see suffering. Wiesel writes, "In the face of suffering, one has no right to turn away, not to see. In the face of injustice, one may not look the other way. When someone suffers, his suffering gives him priority." Some of the eyes are closed tightly while others seem slightly open but look down so as to avoid our seeing into them or them encountering us directly. The artist says "You think about eyes as being windows in, the element in the face that draws us to something beyond." The awareness of something beyond, the transcendent, seems to be avoided by many of these faces of Cain who are aware of themselves but not of others.

A part of ethical problems is not only negative acts but also a blindness to our complex potential for negative acts. My favorite quotation recently comes from Camille Paglia's critique of the report from the Presbyterian's Committee on Human Sexuality. She notes that the report's "opening premise of 'the basic goodness of sexuality' projects a happy, bouncy vision of human life that would have made Doris Day and Debbie Reynolds - those '50s blond divas - proud. ...Pardon me: I happen to think that Italian opera and African-American rhythm and blues contain the real truth about sex, with its Dionysian energies and ungovernable intensities." (The New Republic, December 2, 1991, pages 24-27).

One of Joan Carter's masks has horns emerging from the top of the forehead. She followed a Jewish midrash (commentary on scripture) which identified horns as the mark on Cain. The biblical account does not describe what that mark was except to say that God made a mark on Cain so others would not attack him.

As associate minister at the Presbyterian Church in Sausalito, California, vice-president of the Center for the Arts, Religion, and Education in Berkeley, and in work with other church groups, Joan Carter uses masks in worship as well as in education. She has worked with youth to help them create their own masks and then develop dramas in which to use the masks. Creating the masks after meditating on a biblical text helps to develop insights which later guide the creation of a drama on that scripture. She has students pair off and then take turns making the masks of each other. All of the students may make masks for the same Biblical character so we see many different aspects of that one character; or they may make the masks for the range of characters in the biblical story being studied.

The finished masks may then be exhibited in the fellowship hall or narthex of the church before a worship service dealing with the biblical character or characters. In the worship, she has taken the masks in hand and moved among those in the congregation so they see the masks and may better enter into the heart and mind of each Biblical character. Then she and others put on the masks for the dramatic reading of the scripture or the presentation of the drama written by the youth. She suggests a slow reading of the Biblical story so people may meditate on it and the masks; for the masks invite such meditation. The scripture could be read as the masks are passed throughout our congregation who are invited to put the masks on our own faces so we see ourselves in The Faces of Cain or the Faces of Moses or the Faces of Eve or the Faces of Peter or the Faces of Mary Magdalene or the Faces of Pontius Pilate or many others.

TEACHING TIPS

1. Ask the class members to think of themselves as one of the characters in the Biblical story you are studying. Read that story aloud.

2. Have the students pair off and make masks on each other's faces as the Biblical character each has chosen. Follow the steps noted in this chapter.

3. In a later class session develop a drama utilizing the masks to express insights into the Biblical characters.

4. Have an art exhibition of the masks in the fellowship hall or narthex of the church before a worship service or educational event in which the drama is shared by the class members wearing their masks or passing them throughout the

congregation or audience who are invited to put on the masks. Have small mirrors available to pass with the masks to allow the audience or congregation to see themselves as the Biblical characters.

CHAPTER 24

UPLIFTING UMBRELLAS AND THE IMPORTANCE OF ALL PERSONS

When Christo raised three thousand one hundred huge umbrellas in valleys north of Tokyo and Los Angeles in 1991, most art critics did not realize the religious significance of what we was doing. In the history of both European and Japanese religion, umbrellas are displayed above the most important persons. By providing thirteen hundred and forty blue umbrellas in Japan and seventeen hundred and sixty yellow umbrellas in California, Christo made it possible for hundreds of thousands of people to stand or to sit under umbrellas and to realize that they too are very important.

Over the thirteenth century north entrance of Chartres Cathedral, canopies are visible above the heads of significant biblical figures: Melchizedek, Abraham and Isaac, Moses, Samuel, and David (c. 1230-50; Fig. 69). In the worship services of that period, fixed canopies were located above the seats of the bishop and other major leaders of church and state. When such an important person processed inside or outside the church, an umbrella was held over his head by a person who followed. Similarly in Japan, umbrellas were carried by others who held them over the heads of significant religious and political figures.

Christo's The Umbrellas Japan - USA 1984-1991 (figs. 70, 71, 72, and 73) invited all persons to see themselves as religious or political leaders. What he was proclaiming in his art is similar to the priesthood of all believers in religion or democracy in politics. The umbrellas invited people to gather in community under the huge size of each umbrella (twenty-eight feet and five inches in diameter). People came to picnic together and found refreshing shade under the umbrellas which were up for nearly three weeks in October 1991.

As a Bulgarian who grew up under the tyranny of first Hitler and then Stalin, Christo has long created works critical of such totalitarians as discussed in chapter 15. His rust orange colored Valley Curtain was stretched across a valley of Colorado in 1972 as a parody of the iron curtain; and it was soon ripped to pieces by winds as Christo was certain the iron curtain would not last long. His 1976 Running Fence was twenty four and a half miles long in Northern California as a parody of the twenty four kilometer Berlin Wall; and as the Running Fence was up for only three weeks, so, Christo believed that the Berlin Wall would be coming down much sooner than most political leaders thought.

Briefly in that chapter 15 and more extensively elsewhere, I have written how Christo's Running Fence made those in communities aware of their relations with each other as they supported or opposed the art work which included so many different individuals' properties and political jurisdictions.[1] Similarly, The Umbrellas included many communities as the umbrellas were installed along a twelve mile valley seventy five miles north of Tokyo and an eighteen mile valley 60 miles north of Los Angeles.

The Umbrellas affirmed a wider sense of community not only among those in Southern California who picnicked together but also across the world's broadest ocean. While some politicians bashed Japan as an enemy, Christo raised umbrellas north of Tokyo and Los Angeles to lead us to see similarities as well as differences between America and Japan.

The yellow umbrellas reflected the golden hills and wild yellow poppies of California along Interstate 5 and were often set far apart to remind us of the more expansive landscape and living space per person in the United States. The blue umbrellas reflected the rural wetlands in Japan and were set close together to remind us of the more compact living conditions in Japan. In both places, large numbers of people came together to share meals under the umbrellas.

Christo planned to have The Umbrellas in place for only three weeks to emphasize that we are not immortal as he told students in Bakersfield before the project opened: neither we nor our artifacts last forever. Some people would judge an art work on the basis of whether it lasts; but Christo's art leads us to value the process and not just the finished product. No art work will last forever; but we often try to pretend that our earthly accomplishments or artifacts will last and so make our influence immortal.

In his earliest wrapped works, Christo had them up for as little as three days which raises the issue of mortality and immortality; for three days was the time of Jesus in the tomb between crucifixion and resurrection. With such large projects as The Umbrellas, three weeks allow more people to see the work. The number three persists in his work: three thousand one hundred umbrellas spread out over a total of 30 miles for a period of three weeks.

Even three weeks reminds us of our mortality or finitude; for many could not get to the project in that short time or see as much of it as they wished. While each umbrella was created to withstand all known wind velocities in the areas, a tornado (never reported in California's Tejon Pass before) underscored our mortality when it toppled one umbrella and killed a woman who had come to see the project.) Christo then closed the project early.

His earlier wrapped works made the earth as well as human creations appear as gifts prepared for a celebration; at different times, a museum in Switzerland, a bridge in France, and a coastline in Australia were covered with light colored fabric tied in place. Christo called The Running Fence a ribbon of light as it too wrapped the earth and made it appear as a present. Helping us see the world as gift helps us understand God as gift giver. Umbrellas protect what is beneath them; and so The Umbrellas give us a sense of God's providence for earth and all on it.

What we have taken for granted, we now see anew. When the object is covered, we notice more exactly its outline; but at the same time, it becomes mysterious as we cannot see what is beneath the covering. When the covering is removed, we see explicitly what we have neglected. I have often driven along Interstate 5; but I had never noticed many interesting features of the hills and valleys around it. The Umbrellas gave me eyes to see. Even after his art work is gone, I see so much more in that area than I saw before Christo raised his umbrellas.

The colors of the umbrellas suggest the United States and Japan are complementary countries to be seen together. Yellow is the color of the day; and blue is the color of the night. Yellow is the color of the earth; and blue is the color of the heavens as well as the waters around the earth. One color alone suggests only part of space or part of time just as one umbrella or even all the umbrellas in just one country would be only part of the whole.

Christo notes how his work invites a wider vision:

> There has never been a work of art or architecture in all of human history, in all civilization, that has happened in two places in the world. This is the first. It was inconceivable before the 20th century that man could visually experience something like this in a matter of a few hours.... Today, a 747 takes 9 1/2 hours to fly between Los Angeles and Tokyo. The entire idea is to expand your vision by seeing the project in these places together. Everything about that project is determined to highlight that vision. [2]

Christo's work lifts our vision to see beyond the limits of national boundaries as Christ's stories and actions led early Christians to see beyond the limits of their national boundaries.

TEACHING TIPS

1. Lead students to look at art works in this chapter and discuss how umbrellas call attention to the importance of persons who are under them. Invite students to share what makes them feel important and how they make others feel important.

2. Discuss how Christo's The Umbrellas lead us to see a wholeness beyond national boundaries. Share Jesus' stories or actions that led his followers to see beyond national boundaries. Consider how Samaritans are responsible characters in his parable of the Good Samaritan (Luke 10:29-37) and in the miracle story of ten healed lepers when only the Samaritan returns to thank Jesus (Luke 17:11-19). Jesus' countrymen do not act so responsibly in those stories.

3. Who are the Samaritans of our day? Who are the foreigners who are acting more responsibly than we are and from whom we may learn?

4. While many people value things that last (perennials) and give much more to a building campaign than to the annual budget, Christ likens the kingdom of God to a mustard shrub (an annual) as in Mark 4:30-32. Discuss how likening the kingdom of God to an annual helps us see value in things, persons, and activities which will not last long: a terminally ill person, a musical performance, a party, a three week art installation such as The Umbrellas.

5. At the time of Christ, the Jews likened the kingdom of God to a mighty Cedar of Lebanon which would last longer than a human lifetime and was tall and sturdy providing safety for birds in its high branches. Christ parodies that Jewish parable by his wobbly mustard shrub which at best provides some shade to birds that nest on the not so safe ground. Discuss how Christ's parable is like Christo's temporary art of umbrellas providing shade for people who flock to see them.

6. Discuss how on vacations, some people value the journey itself while others value only the destination and how Christo's process art values the journey of creating and not just the finished product.

7. Bring umbrellas to class and ask students to share their memories of picnicking under umbrellas and being protected by umbrellas.

NOTES

[1] Doug Adams, Transcendence With The Human Body In Art: Segal, De Staebeler, Johns, and Christo, (New York: Crossroad, 1991), pp. 135-146.

[2] The Bakersfield Californian, October 6, 1991, page 46.

SECTION III

ADVENT THROUGH EPIPHANY:

FUTURE-LIFE-IN-CHRIST

DANCING CHRISTMAS CAROLS WITH ANGELS WORSHIPING GOD

In Sandro Botticelli's <u>Mystic Nativity</u> (ca. 1500; National Gallery, London, Fig. 74), angels dance in a circle to celebrate the birth of Christ. This image reflects a practice of worship from Biblical times through the early church to Botticelli's own fifteenth century. In the Bible and later religious literature, those who circle danced were seen as rejoicing in the Spirit close to God; but those who would not move or who criticized dance were seen as rejecting God's leadership. At Christmas, folk dancing carols in worship and education is one way to experience greater joy and community with God and to proclaim Jesus is our Lord as the Word becomes flesh.

The Psalms say, "Praise God's name with dancing" (Psalm 149:3) and "Praise God with timbrel and dancing" (Psalm 150:4). At the time of Jesus, "dancing" and "rejoicing" were expressed by the same word in the commonly spoken Aramaic language as evident in Jesus' saying "Rejoice and leap for joy" (Luke 6:23). New Testament reports of the disciples "rejoicing in the spirit" probably indicate that dancing was practiced.[1]

As rejoicing was an important feature of worship, dancing was common in first-century worship of both Judaism and Christianity. Music and dancing are in Jesus' parable when the son returns to the father - a scene which may be understood as a paradigm of our return to God in worship (Luke 15:25). Such folk dancing in Christian worship is evident in written records and art from the early church through the Renaissance. Negative references in both the Bible and church history tend to be of individual dance and not folk dance.[2]

In the Bible, those close to God are often portrayed as leading others in dance. To thank God for freedom at the Exodus, Miriam led the women "with timbrel and dancing" (Exodus 15:20). In contrast, those who did not follow God remained unmoved in Egypt. At the height of his relation with God, "David danced before the Lord with all his might" leading the people with the ark into Jerusalem (2 Samuel 6:14); but criticizing David, Saul's daughter Michal was barren throughout her life.

David demonstrated ability to lead the people together through music and dancing as well as in political and martial arts. In an eighth century manuscript illustration (British Museum, Fig. 75), David is shown as a king leading those who sing and dance around him. Frequently in their sermons, church leaders urged worshipers to emulate David's dance and pictured angels dancing around God as king.[3]

In <u>The Divine Comedy</u>, Dante continued that angelic motif and contrasted it to the immobile devil. In the <u>Inferno</u>, he revealed the devil as encased in a cake of ice and unable to move except as he "stood forth at mid-breast from the ice." In <u>Paradise</u>, the closer one comes to God, the more active one becomes as the angels dance around God singing, "'Hosanna! Lord God of Sabaoth!' ... Thus, revolving to its own melody, that substance was seen by me to sing, and it and others moved in their dance."[4]

Botticelli created dozens of drawings to illustrate Dante's <u>The Divine Comedy</u>; and his painting with angels doing a circle dance affirms Christ as our king and God. Where dancers had moved around King David, they now move around Christ whom we recognize as king in our lives. As angels danced proclaiming God, they

now dance proclaiming Christ.

Modern artist Richard Lippold has created an abstract sculpture with a moving angel motif which serves as the Baldacchino (the canopy above the altar installed in 1969-70, St. Mary's Cathedral, San Francisco, Fig. 76). Thousands of metal pieces hang down from a frame suspended by wires to the ceiling. The wires are like angel wings while the metal pieces form the body. Each piece of metal moves freely at every breeze whether it comes from the doors opening, the pipe organ playing, or the people singing. Every light source is reflected by the metal; and the whole Baldacchino is ablaze with light as if it were aflame while the angel appears to dance above the altar during worship services. Such art continues the tradition that the closer we are to God the more light-filled and active we become. The angels invite us to dance around Christ in the creche or in communion at the altar table.

TEACHING TIPS

1. To help students enter into the spirit of Botticelli's art, lead them in doing the following simple circle dances to "Angels We Have Heard On High," "O Little Town of Bethlehem," or other Christmas carols.[5] Lead the students to form one circle with everyone facing into the center. (Two or more concentric circles may be formed if there are too many people for one circle or if you prefer to have a circle of boys and a separate circle of girls because some are unwilling to hold hands with those of the opposite sex.) Holding hands with others on either side of them throughout the dance, everyone moves to the right with running steps while singing the words "Angels we have heard on high sweetly singing o'er the plains." Then everyone shifts direction and moves with running steps to the left singing the words "And the mountains in reply echo back their joyous strains." Then everyone faces the center of the circle and moves toward the center singing "Gloria" in the chorus while raising hands upward which are still joined to others' hands. Everyone stops on the phrase "in excelsis," and then leaps up into the air on the word "Deo." Finally, everyone moves backwards to their original positions in the circle singing the next "Gloria" in the chorus, stops on the next "in excelsis," and leaps up in the air on the last "Deo." Repeat the foregoing stanza and chorus three times so that everyone may develop the full possibilities for rejoicing and community.

2. St. Francis popularized leading the people in circle dancing around the creche at Christmas. Set up a creche on the floor or a low table in the middle of the room and lead students in the following circle dance to "O Little Town of Bethlehem." Students take the same initial positions including holding hands throughout the dance as they did in the previous dance to "Angels We Have Heard on High." They take four slow steps toward the creche in the center of the circle as they raise their hands upward singing "O little town of Bethlehem, how still we see thee lie!" Then they take four slow steps backwards to their original positions, lowering their hands, and bowing at their waists as they sing "Above thy deep and dreamless sleep the silent stars go by." They move forward again toward the center with four slow steps and raise their hands upward as they sing "Yet in the dark streets shineth the everylasting Light;" and they move backwards to their original places while lowering their hands, bowing, and singing "The hopes and fears of all the years are met in thee tonight." While singing "Amen," everyone straightens up and raises their hands. Repeating the entire stanza and chorus three times will increase the meaningfulness of the experience.

3. As the class looks at Botticelli's Mystic Nativity and David With Musicians and Dancers, discuss how dance was used to worship God in the Bible from Miriam's dance to David's dance and how dance figured in Jesus' saying and parable noted in this chapter. Ask students when and why they have jumped for joy (at a victory in sports, at freedom on the last day of the school year, at other celebrations, etc.)

4. Ask students to discuss times in their lives when they have been frozen or immobilized or isolated feeling like the devil incased in a cake of ice in Dante's imagery (when they felt left out of a group) and also ask them to think of times they have been most energized like angels dancing around God (when they have

been included in a strong sense of community).

5. Share how the presence of God's Spirit in our lives is evidenced by our greater activity and brightness as wind and light are made evident by Lippold's Baldacchino.

6. Close the class session by singing and dancing again "Angels We Have Heard on High."

NOTES

[1]Matthew Black, The Aramaic Approach To The Gospels and Acts (London: Clarendon Press, 1967), p. 158.

[2]Doug Adams, Congregational Dancing In Christian Worship (Austin: The Sharing Company, 1984). Pertinent portions are reprinted in Dance As Religious Studies, ed.by Doug Adams and Diane Apostolos-Cappadona (New York: Crossroads, 1990).

[3]Margaret Taylor, A Time To Dance: Symbolic Movement In Worship (Austin: The Sharing Company, 1981). An abridgement is included in Dance As Religious Studies.

[4]Dante Alighieri, The Divine Comedy, translated by John Sinclair (New York: Oxford University Press, 1961), Inferno, canto XXXIV, p. 421; and Paradiso, cantos VII and XXIV.

[5]Simple ways to folk dance over thirty favorite carols are given in Dancing Christmas Carols edited by Doug Adams (San Jose: Resource Publications, 1978); and Dramatic Dance With Children in Worship and Education by Margaret Taylor (Austin: The Sharing Company, 1977) details ways to dance improvisationally the carols most appropriate for children ages seven through twelve.

CHAPTER 26

SEEING THE UNEXPECTED IN ADVENT

When two pregnant women meet in the first chapter of Luke's gospel, Mary speaks what we now call "the magnificat" including verses 52 and 53: "he has put down the mighty from their thrones and exalted those of low degree; he has filled the hungry with good things, and the rich he has sent empty away." Advent is filled with unexpected reversals. By surprising us, unexpected reversals remind us that we are not omniscient and are not God.

A contemporary artist's rendering of this meeting of Mary and Elizabeth occurs in Michele Zackheim's The Tent of Meeting (1985). Her 1500 square foot art work is in the form of a Bedouin style tent whose canvas walls are covered with historic imagery from Judaism, Christianity, and Islam. She honors the difference of each tradition by portraying each on a separate wall of the tent. The tent has been exhibited at many sites including the Episcopal Cathedral of St. John the Divine in New York, at Yale University, and at the Roman Catholic Cathedral of St. Mary's in San Francisco. The artist hopes it will be permanently installed in Jerusalem to encourage meetings by those from the three religious traditions who share roots in Biblical stories while appreciating differences.

The Jewish wall (Fig. 77) brings together two major motifs of Jewish religious experience. In the center is Moses on Mt. Sinai while at the left and the right are wings reminiscent of seraphim and cherubim associated with Isaiah's vision in the temple. The clouds evident in that Jewish wall and in the ceiling remind us of the mystery of God's presence which was sensed in a pillar of clouds during the forty years in the wilderness. Just as Moses saw only God's back, so we cannot predict God's actions in advance but may look for God's action in recent events.

The clouds remind us that we do not see God's ways clearly or comprehensively with our human eyes. In Paul's words, we now see as "through a glass darkly." (I Corinthians 13:12).

The central post which holds up the tent has a square base but becomes eight-sided and then sixteen-sided and finally circular as it reaches upward. Such a shape shows the graceful possibilities of affirming differences and unity in one structure. On the Christian wall (Fig. 78), the Jewish background of Christian faith is evident in the first Tree of Life at the left. Many stories from the prophets are shown in small medallions like fruits on the tree.

The middle tree on the Christian wall features the birth and life of Jesus; and the third tree (the one furthest to the right) features the Sermon on the Mount. An appropriate surprise appears at the top of the middle tree where the hand of God appears above the pregnant figures of Mary and Elizabeth meeting. The surprise is that we see God's left hand instead of God's right hand (Fig. 79).

Michele Zackheim has presented God's left hand to include and affirm what has often been excluded or viewed negatively. Traditionally, God's right hand has been featured in art but not God's left hand. In social as well as religious rituals and stories, the right hand has been associated with the clean or the saved while the left hand has been associated with the dirty or the damned. Such associations have been based on social customs arising from use of the left hand to wipe ones rear end in the days before toilet paper. Viewed as unclean, the left hand was not used in eating or in greeting others. One would eat and greet with the right hand.

As a result, the word "left" has negative associations linguistically. In Latin, the word

"sinister" means left; and in French, "gauche" means left and is used in English speech for crude. In popular usage, "left" refers to the abandoned: i.e. he was left alone. Even the term "leftovers" has a somewhat negative association. "Right" refers to the correct or positive way of doing. The righteous are associated with "right."

With that background, we see why religious stories and paintings have usually placed the saved to Christ's right hand and the damned to his left hand. In a vision of the Last Judgment in Matthew 25:31-46, "the King will say to those at his right hand, 'Come, O blessed ..., inherit the kingdom' Then he will say to those at his left hand, 'Depart from me, you cursed, into the eternal fire prepared for the devil and his angels.'" In Last Judgment scenes familiar from the facades of medieval cathedrals in Paris or Chartres, the blessed go to heaven at Christ's lifted right hand and into hell at his lowered left hand.

In my interview of Michele Zackheim, she shared her intentional inclusion of God's left hand to affirm what has often been rejected. Left-handed persons will appreciate this inclusion as they are often "left out" when schools equip classrooms and buy chairs with supports for notebooks at the right. Michele intends a wider inclusion as well. She noted that the left hand is linked to the right hemisphere of the brain which is associated with the artistic and imaginative faculties. She intends her work to encourage such imagination which is neglected in our education and culture. As such artistic abilities are often associated with the feminine, she sees the inclusion of God's left hand as a way to embrace the feminine qualities.[1]

She sees those feminine qualities further developed in Jesus' beatitudes which she portrays in the tree of life on the right side of the Christian wall. At the top of that tree are lips appropriate to the theme of speaking the beatitudes from the sermon on the mount. The lips have a feminine appearance. As Jesus' beatitudes are reversals of wisdom associated with masculine culture, some scholars have called them anti-beatitudes.[2] At the time of Jesus, the Zealots wanted to war with Rome to achieve freedom; but Jesus said, "Blessed are the peacemakers." Peacemakers are negotiators who necessarily compromise and are disliked by all sides. We realize the surprising quality of the beatitudes if we say "Blessed is Henry Kissinger; for he shall be called son of God." People may call Kissinger a son of something but not usually of God. Similarly, being poor or meek or hungry are "blessings" we would gladly do without and would rather not even see. Without such beatific vision, the people will perish. We need to develop eyes to see the unexpected in advent.

TEACHING TIPS

1. Ask students to make a list of what persons or groups are held in "low degree" by our culture and which persons and groups are enthroned or highly esteemed by our culture. Bring in magazines and newspapers and a T.V. Guide; and have students tear out images and headlines and create a collage with the esteemed on top and the lowly at the bottom.

2. Then share how Mary's magnificat (Luke 1:46-55) or Jesus' parables (such as The Rich Man and Lazarus, Luke 16:19-31) would reverse how we see and think and lead us to affirm or exalt the lowly. Rearrange the collage so what was at the top goes to the bottom and what was at the bottom goes to the top. Discuss the reversals in Jesus' Beatitudes (Matthew 5:3-12).

3. Share how Michele Zackheim's Tent of Meeting embodies reversals by including God's left hand. Discuss the experience of those who are left handed; for often left handed students have experienced prejudice.

4. Discuss how the people are surprised to be among the blessed and among the cursed in Matthew 25:31-46. Discuss the unexpected ways we may encounter Christ by interacting with the needy in our world.

NOTES
[1] Doug Adams interview of Michele Zackheim, June 18, 1988.
[2] John Dominic Crossan, The Dark Interval: Towards A Theology of Story, (New York: Argus Communications, 1975).

CHAPTER 27

NATIVITY AFFIRMS DIVERSITY

In nativity scenes, many great artists portray the child Jesus as drawing together the full diversity of humanity. Shepherds appear ragged and poor; and wise men appear elegant and wealthy. One of the wise men is old, another middle-aged, and another young. All the wise men are foreigners; and one may be black. Closest to the child Jesus is a woman, Mary his mother, who is visible to all. The unrighteous as well as the righteous are in Jesus' company.[1]

Such diversity within a community would be a scandal in some countries where women and men do not see each other so fully or where blacks and whites are separated or where foreigners are excluded. Art illumines the Nativity not only with the Biblical stories of Jesus' birth but also with the later Biblical accounts of his scandalizing some of the Pharisees because "sinners were all drawing near to hear him" and he "receives sinners and eats with them" (Luke 15:1-2). In the nativity, art expresses the many meanings of the Christ event including Paul's views that God was in Christ reconciling the whole world to God so that "there is neither Jew nor Greek, there is neither slave nor free, there is neither male nor female; for all are one in Jesus Christ" (Galatians 3:28)

The ragged demeanor of the shepherds is shown in Hugo van der Goes Portinari Altarpiece (1475; Uffizi Gallery, Florence, Fig. 80). We see a similar poverty in the clothing of some figures whose knees poke through worn pants and in the nakedness of others in The Adoration of the Magi (fifteenth-century; National Gallery of Art, Washington D.C., Fig. 81), a collaboration by Fra Angelico and Fra Filippo Lippi.

The symbolic force of including shepherds in Biblical stories and art is felt only if we realize that shepherds were considered sinners.

While Moses and David might be respectfully remembered as shepherds from long ago, first century Jews listed herding sheep among the proscribed trades; for shepherds were notorious for hiding some of their sheep to evade part of their temple tax assessments and engaging in other unethical actions. In addressing his parable of the lost sheep to Pharisees, Jesus unsettled the distinctions between the righteous and the unrighteous by classing Pharisees as shepherds with whom Pharisees would not even associate: "Which one of you having a hundred sheep ..." (Luke 15:3). A low regard for shepherds persisted through medieval church dramas which dealt with the nativity and included the humorous subplot of a shepherd stealing a sheep and pretending it was a baby.[2]

Lucas Cranach, Adoration of the Magi, (1514; Fig. 82) follows the Northern European tradition of portraying one wiseman as black. On his knees, the oldest wiseman is white. The Christ child's very nakedness reveals him to be fully human and affirms incarnational theology that the Word has become flesh.[3] In Fra Angelico's and Fra Filippo Lippi's version, the nakedness of the child resonates with the nakedness of the poor in the upper left corner of the round painting and reveals Jesus' affinity with the poor.

An especially effective method developed by the Smithsonian Institution's National Museum of American Art to involve children and all ages with any painting is appropriately used with these paintings which affirm all people are welcome into the company of Jesus. When there is so much to see in a painting, this method helps us see many details we would otherwise easily overlook.

With everyone looking at a reproduction of

the round painting (or a slide of it), ask each person to choose a different shape in the painting. Each person is then asked to think what sound expresses his or her selected shape. As the teacher, I lead this exercise by giving just a few examples of how some shapes may be expressed in different sounds. A small dot may be making a soft beep, beep, beep; but a large robe may be making a loud roaring sound. A wavy gown may be making a sound which goes up and down and up again in pitch. I make those different sounds; and then invite the class members to try out a variety of their own sounds as they continue looking at the shapes they have selected. While they are making the sounds, I urge them to make their sounds louder and then softer in volume, and later higher and then lower in pitch.

With the painting as the score and the class as the orchestra, I become the conductor and pass my hand across the painting after instructing the class members to begin making their sounds when my hand nears the shapes they have selected and to stop making their sounds when my hand moves beyond those shapes. As conductor, I lead several different performances of the art work: one performance is generated by moving my hand horizontally from left to right, another by moving my hand from right to left, and another by moving my hand vertically from top to bottom or bottom to top. The first time, I move the hand slowly enough so that each class member's sound has at least a brief opportunity to be heard distinctly. At other times, I move my hand at different speeds to combine the sounds in a variety of ways. Later one may ask each person to develop a physical movement to express the shape and sound each has selected. Then as I conduct the painting, we dance it as well as sound it.

After playing the painting a few times, there is a sharing when I ask each person to point out the shape he or she has become and to lead all class members in making the sound (and movement). In these ways, class members come to see many shapes they would have missed while the entire group is drawn into the nativity which affirms diversity.

TEACHING TIPS

1. With all looking at the round Adoration of the Magi, lead the class members into the exercises of the Smithsonian method described in this chapter.

2. Then draw out the full diversity of persons in the painting by asking "Who is rich and who is poor?" and "Who are young and who are old and who are middle aged?" and "Who are male and who are female?" and "How many different styles of clothing are there and from what different countries?"

3. Then direct attention to the other two nativity paintings and ask how many varieties of age and race are evident.

4. Finally share the biblical texts noted in this chapter and discuss how the stories about Jesus' birth and ministry affirm the full diversity of humanity. As the Pharisees would have excluded the shepherds, what groups do we brand as sinners and try to exclude?

5. Discuss how the round painting expresses Mary's Magnificat: "He dethroned princes and lifted up the lowly." (Luke 1:52). The naked and ragged poor and even animals are elevated above many of the wealthy; and the Christ child and Mary are above the wealthy old wiseman who kneels. Note how the young black wiseman is above the older white wiseman in Cranach's work.

NOTES

[1]Jane Dillenberger, Style and Content in Christian Art, (New York: Crossroad, 1986 [1966]), p. 137; and Richard I. Abrams and Werner A. Hutchinson, An Illustrated Life of Jesus From The National Gallery Collection, (Nashville: Abington, 1982), p. 28.
[2]Kenneth E. Bailey, Poet and Peasant and Through Peasant Eyes, (Grand Rapids: Eerdmans, 1983), p. 147; and "The Second Shepherd Play" in The Wakefield Mystery Plays, edited by Martial Rose, (New York: Norton, 1969).
[3]Leo Steinberg, The Sexuality of Christ in Renaissance Art and in Modern Oblivion, (New York: Viking/Pantheon, 1983).

CHAPTER 28

INCARNATION AND RESURRECTION THROUGH MADONNA AND CHILD

Twentieth-century Swiss artist Paul Klee noted, "Art does not render the visible. Art renders visible."[1] In other words, art is not a snapshot showing us what is already easily seen or known; but instead, art helps us see more deeply what is not otherwise evident. Art helps us see and feel interrelations of complex theological perceptions which the logic of verbal forms may isolate or make remote. Art is particularly helpful in expressing the effects of the incarnation where the Word becomes flesh so that the Word does not become mere words.

Images of the Christ child without clothing indicate that he was the new humanity; for clothing was first needed after the fall. For example, the child John the Baptist is clothed while the Christ child is naked in Raphael Sanzio's The Alba Madonna (1508-1511; National Gallery of Art, Washington D.C., Fig. 83). This nakedness expresses the resurrection of creation to the condition God originally made. The raising of creation is symbolized by lifting the lowly poor to high positions on the upper left wall in the Fra Angelico and Fra Filippo The Adoration of the Magi discussed in chapter 27 where we saw Christ's nakedness reveals his affinity with the poor who appear with little or no clothing.

The nakedness of the Christ child reveals his full humanity. During the renaissance, the divinity of Christ was not at issue; but his humanity was doubted. To affirm Christ's full humanity that the Word had become flesh, renaissance artists developed what art historian Leo Steinberg identified as ostentatio genitalium. He cites 500 examples and reproduces 246 in his definitive book The Sexuality of Christ in Renaissance Art and Modern Oblivion.[2]

The interest of these images is not prurient but deeply theological. Often the child is held frontally so the genital area is obvious as in Raphael's work or Dürer's Madonna and Child (National Gallery of Art, Washington D.C., Fig. 84). In many other instances, the child pulls away his clothes, or even more commonly Mary pulls away the clothes or points to the area. In other works, a diaphanous material allows the viewer to see that part of Christ's body. In paintings with the three kings, one kneels to examine that area of Christ's body. Attention is drawn to the same area of Christ on the cross where an enhanced loincloth of great length billows up. This art affirms that Christ and we are made alike - so his resurrection gives us hope as in a stanza of "Christ the Lord is Risen Today": "Made like him, like him we rise. Ours the cross, the grave, the skies."[3]

The theological connection of incarnation and resurrection is visually emphasized not only through the naked Christ child's body but through other details as well. In Raphael's The Alba Madonna, the Christ child looks at a cross held aloft in his right hand; so the viewer is reminded of the crucifixion/resurrection event which lies ahead. Background details of hills or caves in many such works remind us of the child's future dying and rising. (Picturing the child born in a cave is another way for some art to connect his birth and death and resurrection by reminding us of that other cave in which he would be buried and from which he would rise.)

In later Baroque art such as El Greco's The Holy Family with Mary Magdalene (17th century; Cleveland Museum of Art, Fig. 85), details

are added so the viewer will understand more fully the meaning of Christ's birth in the context of resurrection. The presence of an adult Mary Magdalene at the birth of Christ reminds us of resurrection to which she was a witness. Her presence links his birth and rebirth.

In El Greco's work, other details reveal the birth of Christ as the new Adam who overcomes the fall and leads us to resurrection. As Adam was offered the fruit by Eve, now Mary offers fruit to the new Adam. Mary is often seen as the new Eve who undoes the original Eve's sin much as Christ undoes Adam's sin. In El Greco's time, figs were considered to be the fruit mentioned in the temptation story; and so figs are shown in art of the fall by many artists including Michelangelo. With her right hand on the Madonna's shoulder and her head close to the Madonna's own head, Mary Magdalene seems to counsel or encourage the Madonna in her offering of the fruit to the child. In such a position, the Magdalene reminds us of the snake's role in the temptation and fall; but as the snake was the witness of the fall, Mary Magdalene is witness to the resurrection.

Joseph presents a basket of figs to the Christ child; and as El Greco knew Greek customs well, we may discern in that presentation a further reference to resurrection. In the Greek drama competitions, the writer of the best tragedy received a goat; and the winner of the best comedy received a basket of figs and a jug of wine. Because of the resurrection, the Christian story is not a divine tragedy but in the words of Dante, The Divine Comedy.

TEACHING TIPS

1. Ask the students to identify each character in each painting.

2. Divide the class into sub-groups with one sub-group assigned to each character in the paintings. Have concordances (or xeroxed pages from a concordance) for each sub-group to use; and ask each sub-group to look up all the verses where their character encountered the Christ in the Bible.

3. Lead the students in a discussion of why each character is in the painting by having students report what they learned from the Bible about the characters' encounters with Christ.

4. Discuss what other Biblical characters (or characters or objects from history or our own contemporary times) they would include in such a nativity painting to communicate the significance of the incarnation to restore the world to the way God intends it to be. Then have the class work together to create one painting including all the characters they name. (The class may create it by paint or by collage from magazine photographs or some combination.)

5. Before, during, or after creating the art work, discuss why the Christ child is without clothing (with reference to Genesis 2:25-3:13) and how the Christ in the nativity is portrayed as the new Adam and brings resurrection instead of the fall (with reference to Romans 5:12-20).

NOTES

[1] Paul Klee's "Creative Credo" first appeared in German in Schopferische Konfession, ed. by Kasimir Edschmid, (Berlin: Erich Reiss, 1920), pp. 182-186. English translations vary widely; but an interesting one is Norbert Guterman's The Inward Vision: Drawings and Writings by Paul Klee, (New York: Abrams, 1959).

[2] Leo Steinberg, The Sexuality of Christ in Renaissance Art and in Modern Oblivion, (New York: Pantheon/October Book, Random House, 1983).

[3] For a critique of Steinberg's work from a woman's perspective, see Margaret Miles, "Nudity, Gender, and Religious Meaning in the Italian Renaissance," Art As Religious Studies, ed. by Doug Adams and Diane Apostolos-Cappadona, (New York: Crossroad, 1987)

CHAPTER 29

MAGNIFYING THE LOWLY
WITH AN EXPECTANT MADONNA

We would expect God to arrive at the most important place in the world such as the capitol city of the Roman Empire. If he were to be born instead at the edge of the Roman Empire in the small province of Israel, then he would surely be born in its capitol, Jerusalem. Instead he arrived in the small out-of-the-way village of Bethlehem. In an insignificant birthplace, God continued the Biblical story which usually chose the smallest or youngest child (Isaac not Ishmael, Jacob not Esau, Joseph and not any of his older brothers, Gideon and later David and not any of their older and stronger brothers.)

In the New Testament, God chose a lowly woman, Mary, to bear Jesus; and then Jesus called ordinary folk as followers who rarely understood his stories and teachings, denied him, and betrayed him. Thank God for the choosing of those as disciples, for if those lowly Old and New Testament people could be God's followers, then there is hope for us to be disciples too. If instead his disciples had been always faithful, insightful, and powerful, we might doubt our own possibilities to be disciples.

Similarly, Audrey Englert crafts her wooden sculptures in small sizes to empower those who experience them. In my interview with her, she described the effects of such sculpture:

> Making them smaller than life, I create figures in a size so a viewer can look at them, come to them, and take them up in his or her hands and say, "This is something that I can do too." I make it small to draw people into it.

I have noticed the same effect in working with hand puppets: a child finds the puppets are approachable because they are smaller than the child.

In creating her Expectant Madonna (Fig. 86), Audrey Englert chose a piece of redwood two feet tall, which is much larger than her usual carvings of a few inches; but the work is still easy to pick up and handle. Such a size requires the viewer to make a commitment in seeing the work, for, as she notes, "I work in small size so people have to get up close and cannot stand back uncommitted."

In holding the work, we become one with it; and we may remember that Mary symbolically represents the church and that we as the church become the body of Christ who is within her. Audrey Englert chose redwood, a common wood in California, because she thought the Madonna should be in a common low-cost wood rather than in a costly rare one. Mary's words in the Magnificat (Luke 1:46- 55) spoke of God who regarded "the low estate of his handmaiden" and "exalted those of low degree."

The piece of wood has been dated as 1007 years old; and the she carved the hair to follow the rings in the wood so that many years of age are evident in the hair. Chisel marks are intentional and obvious in the robe, while the hair is finer, and the face is the smoothest. The viewers are likely to be drawn to the highly tactile robe first, then their attention is caught by the hair and finally by the face, which appears relatively young. The work combines the old age of the wood with the youthful appearance of the Madonna's face. The sculpture combines the smoothness of the face with the roughness of the robe.

The expectant quality is enhanced by body positions, as Audrey Englert explains:

With her right hand on her stomach, she is feeling life. She is leaning forward conveying a sense of walking forward. I designed her to lean forward so she is not just a standing figure. She is a person who moves and is alive with the child in her body.

A Lutheran minister commissioned her to carve this work so he would have an expectant presence in his home to help him remember how Christ comes into the world - how a simple human being brings Christ to life.

Audrey Englert's Shepherd and Three Shepherdesses (Fig. 87) features four figures, each of which are five to six inches tall. Made of basswood from the linden tree, the figures were commissioned by a student at Pacific School of Religion so she could give one to each of the four United Methodist pastors who helped shepherd her into the ministry. The artist used body positions to reflect each pastor's way of encouraging the student. One shepherdess reaches out to offer help, while a second shepherdess clutches her hand to her breast to reach into her own heart to give to the student. The third shepherdess has her hands relaxed in front of her to suggest her satisfaction with what she and the student have accomplished. At the left, the tallest figure has his hands at his sides to indicate his confidence that the student is prepared for ministry and is ready to give service.

Audrey Englert holds a master's degree in clinical psychology at John Kennedy University as well as serving as faculty secretary at Pacific School of Religion. I asked how her counseling related to her carving. She noted how she draws out persons' perceptions about themselves and others when they ask her to do a carving. For example, the student who commissioned Shepherd and Three Shepherdesses had originally requested four shepherds as gifts for the pastors who had helped train her. It was in response to Audrey Englert's questions about who they were and how they had helped her that the imagery and symbolic gestures for Shepherd and Three Shepherdesses took shape.

Creating works related to Advent and Christmas began when Audrey Englert considered the possible uses of her Christmas tree, an object many people throw away after the Christmas season. She decided to carve a creche scene out of her tree and completed the figure of Joseph first. Over the years, she has also carved Celtic crosses, whales, and recently a Christa, a female crucified figure (Fig. 88). The Christa is only four inches tall and is designed to be worn around the neck.

Her Christa is unlike the female crucified forms crafted by others who usually stress the tortured life of women. Audrey Englert's work shows the suffering of women in the straining of the body; but she chose to carve the sculpture in aromatic cedar so that fragrance accentuates a positive feature she calls the aroma of Christ. She notes that cedar is often chosen to preserve our clothing. The fragrance in relation to the crucified figure is to remind us of the woman who bathed Christ's feet in fragrant and costly nard a week before his crucifixion (John 12:3). She notes that the fragrant wood for the sculpture of Christa "also depicts that through our suffering and through our process of healing, we can be among people and have that same aroma of Christ."

Asked how the Christa relates to her art's primary concern with Advent and Christmas, she responded that it is a gift to share our own past experiences of pain which we have worked through, as Henry Nouwen's concept of the wounded healer helps us understand. Christmas is not only the season of birth but also of the slaughter of the innocent children - one of whom Herod feared would displace him as king. New birth often is accompanied by pain. She elaborates the wounded healer aspect of her art:

> At Christmas time, we identify with the humanity of God, including its pain and suffering, as in the Christa - pain which we know is our own. Women have said, 'I have felt the pain you express here.' Then what we have to do is to go on and work through that pain and use what we learn as we work through it to help others. For ministers, it is a very important aspect of work to use what they have been through to help others move on through their own pain.

Christmas is a season when we give gifts. In

developing sculptures which grow out of life experiences, Audrey Englert creates art which helps people express their own stories and share them with others. Her art helps magnify those who are feeling lowly and has "exalted those of low degree."

TEACHING TIPS

1. Lead the students in taking the arm and hand positions of the shepherd and shepherdesses; and discuss how those positions express different ways of shepherding or helping others. Invite the students to devise their own additional body positions to express ways of helping.

2. Similarly lead the students in taking the body position of the Madonna and then other positions of their own to express their feelings when they are expecting something or someone.

3. Then create a Madonna and shepherds and other components of a creche either by bringing in wood and carving it with each person creating a different figure (or by creating figures out of soap or cardboard). Invite the students to create the figures so they use the arm and hand positions the students themselves used in the first two exercises.

EMBRACING TENSIONS BETWEEN GENERATIONS

The Christ child faces straight forward while Mary looks to her right in Henry Moore's dark sculpture <u>Madonna and Child</u> (1942; St. Matthew's Church, Northampton, England, Fig. 89). Her right hand on his shoulder and her left hand cupped under his left hand and arm would hold him back; but his chest expands forward while his diagonally placed legs and feet appear prominently poised to leap from her lap. His readiness to stand on his own and to move forward contrasts with her attempts to hold him back and to protect him.

Tension between mother and child in Henry Moore's sculpture resonates with the biblical stories where Mary and Jesus rarely see eye to eye. Even at twelve, he remained in Jerusalem and went to teach at the temple when his parents thought he was with them as they headed home. They anxiously searched for him for three days; and when they found him, they did not under-stand him. He then continued to live under their authority at home. (Luke 2:41-52)

As an adult, he was once told that his mother and brothers had arrived and wanted to speak with him; but instead of going to greet his family, he continued teaching others and said, "Who is my mother? Who are my brothers? ... Whoever does the will of my heavenly Father is my brother, my sister, my mother." (Matthew 12:46-50). At the marriage in Cana, Mary told Jesus that the wine supply had run out; but he responded by saying "What is that to me wom-an; my time has not yet come." (John 2:1-11) If my mother asked me to take out the garbage and I responded, "What is that to me woman, my time has not yet come," she might respond, "Your time is closer than you think!"

In contrast to the biblical stories and the Henry Moore sculpture, many art works show a Mary and Jesus who seem in perfect harmony. For instance, in the illuminated manuscript <u>Adoration of the Magi</u> (c.1240, Wurzburg School, Germany, Fig. 90) both mother and child look in the same direction; and the lines of their bodies are harmonious. Where did such harmony between mother and child enter into the art? The harmonious Madonna and child became most prominent in churches during the crusades when many male leaders left their lands under the temporary supervision of their wives who were raising their male heirs. To buttress the authority of the women and young male heirs in the civil state, the churches raised up more prominently and more frequently the image of the Madonna and child to whom the people should show reverence.

In some of the art works, the three kings are shown worshiping the mother and child. The oldest of the kings typically was shown kneeling to the woman and child as in <u>Adoration of the Magi</u>. That kneeling was a reminder to older nobles left at home that they should show obedi-ence to the regent queen (or duchess) and young heir apparent and not dominate them while the king (or duke) was away at the crusades or other affairs of state. Liturgical gestures reenforced civil authority as the viewers regularly genu-flected in the same way that the king kneels to the Madonna. The kneeling king offers up to her and the child a gift looking like a communion chalice; and the Madonna holds an object ap-pearing to be a communion wafer. As priests and bishops customarily raised the chalice and wafer, the art reminded them also to show

obedience to the authority of the queen and her child.

Toward the end of his life, Henry Moore created another Madonna and Child (St. Paul's, London, England, Fig. 91). While this white sculpture is abstract, the figures of Mary and the Christ show some dynamics similar to his earlier figurative work. In a diagonal shape, the child may be seen to thrust forward from her lower body. The upper half of that diagonal shape strains forward as did the child's chest in the earlier work.

The mother's shape seems to lean forward protectively over the child; so her concern for the child is evident as in the earlier work. But with no lower arms or hands, the mother in this recent work does not hold Christ back as she did in the earlier work. With care, she seems to observe his development but not restrain it.

In art, a linear shape is often associated with the male while a curved shape is associated with the female. Mary is sometimes a symbol for the church as the bride of Christ; and so Christ may be seen as emerging from her in nativities and merging into her in pietas as shown in chapter 6. In this abstract Henry Moore work, Christ may be seen both as emerging up and out from the mother and as merging down into her. In either case, we have a sense of impending new creation which embraces tensions between generations.

To help students explore their own relationships with their mothers as well as the dynamics of the Biblical relationships between Mary and Christ, I suggest using a method recently detailed by Jo Milgrom in her book Handmade Midrash: Workshops in Visual Theology (Philadelphia: Jewish Publication Society, 1992). The method may be used with any biblical story. For instance, in exploring Abraham's binding of Isaac, she details the method:

> participants are given assignments with specific instructions and materials: for example to interpret the binding of Isaac (Genesis 22) by tearing forms out of four sheets of colored construction paper without using scissors. In this case, the instructions are to represent Abraham, Isaac, the ram, the altar, and

the Divine Presence, gluing them in a relationship to a background sheet of paper. (page 10)

She allows twenty minutes for each of the students to create a collage. Then she has them share the meanings of their art. She asks them which shape was the easiest to make and which was the hardest. They are asked to describe the sizes, shapes and movements of the parts and how the parts relate to each other. Why did they choose the colors as they did for each character? Which lines in the Biblical story are most evident in the art work? How does the art work and biblical story also express aspects of the student's own life and relationships? She then has students write brief papers expanding on their responses to some of those questions.

Requiring the students to tear paper and not to use scissors make the students equal with little advantage from previous use of scissors. Also tearing of paper is appropriate to deal with rough edged relationships which characterize most biblical stories. As detailed in "Teaching Tips," adapt the Milgrom method to use it with the Biblical stories about the relationships between Mary and the Christ recounted earlier in this article.

TEACHING TIPS

1. With the students, read aloud the three Biblical accounts about Mary and Jesus noted in this chapter: Luke 2:41-52, Matthew 12:46-50, and John 2:1-11. Discuss the tensions in the relationships of Mary and Jesus evident in those stories and in the art works accompanying this chapter.

2. With plenty of paper in four different colors, ask each of the students to tear pieces of paper to create a collage based on one of the biblical stories using one color of their choice for Mary, another color for Jesus, and a third color and a fourth color for other characters in the story each student chooses (persons Jesus taught at the Temple and Joseph in the first story; people Jesus was teaching and Jesus' brothers in the second story; and servants and disciples at the wedding in the third story). Tell them they have twenty minutes to create their separate collages by tearing colored pieces of

paper and gluing them on a large piece of white background paper given to each student. On the background paper, the torn pieces may be glued flat or in three dimensional shapes.

3. Use questions detailed in this chapter as you ask students to talk about the meaning of the shapes and sizes and relationships of the pieces of paper in their collages.

4. Additional insights occur when doing this experience with an intergenerational group.

CHAPTER 31

TRANSCENDENCE WITH THE HUMAN BODY IN DE STAEBLER'S SCULPTURE

The human body is reemerging with increasing frequency in the painting and sculpture of the last thirty years as artists such as Stephen De Staebler create works affirming the human body as the medium to experience and express transcendence - a sense of the other which makes us aware that we are finite. Similarly in other arts, we sense more often the human voice in music, first person speech in poetry, and personal narrative in novels.

Much abstract expressionist art eliminated the overt human form along with most subject matter in the art of the 1940's and 1950's and advocated such abstraction as the only way to transcendence. Although there were residual references to the body in the verticality and human dimensions of some abstract expressionist art, Stephen De Staebler has reasserted that the spiritual comes through the imaging of the human body in art.

In approaching Advent and the celebration of incarnation, we use a kinesthetic teaching method to experience the spiritual through visual art works by Stephen De Staebler. This method may aid teaching with any painting or sculpture featuring the human form so that our religious studies become informed by the visual arts.

Stephen De Staebler's sculptures rarely deal with Biblical characters. Exceptions are his Crucifix (1968; Newman Center Chapel, Berkeley, Fig. 92) and his Pietà (Fig. 19) discussed in chapter 6. His works resonate, however, with Biblical faiths' concerns for the individual human body. He notes, "These religious concerns are not what make me a figurative artist, but they do help me to rationalize the validity of dealing with figurative forms."[1]

He has long maintained a tension between separateness and fusion. His works avoid an idealization of a whole human form and instead affirm a transcendence through fragmented bodies which frontally engage us. Such an assemblage of fragments asserts that the human being is "not a whole or a unity but an idiosyncratic bundle of contradictions."[2]

When students sit in his many stoneware clay chairs entitled Seating Environment (1970; Lower Lobby, University Art Museum, Berkeley), each finds one chair that best fits his or her own body. These seats are highly individuated places and not as similar as they first appear. Students report that their own different body shapes feel affirmed by the experience of finding a fitting chair. That affirmation is especially appreciated by those students whose bodies would not win them awards in our culture.

His sculptures of the human body have similar effects. As the sculptures are made up of fragments without fully articulated limbs, the kinesthetic method concentrates on taking the pose of a form which is often seated. While looking at the bronze Seated Woman with Oval Head (1981; long term loan to Pacific School of Religion, Berkeley, Fig. 93), we sit on the edge of desk tops or counters so that the lower legs hang straight down from the thighs which are slanted down at a 45 degree angle. Our feet are flexed with toes pointing toward the ground as the left foot appears in front. We hold torsos and heads erect facing straight forward. This frontal presentation evokes a sense of transcendence and reminds us of similar confrontations we have had in seeing and being seen by the figures of Christ and others in Byzantine churches such as

the Pantocrator (Fig. 16) shown in chapter 5.

This is not an easy position to maintain as students become aware of a precarious balance. For example, one ballet dancer reported that her upper torso, head, and feet felt like she was on point, although her legs defied that feeling. If we lean forward, we feel we will fall. The figure is as far forward as is possible without falling.

In that position, students feel a sense of dignity. This kinesthetic knowledge contrasts with their initial thought about the sculpture which had appeared relaxed or hopelessly shattered. The lack of arms adds to the sense of dignity and historic worth as the work resonates with our memory of much surviving classical art. In other respects, De Staebler's work is very different from such classical sculpture as two students observed.

These two permanently disabled students reported that they felt profoundly affirmed by De Staebler's sculpture with its fragmented legs, no arms, and fragile balance. For them, this art work expresses the condition of bodily brokenness not to decry some larger issue (as many artists have used the broken body to protest warfare or poverty) but to affirm deeply the individual's worth. In contrast, their experience of classical sculpture had made them feel hopelessly inadequate as their bodies could never measure up to those classical shapes.

In using the kinesthetic approach to Seated Man With Winged Head (1981; long term loan to Pacific School of Religion, Berkeley, Fig. 94), males in the class expressed a sense of relief and well-being at modelling themselves after a body that was not too broad chested or muscular. In contrast, before classical sculptures, these same males had felt impoverished; but before this De Staebler sculpture, they felt well endowed. The genitals of the male sculpture are evident without idealization as were the breasts of the woman in the other sculpture.

These works resonate with a Biblical faith that reveals God and reconciles the world to God through Jesus who is born in Bethlehem instead of Jerusalem, who enters Jerusalem on as ass rather than in a chariot of fire, who tells unresolved stories about ambiguous often unethical characters instead of famous moral leaders,

and who dies on a cross abandoned by his disciples rather than in comfort adored by everyone.[3]

TEACHING TIPS

1. Ask students to compare how they feel and act in the presence of the following: a person who is tall and powerful, a person who is small and weak, a baby, a wounded person, a disabled person, a person who confronts you.

2. In many Biblical stories, God chooses the younger or youngest child (and the smaller or weaker) so that God's presence is evident in what he or she does. In what moments of your life have you felt God's presence most strongly?

3. At the Christmas season, we are drawn together around a baby born in an obscure place; and at Easter season, Paul says that God was in Christ on the cross reconciling the world to God's self (Romans 5:10). In our relationships, how do we draw others together or effect reconciliation?

NOTES

[1]Stephen De Staebler and Diane Apostolos-Cappadona, "Reflections on Art and the Spirit: A Conversation," Art, Creativity, and the Sacred, ed. Diane Apostolos-Cappadona (New York: Crossroad, 1984), p. 30.

[2]Ted Lindberg, Stephen De Staebler, (Art Museum Association of America, 1983), p. 8.

[3]Additional insights on these and many other De Staebler art works are available in chapter 3 of Doug Adams' Transcendence with the Human Body in Art which is based on my interviews with artists such as Stephen De Staebler, George Segal, Christo and others.

CHAPTER 32

BAPTIZING WITH CHRIST AND TURNING THE WORLD AROUND

As we turn from the old year to the new year in January, the church traditionally celebrates the baptism of Jesus. Art portraying John the Baptist and the baptism of Jesus depicts the central figures in the act of turning around. Such turning is appropriate for at least two reasons. Repentance is associated with baptism; and repentance means a turning away from sin and toward new life. Further, baptism recalls the Exodus experience of passing through the waters from slavery to freedom in the Hebrew Scriptures. In many passages of the Gospels of Matthew and Mark, Jesus becomes the new Moses.

The Gospels identify Jesus as the new Moses through a series of allusions to the Old Testament. At Jesus' birth, the male children are slaughtered by the political ruler, King Herod, (Matthew 2:16) as the male children of Moses' day were slaughtered by Pharaoh. Later, Jesus stilled a great body of water so the people could pass peacefully in boats from one land to another (Matthew 8:23-27 and Mark 4:35-41) as Moses had parted the sea waters so the people could pass. In the presence of Jesus, the demons went into the pigs and were drowned (Matthew 8:28-34 and Mark 5:1-13) just as Moses had made the waters drown Pharaoh's army. (So no one would miss the correlation, Mark 5:9 noted the demons' name was "legion" reminding us of troops such as Pharaoh's army.) After crossing the waters, Jesus fed the five thousand in the wilderness (Matthew 14:16-21 and Mark 6:37-44) as Moses fed the multitudes in the wilderness. There are other parallels including teachings presented from a mountain with Jesus' sermon on the mount and Moses' presentation of the ten commandments to those gathered at Mt.

Sinai.[1]

Our attention in this chapter focuses primarily on helping students to experience movement of the art with baptism or water imagery drawn from the New Testament and to reveal the connection of such movement with the turning from slavery to freedom in the Exodus of the Hebrew scriptures. In Auguste Rodin's life-sized sculpture St. John the Baptist Preaching (1878; Legion of Honor Museum, San Francisco, Fig. 95), we see a figure known for calling the people out of the cities and into the wilderness (Matthew 3:1-6 and Mark 1:1-6) much as Moses called the people out of their settlement in Egypt and into wilderness. However, John makes it clear that another more significant leader will take his place (Matthew 3:11-12 and Mark 1:7-8).

As I led students to replicate the body positions of Rodin's St. John the Baptist Preaching, they were surprised to discover that he was positively calling them to turn rather than negatively accusing them. On first view, they thought his extended right arm was chastizing them; but on replicating the body positions, they found the index finger of the right hand was not pointing at them accusingly but rather was curling back toward himself bidding them to come closer. The bent right elbow lessened any aggressive feeling compared to how one would feel if one's right arm were extended straight out with no bend at the elbow. I shared with students that the uplifted right hand and the downturned left hand helps us to see John as prefiguring Jesus; for in many representations of the resurrected Jesus in Last Judgment scenes, he raises a right hand toward the saved and lowers a left hand

toward the damned as shown in chapter 10.

As they position their legs in John's stance, students report that his forward right foot is turned slightly inward toward the left. This position reduces any aggressive sense compared to how it would feel to have the right foot pointed straight forward or turned slightly outward to the right. Such a positioning of the right foot gives the students a sense of turning to the left. The turn of the head away from the right hand adds to this sense of turning. The movement from the figure's right to left is further emphasized visually as his left shoulder is higher than his right shoulder. Positioned in these ways, students feel more weight on their left foot than on their right foot. Those who have been either dancing or boxing note that such positioning prevents the figure from falling forward or from being easily knocked out by any blow. (If weight were primarily on the forward right foot, then a punch would have greater force; but with the weight on the receding left foot, the figure may reduce the force from any blow by moving back from it more quickly.) The weight on the left leg also contributes to a sense of the figure turning and bidding us to follow whereas weight on the right foot would have made the figure appear to come after the viewer. These dynamics provide opportunities to discuss the difference between calling people to faith and coercing or compelling others. Rodin's John the Baptist prefigures how Jesus calls but does not compel.

Having students work in pairs helps them sense the dynamics in The Baptism of Christ by the Venetian Paris Bordonne (16th century; National Gallery of Art, Washington D.C., Fig. 96). Both the figures are turning. At the right, John the Baptist appears to be in a position reminiscent of a discus thrower more than half way through his spin in a counterclockwise direction. His right hand holds not a discus but instead a small inverted dish so the water rains down on the head of Jesus. If John continues moving in the counterclockwise direction, his attention will move away from Jesus. At the center of the painting, Jesus has his back turned to John and his hands raised in prayer before his own body. Only by the temporary turn of his head somewhat toward John does Jesus delay moving away from the one who baptizes him. (If the viewer covers the head of Jesus, he or she will see clearly where the body is moving.) The implied movement away from each other prefigures John's later question whether Jesus is the Messiah (Matthew 11:2-3 and Luke 7:18-20) and Jesus' ironic comment about John's importance (Matthew 11:11 and Luke 7:28).[2]

The position of Jesus is reminiscent of a priest at the altar with hands raised in prayer and the head turned down to his left side to read the liturgical text. The angel to Jesus' right holds Jesus' outer garment much as an assistant holds the chasuble which the priest puts on after the sermon but before communion.

The whole class may together replicate the figures in Christ on the Lake of Gennesaret (19th century; Metropolitan Museum of Art, New York, Fig. 97) by French artist Eugene Delacroix. While the coloration of the other figures' garments stand out over against the water and the land, the green color of Jesus' garments is in continuity with the color of the lake and the mountain. He is at one with nature while the disciples seem at odds with nature and each other. The boat moves in a dynamic diagonal direction in line with the diagonal direction of Jesus' body in the bow. The boat moves away from us and so makes us realize that we must be moving also if we are to follow Jesus.

TEACHING TIPS

1. With each of the works, lead the class members to replicate the body positions, to discover the turning movements, and to discuss the movements' meanings in the students' own lives and in this chapter.

2. Read together or summarize the biblical episodes relating the stories of Moses and Jesus cited in this chapter.

3. Discuss how baptism and Exodus are related with respect to turning from slavery to freedom; and lead students to share what they find to be the slaveries and freedoms in their own lives.

4. After pairs of students replicate Bordone's The Baptism of Christ, discuss the differences between the directions of Jesus' and John's

ministries with reference to Jesus' comments in Matthew 11:16-19 or Luke 7:31-35.

NOTES

[1]For more parallels between Jesus and Moses, see Edward Hobbs' doctoral dissertation, The Gospel of Mark and the Exodus, University of Chicago, 1958.

[2]Bordone's painting is especially appropriate for study as we leave the old year and begin the new year; for "If John the Baptist represented the death of the old era in preparation for the new, Jesus represented the birth of the new" Conrad Hyers, And God Created Laughter: The Bible as Divine Comedy (Atlanta: John Knox, 1987), p. 29.

SEEING DEVELOPMENTAL STAGES IN COLE'S "VOYAGE OF LIFE"

Thomas Cole reveals developmental stages of the individual and the nation in the most popular painting series of nineteenth-century America, Voyage of Life (1842; National Gallery of Art, Washington D.C., Figs. 98, 99, 100, 101). When the United States' population barely exceeded seventeen million people, over half-a-million viewed this series of four paintings on tour. Cole's four individual canvases in the series were entitled "Childhood," "Youth," "Manhood," and "Old Age."

Cole's earlier efforts toward what he described as "a higher style of landscape" were St. John the Baptist Preaching in the Wilderness, The Expulsion (from the Garden of Eden), and Moses on the Mount. In each of these works, he puts humans in their places, as Jane Dillenberger has noted:

> Even the last of the prophets, John the Baptist, and Moses, the greatest of the prophets, are reduced in their canvases to gesticulating pygmy-like figures, whose mighty words and acts are belittled by the expanses of mountainous settings.[1]

When a human figure first looms large on one of Cole's canvases, it is not a moment of human triumph but rather the slain body of The Dead Abel (1832) to stress the destructive sinfulness of humanity. Biblical background helps the viewer understand the social commentary implicit in those paintings. Moses and John the Baptist called the people out of the cities and into the wilderness for renewal. Being at home in nature (Eden) was lost by Adam and Eve's violation of the tree which was to be left untouched; and Abel's murderer, Cain, was the biblical founder of cities.

Shortly after painting the Voyage of Life series, Cole painted Angels Ministering to Christ in the Wilderness (1843). The canvas was later cut in two parts; but when put back together, it shows a small shadowy figure hurrying down a mountain and away from Christ and angels who radiate light. That shadowy figure is the devil whose temptations Christ has rejected. Cole's Lord rejected the temptation for earthly kingdoms, even if Cole's countrymen did not. While John L. O'Sullivan did not write of "manifest destiny" until 1845 in his New York Morning News (and the United States did not fight the climactic war with Mexico until the following year), Texas had been taken from Mexico in 1835; and other aspects of American expansion were evident throughout the continent. Cole's Course of Empire series (1835-1836) as well as the Voyage of Life reveal the folly of such a quest for empire.[2]

The Voyage of Life series portrays the stages of human development. In Childhood, the immediacy of experience is impressed on the viewer by the river which flows peacefully from left to right across the delightful flower-strewn foreground. In the middle of the boat, a little baby unselfconsciously delights in the pleasurable objects at hand while an angel at the rear of the boat looks after him. The baby seems unaware of anything beyond his immediate grasp; and the colorful flowers and flow of the river prevent the viewer from looking far into the horizon.

In Youth, the young man takes the helm

himself and looks far away toward visions of empire on the horizon. Leaving the angel on the shore, he is accompanied only by the wooden figurehead extending upward from the boat's bow. In the figurehead's uplifted hands is an hour glass with plenty of time remaining. The river seems to go straight back toward the vision of empires above the horizon. Engravings of this painting were the most popular of the series in our growing young independent country. Hough's engraving eliminated all doubt as to the possible realization of the Youth's dreams of empire for the artist drew the river straight to the land below the buildings in the sky (Fig. 102). The youth shows no sign of critical self-reflection and is concerned only with earthly accomplishments.

In Manhood, however, we see the river did not flow smoothly back to the horizon but took a precipitous turn so the helmsman now faces threatening rapids in a rocky ravine. With his helm destroyed, he is at the mercy of forces beyond his control. He looks imploringly toward heaven. The visions of empire in the sky have been replaced by demons which Cole called "Suicide, Intemperance, and Murder."[3] The immediacy of the man's situation is impressed on the viewer as the river sweeps from left to right across the foreground of the canvas. Because neither the man in the painting nor we as viewers of the art see what is coming next and are surprised, we become acutely aware of human limits and our finitude - we are not in control but are creatures and not the Creator.

In Old Age, the hour glass is gone; but the angel has returned near the boat. The old man's attention and our attention are drawn far beyond ourselves toward angelic light in the sky. The river has emptied into a vast peaceful sea which stretches out in all directions.

Through the Voyage of Life, we experience the shifts from childhood's awareness of only immediate objects to youth's simplistic dreams of infinite accomplishments to manhood's self-awareness of finitude in crises to old age's broad perspectives. We see childhood's unconscious dependence, youth's illusionary independence, manhood's consciousness of other forces beyond his control, and old age's awareness of

dependence.

Thomas Cole's environmental concerns are also evident in his paintings. The dangers of aspirations to build kingdoms are revealed when a person fails to foresee the direction of the river and also loses control of the boat. Rather than self-confidently turning our backs on our better angels, we may recognize our need for help and look beyond ourselves.

TEACHING TIPS

1. Ask students to list where their attention is drawn to in each painting by the different directions of the river and by where the person in the boat is looking.

2. Ask students to list what the person in the boat is aware of in each painting. Then ask them to list what the person is unaware of in each painting.

3. Discuss how those different awarenesses and lack of awarenesses are associated with a person's different developmental stages.

4. Read the account of Christ's temptations from either Luke 4:1-13 or Matthew 4:1-14 and discuss the dangers of the aspirations for empire in Cole's paintings and in our country's history. How do Cole's insights into our finitude reveal sources of our environmental problems?

NOTES

[1]Jane Dillenberger, The Hand and the Spirit: Visual Art and Religion In America, 1700 to 1900, (Berkeley: University of California Art Museum, 1972), p. 105.
[2]Doug Adams, "Environmental Concern and Ironic Views of American Expansionism Portrayed in Thomas Cole's Religious Paintings" in Cry of the Environment: Rebuilding the Christian Creation Tradition, ed. Philip Joranson and Ken Butigan, (Sante Fe: Bear and Company, 1984), pp. 296-305 and 469-476.
[3]Ibid., p. 299.

CHANGING THE WORLD THROUGH HUMOROUS LAST JUDGMENTS

Jews celebrate Yom Kippur (the day of atonement) in the early autumn; and Christians and others celebrate Halloween (the end of the year in the old English Druid calendar) on October 31. In agricultural societies, the year ended after the harvests as death seemed to settle over the land. The figure of death appeared in the end-of-year celebrations to mock those who took too seriously the trappings of life as if they would last forever. These celebrations are opportunities to help our students design costume parties which lead us to laugh at our idolatries and understand that idols are what we take too seriously or that at which we cannot otherwise laugh. Such costume parties may take their cues from the humor of last judgments and other late medieval art just as such art reflects the liturgical dramas of that day.

Halloween costume parties continue earlier imagery such as the skeletal figure from the Dance of Death who appears to surprise others. In continental Europe, such figures appear in Mardi Gras (Fat Tuesday) celebrations which were the end of the old year on the old Roman calendar when March was the first month of the year; and Christians developed the Dance of Death, the Feast of Fools and other humorous festivals during January and February to lay low those who had grown too great with powers. Lent which starts on Ash Wednesday then begins the new year a little freer of such powers. Most parts of the United States follow England where humorous imagery and pranks occurred at Halloween.

The skeletal Dance of Death figure shows us our future condition when we would rather think of ourselves as immortal. In an early version,

three elegantly clad knights go riding off but then return as three skeletons. Another treatment of the Dance of Death, preserved in Marchant's faithful copies of the Innocents' church yard murals, revealed this humorous incongruity between a person's aspiration and his or her end (Fig. 103). To the left, a scholar gazes off to the stars with thoughts of eternal truths; but a skeletal figure, symbolic of his future, takes him by the arm and carries a shovel pointing to the earth where in truth his body will spend eternity. To the right, a well-dressed figure with elaborate hair and hat faces a skeletal figure whose baldness and nakedness remind us how passing are our hair and clothing on which we spend so much time and money.[1]

Additional humorous devices of medieval dramas used in churches are evident in the visual art. A wonderful visual pun by Giotto pokes fun at a steward who has clearly spent too much time drinking and eating; for the steward's belly has the same shape as the large wine vessels in the foreground of this detail from The Marriage at Cana, (1303/1305; the Scrovegni Chapel, often called Arena Chapel, Padua, Fig. 104).

Others who have grown too great with power are mocked in the Last Judgment scenes over the entrances of many churches. In the Last Judgment (Princes' Portal, Bamberg, Fig. 105) many wearing crowns (and one with a bishop's mitre) are led off to hell to our right; and the saved to our left move toward Christ at the center. The one king who makes it into heaven is Charlemagne; but at our far left, he barely makes it into the scene. Note that his hand is taken by a person who led him to build a

church.

Humor comes from placing in hell in undignified ways those persons whose easily identified costumes reveal them to be kings and bishops whom we usually treat with near reverence. In a detail of a Last Judgment (west front central porch, Notre Dame, Paris, Fig. 106) a gleeful devil squats on top of a bishop and a king with the king on the bottom of the heap. Such art resonates with the spirit of Mary's Magnificat from Luke 1:52: "He has put down the mighty from their thrones, and exalted those of low degree." The costumes in liturgical dramas paralleled this artistic satire; for costumes were drawn from churches' treasuries of robes and accessories which bishops and royalty sometimes wore. Those going to hell or those judging and mocking Christ were thus dressed in ways which linked Pharisees to contemporary priests and linked Pilate to the king.

Kings did not always smile at such art. In England, the last judgment (which became known as the "Doom Painting") was often portrayed by visual art inside the church (South Leigh, Oxfordshire, Fig. 107). In the midst of church and state conflicts, those doom paintings showed the Catholic side of the controversy with many kings and queens populating hell (with few bishops below); but nobility were not so obviously in heaven. After Henry VIII had subdued the church, these scenes (belittling the kings) were ordered whitewashed during Edward VI's reign (1547-1553). Ironically, the very operation designed to destroy the paintings proved to be the means of their preservation; for sun light would have long ago faded these frescoes. In this century, the white wash has been removed so the Doom Paintings are visible once again.

Those with swelling authority and aspirations were often treated with humor. The power of the monks and women increased when kings and dukes were away at wars, so an artist in the late thirteenth century (Fig. 108) pictured a woman and a Dominican jousting. However, the Dominican's lance is not up to the occasion as the woman evidently will win in such a conflict. We may consider who are our authorities and what are our swelling aspirations which may

need a little humor to keep them in proper perspective so they do not become idols. Pictures of such authorities and symbols of such aspirations could be clipped out of magazines and newspapers by class members and assembled in a contemporary Last Judgment

TEACHING TIPS

1. In planning a Halloween party with your class, first share the origin and function of the skeletal figure and the other humorous devices in the art discussed in this chapter. Discuss how the art resonates with passages such as Luke 1:52 and Psalm 2 (where God laughs at those earthly kings who have grown too great and wish to throw off their bonds to God).

2. Discuss how humor identifies and lays low idolatries in our lives as those things we take too seriously (what we give our time and thought to and what we cannot laugh at). Help students locate symbols of their own idolatries in magazines and newspapers and create a collage as a contemporary Last Judgment.

3. Have each student pick out his or her own main idolatry and think about what costume (and props) he or she could assemble in such an outlandish way as to help evoke laughter at that idolatry. For example, one student came weighed down with all the outfits and equipment needed to pursue his favorite sports: one foot in a snow ski and another in a rubber flipper from scuba diving, one hand in a bowling ball and the other grappling to hold onto a tennis racket and a football and a basketball! His head was topped with a football helmet, snorkle, and snow goggles. Another person came as her house with the address stenciled on her forehead, a pitched roof as a hat, and twigs from the backyard in her hands. One person came as all musical instruments and music books and music stands and carrying cases. Another came with the banners and buttons and placards of favorite causes. One came as money (wrapped in simulated Visa cards and Mastercards and dollar bills). Another came as his pet dog (and all the feeding and cleaning and housing paraphernalia and magazines connected with raising a pet along with a large paper flea). One came as a huge telephone and another as her social calendar (with pages

from the calendar stuck into her glasses like blinders; for she said that she never allowed herself to see anyone not on the calendar).

4. Have the students come to class in their costumes for the Halloween party and then have each person share about his or her idolatry with reference to the costume and props they have brought with them. Take Polaroid snapshots of the costumes and props and put them together in a last judgment art work to lay low the idolatries. (The teacher needs to come as his or her idolatry and be as involved as the students.)

NOTES

[1]Doug Adams and Diane Apostolos-Cappadona, ed., Dance As Religious Studies, (New York: Crossroad, 1990).

[2]Andrew Ladis, "The Legend of Giotto's Wit and the Arena Chapel," The Art Bulletin, L/VIII, 4 (December 1986), pp. 581-595.

CHAPTER 35

EMBRACING THE PRODIGAL IN EACH OF US

Which of the art works accompanying this article best expresses the Biblical account in Luke 15: 11-32? Verse twenty says, "But while he was yet at a distance, his father saw him and had compassion, and ran and embraced him and kissed him." Leonard Baskin's The Prodigal (1990; Fig. 109) shows the two standing figures with the father wrapping his arms around his son to hold him close and kiss his head. We see clearly the father's face and hands; but we see little of the son except his back and bare feet as attention is on what the father is doing. In contrast, a popular nineteenth century American lithograph, The Return of the Prodigal (1846-1847; Kellogg Company, Hartford, Connecticut, Fig. 110) shows the son on his knees reaching out to the father who does not touch him. That father acts like a Victorian father who lectures his son but does not embrace him much less kiss him. In that lithograph, we see both figures in profile with the son's actions more dramatic and so the focus of attention. Rembrandt's The Return of the Prodigal (1668-1669; Hermitage, St. Petersburg, Fig. 111) shows the son on his knees before the father who bends tenderly to embrace him with the father's hands on the son's back in a gesture of blessing. Our attention is on the father whose face and hands are toward us while we see the son's back and only part of his face.

In chapter 19, we see that George Segal (Fig. 113) has portrayed Abraham's hands on Ishmael's back similarly to the father's hands on the son's back in Rembrandt's work (Fig. 112). The figure's right hand is finely detailed while the left hand is more roughly expressive.In The Road To Daybreak, Henri Nouwen associates those different hands with feminine and masculine responses which the father compassionately combines.

The parable does not say the son was on his knees. In fact, a close reading of the story reveals that his character makes it unlikely he would be on his knees in genuine repentance. In the Bible, the father clearly initiates forgiveness before the son has had a chance to say anything including the self-serving speech he has prepared to get food. The kneeling by the son in the Kellogg art work (but not in the Biblical parable) would lead the viewer to think the son is prayerfully repentant and would lead us to think that repentance comes before forgiveness. That the nineteenth century art work stresses the son's action more than the father's action is connected to the emphasis on repentance and conversion in the first half of that century, a period historians call "the second great awakening." Rembrandt's period was much closer to the Reformation when God's graceful action toward us was stressed as the basis of any of our responses such as repentance or good works. Martin Luther stressed "justification by faith through grace"; but by the nineteenth century, American preachers often stressed "justification by faith" emphasizing our action of faith with less notice given to God's action of grace.

Read over the parable carefully with your students and discuss what each sentence reveals about the characters and where any of the character traits may be evident in the art works. In the last part of the first sentence (verse 12), the younger son says to the father, "Father, give me the share of the property that falls to me." Ask students to say what their fathers would say to them if they said that line to their fathers. To realize what an insulting line that is, remind them that normally property would come to the son when the father is dead; so, the younger son,

is treating his father as dead as if he said, "You are dead to me old man, give me the inheritance." Without asking the son why he wants property, the father then divides his living between the two sons; and so, the father is left with no property (an important fact to remember to understand developments at the end of the story)

Later in a foreign land, the son loses everything in loose living. The story does not say what kind of loose living it was. It could have been simply spending or investing unwisely. People tend to think it was wine, women, and song; but the story does not give details. Toward the story's end, the elder brother says it was harlots; but we will see that he has lied twice by that time and was angry because the father took back the younger brother. Ask students how many of them are elder brothers and then how many of them have elder brothers. They will understand why the elder brother said that; for elder brothers often try to put younger brothers in the worst possible light even by lying about them. Toward the beginning of the story, one knows much about the elder brother precisely because he has not yet done anything, except receive part of the property. He should have acted to reconcile the family as the elder brother is in charge of bringing about harmony in a Jewish family. He should have tried to bring the younger brother and father together and to keep the son from leaving home; but he did nothing and so failed in his responsibility as elder brother.

In several ways the art works show the younger son's loss. Baskin's work portrays him without shoes and in bare feet. The Kellogg work shows him in a coat with holes in it. The Rembrandt work shows him with no robe whereas the father and others wear robes. The younger son's loss is so complete that in verse fifteen he "joins himself to one of the citizens" in the foreign country. To "join himself" to another is to act as if his family were dead and to take a new family (so he treats his father as dead a second time); but the new family does not treat him well and sends him into the fields to feed the swine which would be as low as you can get in the minds of Jewish listeners to the story.

The story emphasizes his hunger in verse sixteen. Then in verse seventeen, it says "when he came to himself" which is often misinterpreted as repentance; but to come to yourself is simply to get an idea. It could be a good idea or a bad idea. In this case, his thought is a selfish one of how to get food: "when he came to himself, he said, 'How many of my father's hired servants have bread enough to spare, but I perish here with hunger!'" Notice his thought is of getting food and not making his father feel better. He plans a speech which reveals his concern remains getting food. When he came to himself, he thought how the father's hired servants have bread enough to spare; so, he will go to the father and say, "treat me as one of the hired servants" which means "give me food." Of course he will preface this clever indirect plea for food by buttering up the old man in saying "Father" to the man he has twice treated as dead and saying he has sinned against heaven (as if he has thoughts of God, which were not in his mind when he came to himself). Note that in the art works by Rembrandt and Baskin there is little or no attention to the face of the younger son, so his motivations are hidden as cleverly as he tries to hide them in his speech; but in the Kellogg work, there is focus on the son's face which is detailed in profile at the center of the art. Is the son truly sorry? The Kellogg work gives us some evidence to argue that matter while the other art works focus on the father's love instead and ignore whatever might be the motivations of the son. We do note in the story that once he has been embraced by the father, the son never gives the last part of the speech he had planned: he never says "treat me as one of the hired servants." He throws that part of the speech away for he is getting the fatted calf without having to become a servant.

Notice what else he does not say: this younger brother never says thank you to the father. We do not see him again. He is in the party for the last third of the parable even when the father has left the party to ask the elder brother to come into the house. If the younger brother were really repentant might he not have noticed the father had left the party and might he not have gone out to the courtyard to find

him? If the younger brother were truly repentant might he not have cared enough to invite the elder brother to the party. Note that the elder brother was unaware there was a party. He never received an invitation; for he is surprised there is music and dancing and asks what is the meaning of this. (Most scholars note that music and dancing came during or after dinner.)

The servant tells him about the fatted calf but neglects to mention the robe and ring. Who properly owns that fatted calf and robe and ring? They belonged to the elder brother for the father had divided his living between them; and the younger son had lost everything. (Some scholars note the ring may be the family seal conveying control of all the property.) Little wonder the elder brother is angry! He then lies twice. When the father pleads with him to come into the party, the elder son says at verse twenty-nine, "Low these many years I have served you, and I have never disobeyed your command." Yet in truth, he just disobeyed the father's plea that he come into the dinner. Then the elder son adds another lie as he says to the father, "You never gave me a kid, that I might make merry with my friends." In fact, the father had given him that very fatted calf and many more. The fact he did not choose to use it for a party for his friends was his own business; but it was untrue to say "You never gave me a kid."

The story ends without an ending with them arguing in the courtyard. Most parables end in this way as cliff hangers. With no endings there are no final judgments; and any of the characters could change. Each of the art works leave open the question of what will happen next.

TEACHING TIPS

1. Ask students to note differences in the art works and which best reflects the parable in Luke 15:11-32 and especially verse twenty.

2. Discuss aspects of each character revealed in each line of the parable and each art work as this chapter details; and have students imagine several different endings they could write or paint to complete this parable.

3. After giving them time to write or paint the endings they have imagined, lead them in discussing each student's creation.

CHAPTER 36

MAKING SPACE FOR FAITH

Making space for faith and sharing faith require being open to the unknown rather than clinging to what is already known. "Now faith is the substance of things hoped for, the evidence of things not seen." (Hebrews 11:1) What is not seen in art is called negative space which like the silences in music is the space not filled. In the works of artists such as Stephen De Staebler and Tomàs Fernàndez, we see how such spaces help us grow in relation to the art and the world beyond us.

Negative space in De Staebler's <u>Archangel</u> (1987; private collection, Fig. 114) draws our attention to the incomplete lower body where one leg is absent and the other incomplete. The old body falls away. Above the shoulder rises a concave form which could be a flame or a wing or an as yet unknown transformation. Like the empty tomb at the resurrection or the abandoned shell of the caterpillar, such concave negative spaces witness to the emergence of a new being.

De Staebler shares how incomplete forms develop empathy between the viewer and the art and among viewers:

It helps bridge the gulf when the other person or the image in art is less complete. I think everyone feels inadequacies, incompleteness; and of course the worst of society is trying to pretend you do not have these limitations, violating, possibly irreparably, your own uniqueness, which is largely a factor of incompleteness. We are who we are not so much because of what we have or are endowed with but because of what we are not endowed with. To have an image which is less than fully endowed is a basis for empathy, but not easy to accept if the person who is the viewer

wants to deny that he has any limitations. Its like saying, O.K., we can have a dialogue if we agree we both have limitations. ...That is really the basis of mature interpersonal relationships.[1]

De Staebler's comments resonate with Biblical faith sharing which concentrates on how often the disciples and other Biblical characters did not obey or did not understand. If they had been perfect, we could not image that we could be disciples; but when disciples are like Peter with all his failings, then any of us may be disciples. So, in faith sharing, we reveal our own weaknesses rather than our strengths; as Paul enjoins "I will not boast except of my weaknesses." (II Corinthians 12:5) and gives us an autobiography exactly the opposite in each detail to what most of us would customarily submit to <u>Who's Who In America</u> or on an application for a job or to college. (II Corinthians 11:21-33 and 12:1-5).

In <u>Crux Gloria</u> (1991; St. Francis De Sales, Purcellville, Virginia, Fig. 115), Tomàs Fernàndez creates a negative space within the cross which engages our imagination. He describes some of the effects of that space within the work which is 33 feet tall and contains 17,000 pounds of corton steel:

The figure of Christ has been cut out of the cross, leaving the negative space to become the positive, allowing our imagination to expand within the sculpture. It is a work that calls forth many different interpretations and levels of appreciation. Some of my thoughts include: the opening Christ has created for us, by way of the cross, can be viewed as a window to view our world or that we may be seen through; the image of Christ also becomes a doorway, a place

of transition and transcendence, and has been left open for all. The interior of the cross holds five halogens [fluorine, chlorine, bromine, iodine, and astatine] that illuminate the figure at night as the exterior cross fades into darkness.[2]

That cross may be seen outside St. Francis de Sales in Purcellville, Virginia.

Through Tomàs Fernàndez's Heaven and Earth (1984; private collection, Fig. 116) which is fourteen feet tall of painted steel, we see the world beyond and realize we may be seen. Such a work welcomes us and invites us to question subject/object dichotomies and mind/body dichotomies as the artist explains:

> This style of depicting this salutatory man compliments my intent of having the person filled by the very object of his reach. Another pleasing benefit of this style is the viewers seeing through to each other.[3]

By being able to see through the figure to the woods, we understand that there is less separation and more relationship between objects and between ourselves and objects than we might have supposed if the sculpture had been solid. As the head and body of the sculpture are a continuum of the same material, we sense that mind and body as well as subject and object are not mutually exclusive. Such spaces invite us to relate to others beyond ourselves.

Sharing faith is like a concave space which invites the viewer to enter. In contrast, sharing beliefs is like a convex space which may leave no space for the viewer. The Biblical stories leave much space to the imagination by not overloading stories with details. Orthodox Christian theology is characterized by the via negativa, the negative way, so as to avoid detailing beliefs which too often lead to a static certainty rather than a dynamic faith open to the movement of the Spirit. (See chapter 14.) The sculptures we have discussed invite the viewers to grow in faith toward things unseen.

TEACHING TIPS

1. Discuss with students how the negative spaces in these sculptures are like windows to seeing beyond what we know or doorways to relating beyond ourselves. Have a solid shaped cross and a solid shaped body to lay over the photographs so students may compare and contrast the effects of concave negative space and convex positive space.

2. Discuss how biblical stories emphasize the incompleteness of the characters rather than their perfection and how such incompleteness encourages us to have hope to be disciples: e.g. how often the Bible reveals Peter's failings (sinking in the water, Matthew 14:28-33; misunderstanding Jesus' actions and teachings, Mark 8:33; going to sleep when Jesus asked him to stay awake, Mark 14:37; denying Jesus three times, Mark 14:66-72; and breaking his promise to Paul, Galatians 2:11-14).

3. Using II Corinthians 11:23-12:5 as a model, have each student write a parallel list of things from his or her own life which emphasize what may first seem to be negative experiences. It will help if you as teacher share something from your life for each item in the list as students are creating their own: as Paul says he had far more imprisonments, we may name the subjects at which we received the lowest grades in school; as Paul mentions he had countless beatings, we may share when we lost an election or were bested by someone else in some way; as Paul notes how he was often near death and not the perfect specimen of healthy vigor, we may share the sports we are the worst at; as Paul notes how he was whipped, we may share when we have been criticized; as Paul shares when he was shipwrecked and adrift at sea, we may share when we lost a job or a friend; as Paul shares when he felt in danger, we may share what we fear; and when he shares he had sleepless nights, we may share why we had a sleepless night.

4. Then have each class member create an art work (preferably a sculpture in clay or cardboard) which embodies one of the experiences on his or her list. After creating the works, students may discuss how the sculptures embody and communicate their experiences.

NOTES

[1] Doug Adams, <u>Transcendence With The Human Body In Art</u> (New York: Crossroad, 1991), pp. 55-56.

[2] Letter from Tomàs Fernàndez to Doug Adams, July 1, 1992

[3] Ibid.

CHAPTER 37

"WINGED FIGURE" INFORMS THEOLOGY

Sculptor Stephen De Staebler's <u>Winged Figure</u> (1993; Graduate Theological Union, Berkeley, figs. 117, 118, 119, and 120) rises up through the center of the Graduate Theological Union Flora Lamson Hewlett Library in Berkeley, California. This human scale bronze figure emerges from the top of a bronze sheathed square column and reaches a height of twenty-four feet above the library's first floor. An additional six feet of the column extends into the bedrock below the library.

The viewer may discern at least four theological features in De Staebler's <u>Winged Figure</u>. Incompleteness embodies human finitude and evokes empathy for others. Attention to the body and to our connection with the earth reveals the basis for transformation and resurrection. Frontality invites commitment to the other and transcendence of self. Concave shapes draw us into appreciation of the unseen and faith; and one wing and one arm strike a balance between being and doing, between faith and beliefs.

Incompleteness is evident in the sculpture's one leg, one arm, and partial torso. As noted in chapter 36, the artist speaks of how such incompleteness is a way of encouraging the viewer to acknowledge his or her own incompleteness which is the basis for empathy with others.

De Staebler's works have effects similar to Henri Nouwen's idea of the wounded healer: i.e. a person who has been wounded is better able to minister to other wounded people who would not relate well to an unwounded person. The ability of the wounded healer to help is evident in the story told by Tom Woodward in chapter 5.

De Staebler does not present an ideal body for that would set up a model which makes us feel worse as we age and fall further short of it.

He says, "I think the idealization of the body has been a very questionable enterprise at best because at its extreme what it leads to is a kind of glorification of youth which just doesn't allow for graceful aging."[1] May our experience of <u>Winged Figure</u> increase our acceptance of our own incompleteness and increase our empathy for others and their empathy for us.

His sculpture does not detail the head for he has learned that we too easily focus on the head and neglect the body. When the other person's eyes or head are not visible, we are more likely to focus on his or her body. If there were a head at the top of <u>Winged Figure</u>, we might focus there; but with our attention focused on the body, we are likely to follow its shape down the column and notice its connection to the earth. The precariousness of that connection is stressed by the break in the column not far below the figure's foot. If the figure stood upon a column without such a break in its continuity, the figure could appear to be static as De Staebler notes:

> The small rock-like transitional form, like a Corinthian column capital, gives it a freedom from the column, a felt freedom. It also allows the positioning of the sculpture to be off center from the column which is important because it gives it a precarious energy that it wouldn't have if it were just a continuous column leading up to the figure. It isn't a physical precariousness; it is more an internalized sense, symbolic. What else could be appropriate for the end of the second millennium.[2]

The sense of transformation and resurrection we receive from De Staebler's sculpture derives in part from the wing shape around the shoulder and in part from the forward thrust of the figure;

but such features relate us to the earth and other bodies and De Staebler's ecological concerns. The wing shapes in his 1989 Pietà he identified as stuff of the earth:

> The forms that seem to be growing upward can be seen as flames as well as wings. They are still ultimately earth forms. They are not ethereal feathers of a bird. They are the stuff of the earth that has power to transcend.[3]

When we learn that the wing of Winged Figure derives its shape from being modelled on the belly of a pregnant woman, we realize how earthy it is. Of the wing shapes in the Pietà, De Staebler related the ecological connection:

> It is using earth forms like fractured stone ... making it the connection with the divine, which I think really is the secret anyway. The earth is sacred. We have lost sight of it. Now we really know because we are so close to extinction; and the ecological disasters are multiplying. But symbolically, winged flame lifting the figure of mother and child upward speaks to what the earth is made of.[4]

The transformation and resurrection are therefore of the body and of the earth and not away from body and earth. May our experience of Winged Figure increase our care for the body and the earth.

On first entering the library, one is engaged by the frontality of the sculpture. For De Staebler, the frontal form embodies a commitment with another person such as depth conversation at a dinner. He contrasts such depth with the uncommitted superficial chatter at a cocktail party where one usually stands at oblique angles to be able to look beyond the person to see if someone more interesting is coming. He develops this contrast:

> The ground rule of a cocktail party is never to become engaged or never to be cornered so that you can't slip away before a situation becomes less than enjoyable or threatening; whereas at a dinner party, you can't very well edge your chair over and sit next to the other guy.[5]

A transcendence of the self through a deepening attention to the other may occur in conversing at dinner, in making love, in confronting another, or in meditating on an icon.

De Staebler notes some differences among these modes of frontality and details how the absence of eyes or head in his sculpture invites a nurturing dialogue:

> Even if you think of the nurturing relationship, an infant with its mother, there's frontality; but there is not eye-focus frontality. There is the embracing, protecting, nourishing relationship. ...The Byzantine frontality had no escape. You enter the world of the Pantocrator or the crucifix; and you are held by it. The experience I would be more interested in is one that is less of confrontation and more of embrace. You are allowed your own kind of freedom to be in the relationship without being dominated by it.[6]

Let this sculpture increase our sense of commitment with others.

De Staebler creates much negative space through the deep concavity of the wing and through the absence of one arm, one leg, and part of the torso. Such negative space invites the viewer into the work whereas too much convexity or too much articulation would leave little room for the viewer's imagination. Such space invites many possibilities or potentialities. Such negative space witnesses to being and God. At the dedication of the sculpture, De Staebler closed his remarks with this story and poem which reveals the balance between being and doing in his work.

> I want to recite a little poem that I wrote for Jane Owen, who commissioned me to do a Pietà for the Roofless Church in New Harmony, Indiana. It turned out that it had no arms. Jane told me that people were saying, "Well it's interesting, but why doesn't the figure have arms." So, I wrote this poem for her.
> "We don't need arms when we are in the arms of God. They could have been wings anyway if God wanted it so. How

101

many times in life do we wish we had wings rather than arms. To float, to fly, to soar is to be; to have arms is only to do."

Perhaps Winged Figure here in the GTU Library offers the possibility of both being and doing, simultaneously over a lifetime.[7]

His solution of one arm and one wing he describes as "making your peace with two states (the state of being and the state of doing) and resolving that dichotomy."[8] Let this sculpture increase our thoughts and faiths and hopes and dreams of things unseen.

TEACHING TIPS

1. Share with your students the story of the clown Lydell's visit with the hospital patient from chapter 5 and Henri Nouwen's idea of the wounded healer as all look at Winged Figure. Then ask each person to share ways he or she is incomplete as you continue looking at the Winged Figure and as you discuss the incompleteness in the sculpture and share the sculptor's words quoted in this chapter.

2. Discuss how a crucified Jesus is a wounded healer.

NOTES

[1]Doug Adams, Transcendence With the Human Body in Art: Segal, De Staebler, Johns, and Christo (New York: Crossroad, 1991), p. 55.
[2]Stephen De Staebler, interview by Doug Adams, October 6, 1993.
[3]Adams, op.cit., pp. 74-75.
[4]Ibid., pp. 71 & 74.
[5]Ibid., p. 58.
[6]Ibid., p. 62.
[7]Stephen De Staebler speech at the dedication of Winged Figure, September 18, 1993.
[8]Stephen De Staebler, interview by Doug Adams, October 6, 1993.

APPENDICES

APPENDIX 1

SECURING PHOTOGRAPHS AND SLIDES

FOR USE IN EDUCATION AND WORSHIP

Teaching and preaching may be enriched by describing visual art even if it is not shown; but there are simple ways to include the visual images in the classroom and worship. To show the visual art, there are two ways which work in different settings. The first way is to feature the art works in worship as bulletin covers (on the front and back covers) or as xeroxed handouts. (Similarly in the classroom, one may use xeroxed handouts of the art.) The second is to project a slide of the work. Both methods are easier than many realize.

For bulletin covers, one needs to remember that copyright attaches to the photograph or slide of the work. If you have taken the slide or photograph of the actual art work such as a Rembrandt, then you reproduce the bulletin cover or xeroxed sheets from your own photograph or slide. A good quality copy machine produces bulletin covers (of black and white art) which are excellent. Xeroxed reproductions of line drawings or engravings are often very fine. If you wish to reproduce from someone else's photograph of the art work, then you need to obtain permission. This is a simple process but requires working ahead of time to gain the permission.

For instance 8 1/2" x 11" black and white photos of most famous works of art at the National Gallery of Art in Washington D.C. may be obtained for $10 each. (That $10 includes one time rights to reproduce it in a book, article, or bulletin, etc.) Contact Coordinator of Photography, National Gallery of Art, Washington D.C. 20565. The Smithsonian Museums have similarly reasonable rates. For a somewhat higher rate, one may secure photographs (and reproduction rights) of works at the Metropolitan Museum of Art, Fifth Avenue at 82nd Street, New York, New York 10028.

Other museums have similar policies but costs vary widely. Always remind them you are a non-profit organization using the work in a non-commercial publication; for commercial ventures may pay much more for reproduction copyrights. While a direct approach to any museum may result in the lowest cost for the photo (which you usually get to keep), you can obtain permission (and a photo which must be returned) for almost any work in the United States or Europe or elsewhere from ART RESOURCE, 65 Bleecker Street, New York, New York 10012 (telephone 212-505-8700).

Some people have huge collections of postcards of art works and reproduce from those; for many museums never put copyright notice on earlier postcards. Also many older art books are beyond copyright protection (books in the 19th century for instance have fine reproductions of major artists' engravings); so one may reproduce freely from those. For works by some more

recent twentieth century artists, a few states such as New York require that a small fee be paid to the artist through VAGA (an agency run by the same people who operate ART RESOURCE).

To make slides from books, utilize the services of someone in your school or church who knows how to use a copy stand. That way you will be able to secure one slide of the entire art work and many close-up details of the same art work. (Using many slides with different details of one or two art works produces a deeper educational and spiritual experience than trying to introduce people to a dozen different art works.)

As more churches develop Saturday evening worship services, the use of slides in preaching and worship becomes viable even in churches without the means of blocking out daylight in Sunday morning services. When using a black and white reproduction on a bulletin cover, one may project a color slide of the art so that the congregation or class has some sense of the work's colors. Such projections are possible even in broad daylight in some parts of any church. Take a slide projector into your worship or classroom setting and see which surfaces may prove to be surprisingly suitable for projection.

Rear view projection screens may produce a brighter image than straight projection. Slides may be transferred to video tapes; and the video tapes may then be played on a regular T.V. screen through a VCR. The slides will usually be brighter on the T.V. screen (which sends out a direct intense light to the viewer) than the image reflected by a slide projector off a screen. A 24 inch or 26 inch T.V. screen placed in the front of the sanctuary will produce an image easily seen by those in the back pews of a large worship space as appendix 2 elaborates.

APPENDIX 2

DEAD POETS' SOCIETY:

A VIDEO FOR EASTER AND PENTECOST

Film and video are the primary languages of our day when over sixty percent of the population remember primarily by what they see. Integrating into a sermon or class presentation even a minute or two from a current video relates the gospel in contemporary ways which are remembered. A regular T.V. set and VCR at the front of a church worship space or classroom provides a bright enough image to be seen from the back pew or row even in broad daylight. (If you are in a large church worship space, then place a microphone near the T.V. loudspeaker so louder volume is possible without distortion.)

For instance, I found that a large percentage of youth and adults value the film The Dead Poets' Society. Much of the story in that film parallels the story of Jesus. The teacher, played by Robin Williams, gives his students eyes to see and ears to hear and brings life to his poetry class. Later in the story, one student betrays him and the others abandon him. After he has been fired and is leaving, the students (who had been fearful of the headmaster) find the courage to rise up and to proclaim the teacher as their captain in a moment which parallels Pentecost.

I use the last minute or two of the video of that film in sermons and in classroom presentations during the time from Easter to Pentecost. Most of the people have already seen the film; but for those who have not seen it, I inform them that earlier in the film the teacher has shared with the students the poem "O Captain, My Captain" which Walt Whitman had written after the martyrdom of Abraham Lincoln. Similarly, I tell them that the teacher had helped a particularly shy student to overcome his fear of speaking in public by having him stand on top of a desk so he is looking down on everyone else and is no longer inhibited by them.

Then I play that last scene in the film from the moment Robin Williams walks through the classroom for the last time having reclaimed his effects from his office. The headmaster was then in control of the class; but that formerly shy student blurts out his apology to Robin Williams and then is silenced by the headmaster who informs the student that one more outburst from him and he will be expelled. Then just as Williams has reached the door and is about to exit, the shy student stands up on his desk and speaks out the first words of the Walt Whitman poem, "O Captain, My Captain." As the headmaster tries to make the student sit down, many of the other students rise up in a similar way so that most are standing on their desks at the end of the film when Williams simply says, "Thank you, boys. Thank you."

The week before the worship or class session, I ask the students to watch The Dead Poets' Society at home. Many of them have copies of the video; and others, who do not have the video,

arrange to view it at the homes of those who do have it. I ask them to note parallels between the events in the movie and the events of Jesus' ministry, betrayal, and resurrection. As the church becomes the body of Christ and continues the resurrection from Pentecost to this day, I ask students to consider how the end of the film bears a resemblance to Pentecost. I have them study the story of Pentecost in chapters two and three of The Acts of The Apostles.

In the class itself, we discuss the students' perceptions of parallels between episodes in the film and episodes in the Bible. We note similarities and differences. We climax the class session by playing the last couple minutes of the film. If the church or teacher does not have a video playback system, then one of the students may be able to bring in the needed T.V. monitor and video player as well as a copy of the video of that film.

Showing such a brief excerpt of a video in a classroom setting is an educational use which does not pose the copyright problem of showing the video in a large non-educational setting. For frequent use of videos in sermons before large congregations and in other church assemblies, I advise churches to obtain a replay license; for instance, Pacific School of Religion (where I use video excerpts in teaching full time and preaching occasionally) pays $75 per year to Motion Picture Licensing Corporation for a copyright license which permits all of our teachers, staff, and students to use most films and videos not only in large classes but even in worship services. (Write to Motion Picture Licensing Corp., 13315 Washington Blvd., 3rd Floor, Los Angeles, Ca. 90066-5145.)

I advise using an excerpt from a current film or a very recent film (or one recently shown on T.V.) or one many people have in their home video collections so the excerpt links the people's current life with our Biblical study or worship. Forrest Gump resonates with Jesus's ministry in the brevity of his stories, the focus on what people say and do (with motivations not noted), the unwillingness to interpret the stories, and his responsibility interacting with others. Prodigal sons and daughters abound in movies from On Golden Pond to Wallstreet. Whoopie Goldberg's character in Ghost bears a resemblance to Mary Magdalene who heard Jesus but whom others did not believe. Kevin Costner's Robinhood has many affinities with Revelation. Movies do not need to have moral characters to be brought into conversation with Biblical stories but quite the opposite. Bullets Over Broadway (where a hit man saves the play) relates well with many Jesus parables where helpful characters are often considered immoral such as a shepherd, an unjust steward, a Samaritan, a son who says he will not help but does help.

If our worship, preaching, and teaching remain largely verbal, they may as well be spoken in Latin for they will not be remembered by the majority of the population whose language is now the visual arts. If we communicate with the visual arts, then the Word will be remembered. In the words of Roethke, "Give us eyes that hear and ears that see."

LIST OF ILLUSTRATIONS

1. Raphael Morghen after Leonardo, The Last Supper, 1800, courtesy of the National Gallery of Art, Washington D.C.

2. William Blake, The Last Supper, 1799, courtesy of the National Gallery of Art, Washington D.C.

3. Emile Nolde, The Last Supper, 1909, courtesy of the Nolde Foundation, Seebull.

4. George Segal, The Holocaust, 1984, Legion of Honor Museum, San Francisco. Photograph by Doug Adams. c. George Segal/VAGA.

5. George Segal, The Holocaust, 1984, Legion of Honor Museum, San Francisco. Photograph by Doug Adams. c. George Segal/VAGA.

6. George Segal, The Holocaust, 1984, Legion of Honor Museum, San Francisco. Photograph by Doug Adams. c. George Segal/VAGA.

7. George Segal, The Holocaust, 1984, Legion of Honor Museum, San Francisco. Photograph by Doug Adams. c. George Segal/VAGA.

8. George Segal, The Holocaust, 1984, Legion of Honor Museum, San Francisco. Photograph by Doug Adams. c. George Segal/VAGA.

9. George Segal, The Holocaust, 1984, Legion of Honor Museum, San Francisco. Photograph by Doug Adams. c. George Segal/VAGA.

10. George Segal, The Holocaust, 1984, Legion of Honor Museum, San Francisco. Photograph by Doug Adams. c. George Segal/VAGA.

11. George Segal, The Holocaust, 1984, Legion of Honor Museum, San Francisco. Photograph by Doug Adams. c. George Segal/VAGA.

12. Georgia O'Keeffe, Black Cross, New Mexico, 1929, courtesy of The Art Institute of Chicago.

13. Louise Nevelson, Cross of the Good Shepherd, 1976, Erol Beker Chapel, courtesy of St. Peter's Lutheran Church, New York.

14. Barnett Newman, Station #1 of Stations of the Cross, 1958, Courtesy of the National Gallery of Art, Washington D.C.

15. Barnett Newman, Broken Obelisk, 1963-1967, Photograph by Balthazar Korab, courtesy of The Rothko Chapel, Houston.

16. Pantocrator, 11th century, courtesy of Monastery at Daphni, Greece.

17. Michelangelo, The Roman Pietà, 1500, courtesy of the Basilica Church of St. Peter, Vatican City.

18. Michelangelo, The Rondanini Pietà, 1564, courtesy of Castello Sforesca, Milan

19. Stephen De Staebler, Pietà, 1989, The Roofless Church, New Harmony. Photograph by Scott McCue, courtesy of Stephen De Staebler.

20. William Blake, The Just Upright Man is Laughed to Scorn, #10 from Illustrations for the Book of Job.

21. William Blake, When the Morning Stars Sang Together & All the Sons of God Shouted for Joy, #10 from Illustrations for the Book of Job.

22. Ann Honig Nadel, Soul Catcher, 1985, courtesy of Ann Honig Nadel.

23. Torah Niche, mid 3rd century, Dura-Europa Synagogue, Syria.

24. Christ from The Book of Kells, courtesy of Trinity College Library, Dublin.

25. Andrea Mantegna, The Agony in the Garden, mid 15th century, courtesy of the National

Gallery, London.

26. Piero della Francesca, The Resurrection, c. 1462-1464, courtesy of Palazzo Communale, Sansepolcro.

27. Berthold Missal Last Supper, c. 1225, courtesy of Pierpont Morgan Library, New York.

28. Michelangelo, "Detail of Christ in Judgment" from The Last Judgment, 1541, courtesy of the Sistine Chapel, Vatican City.

29. Michelangelo, The Creation of Adam, c. 1511, courtesy of the Sistine Chapel, Vatican City.

30. Michelangelo, Temptation and Expulsion, c. 1511, courtesy of the Sistine Chapel, Vatican City.

31. Salvador Dali, The Sacrament of the Lord's Supper, 1955, courtesy of the National Gallery of Art, Washington D.C.

32. Rembrandt van Rijn, Christ at Emmaus, mid 17th century, courtesy of the National Gallery of Art, Washington D.C.

33. Rembrandt van Rijn, Sacrifice of Abraham, 1635, courtesy of the Hermitage, St. Petersburg.

34. Jack Levine, Sacrifice of Isaac, 1974, courtesy of Jack Levine.

35. Marc Chagall, The Sacrifice of Isaac, 1935, courtesy of Musée National Message Biblique Marc Chagall, Nice.

36. The Sun God Ascending Between Two Mountains, c. 2800 B.C.E., courtesy of the Pierpont Morgan Library, New York.

37. Marc Chagall, Moses Before the Burning Bush, n.d., courtesy of the Musée National Message Biblique Marc Chagall, Nice.

38. Mathias Grünewald, Resurrection detail of the Isenheim Altarpiece, 1515, courtesy of the Musée d'Unterlinden, Colmar.

39. Andrei Rublev, The Holy Trinity, 1411, courtesy of the Tetreyekov Gallery, Moscow.

40. Old Testament Trinity, 1410, courtesy of the Russian Museum, St. Petersburg.

41. El Greco, St. Francis, c. 1590-1604, courtesy of The Art Institute of Chicago.

42. Christo, The Running Fence, Sonoma and Marin Counties, California, 1972-1976. Photograph by Gianfranco Gorgoni, courtesy of Christo.

43. Christo, The Running Fence, Sonoma and Marin Counties, California, 1972-1976. Photograph by Wolfgang Volz, courtesy of Christo.

44. Christo, The Running Fence, Sonoma and Marin Counties, California, 1972-1976. Photograph by Wolfgang Volz, courtesy of Christo.

45 Christo, Wrapped Kunsthalle, Bern, Switzerland, 1968. Photograph by Thomas Cugini, courtesy of Christo.

46. Christo, Wrapped Coast, Little Bay, Australia, 1969. Photography by Harry Shunk, courtesy of Christo.

47. Timothy Grummon, Panels of Love, 1988. Photograph by Jann Weaver, courtesy of Timothy Grummon.

48. Jan van Hemessen, Arise, Take Up Thy Bed, and Walk, mid 16th century, courtesy of the National Gallery of Art, Washington D.C.

49. Jacques Callot, Jesus and Saint Peter on the Water, early 17th century, courtesy of the National Gallery of Art, Washington D.C.

50. The Master of the Retable of the Reyes Catolicos, The Marriage at Cana, late 15th century, courtesy of the National Gallery of Art, Washington D.C.

51. Edgar Degas, <u>The Glass of Absinthe</u>, 1878, courtesy of the Musée d'Orsay, Paris.

52. Camille Pissarro, <u>The Corner of Hermitage Garden</u>, 1877, courtesy of the Musée d'Orsay, Paris.

53. Auguste Renoir, <u>Seine at Argenteuil</u>, 1873, courtesy of the Musée d'Orsay, Paris.

54. George Segal, <u>Abraham's Farewell To Ishmael</u>, 1987, c. George Segal/VAGA.

55. George Segal, <u>Abraham and Isaac: In Memory of May 4, 1970, Kent State</u>, 1978, c. George Segal/VAGA.

56. Mathias Grünewald, <u>The Crucifixion</u> from the <u>Isenheim Altarpiece</u>, c.1515, courtesy of Musée d'Underlinden, Colmar.

57. Raphael Sanzio, <u>The Crucified Christ</u>, early 16th century, courtesy of the National Gallery, London.

58. Master of Saint Veronica, <u>The Crucifixion</u>, c. 1400-1410, courtesy of the J. Paul Getty Museum, Malibu.

59. Barbara Baumgarten, <u>Two Praying at Temple</u>, 1984, courtesy of Barbara Baumgarten.

60. Barbara Baumgarten, <u>Woman</u>, 1985, courtesy of Barbara Baumgarten.

61. Rembrandt van Rijn, <u>Head of Christ</u>, 17th century, courtesy of the Metropolitan Museum, New York.

62. Paul Cezanne, <u>Madame Cezanne</u>, late 19th century, courtesy of the Metropolitan Museum, New York.

63. Edouard Manet, <u>Christ</u>, 19th century, courtesy of the Legion of Honor Museum, San Francisco.

64. René Magritte, <u>The Therapeutist</u>, 1967, courtesy of the Hirshhorn Museum, Washington D.C.

65. Joan Carter, <u>Faces of Cain</u>. Photograph by Jann Weaver, courtesy of Joan Carter.

66. Joan Carter, <u>Faces of Cain</u>. Photograph by Jann Weaver, courtesy of Joan Carter.

67. Joan Carter, <u>Faces of Cain</u>. Photograph by Jann Weaver, courtesy of Joan Carter.

68. Joan Carter, <u>Faces of Cain</u>. Photograph by Jann Weaver, courtesy of Joan Carter.

69. <u>Melchizedek, Abraham and Isaac, Moses, Samuel, and David</u>, north entrance, c. 1230-1250, courtesy of Chartres Cathedral.

70. Christo, Japan site, <u>The Umbrellas Japan - USA 1984-1991</u>. Photograph by Wolfgang Volz, courtesy of Christo.

71. Christo, Japan site, <u>The Umbrellas Japan - USA 1984-1991</u>. Photograph by Wolfgang Volz, courtesy of Christo.

72. Christo, USA site, <u>The Umbrellas Japan - USA 1984-1991</u>. Photograph by Wolfgang Volz, courtesy of Christo.

73. Christo, USA site, <u>The Umbrellas Japan - USA 1984-1991</u>. Photograph by Wolfgang Volz, courtesy of Christo.

74. Sandro Botticelli, <u>Mystic Nativity</u>, ca. 1500, courtesy of the National Gallery, London.

75. <u>David</u>, eighth century, courtesy of the British Museum.

76. Richard Lippold, <u>Baldacchino</u>, 1969-1970, courtesy of St. Mary's Cathedral, San Francisco.

77. Michele Zackheim, "Jewish Wall," <u>The Tent of Meeting</u>, 1985, courtesy of Michele Zackheim.

78. Michele Zackheim, "Christian Wall," <u>The Tent of Meeting</u>, 1985, courtesy of Michele Zackheim.

79. Michele Zackheim, "Mary and Elizabeth," <u>The Tent of Meeting</u>, 1985, courtesy of Michele

Zackheim.

80. Hugo van der Goes, <u>Portinari Altarpiece</u>, 1475, courtesy of the Uffizi Gallery, Florence.

81. Fra Angelico and Fra Lippi, <u>The Adoration of the Magi</u>, fifteenth century, courtesy of the National Gallery of Art, Washington D.C..

82. Lucas Cranach, <u>Adoration of the Magi</u>, 1514.

83. Raphael Sanzio, <u>The Alba Madonna</u>, 1508-1511, courtesy of the National Gallery of Art, Washington D.C.

84. Albrecht Dürer, <u>Madonna and Child</u>, courtesy of the National Gallery of Art, Washington D.C.

85. El Greco, <u>The Holy Family with Mary Magdalene</u>, 17th century, courtesy of the Cleveland Museum of Art.

86. Audrey Englert, <u>Expectant Madonna</u>. Photograph by Jann Weaver, courtesy of Audrey Englert.

87. Audrey Englert, <u>Shepherd and Three Shepherdesses</u>. Photograph by Jann Weaver, courtesy of Audrey Englert.

88. Audrey Englert, <u>Christa</u>. Photograph by Jann Weaver, courtesy of Audrey Englert.

89. Henry Moore, <u>Madonna and Child</u>, 1942, courtesy of St. Matthew's Church, Northampton.

90. Wurzburg School, <u>Adoration of the Magi</u>, c.1240, courtesy of the J. Paul Getty Museum, Malibu.

91. Henry Moore, <u>Madonna and Child</u>, courtesy of St. Paul's, London.

92. Stephen De Staebler, <u>Crucifix</u>, 1968, Newman Center Chapel, courtesy of Stephen De Staebler.

93. Stephen De Staebler, <u>Seated Woman with Oval Head</u>, 1981, Pacific School of Religion, Berkeley, courtesy of Stephen De Staebler.

94. Stephen De Staebler, <u>Seated Man with Winged Head</u>, 1981, Pacific School of Religion, Berkeley, courtesy of Stephen De Staebler.

95. Auguste Rodin, <u>St. John the Baptist Preaching</u>, 1878, courtesy of Legion of Honor Museum, San Francisco.

96. Paris Bordonne, <u>The Baptism of Christ</u>, 16th century, courtesy of the National Gallery of Art, Washington D.C.

97. Eugene Delacroix, <u>Christ on the Lake of Gennesaret</u>, 19th century, courtesy of the Metropolitan Museum of Art, New York.

98. Thomas Cole, <u>Childhood</u>, from <u>Voyage of Life</u>, 1842, courtesy of the National Gallery of Art, Washington D.C.

99. Thomas Cole, <u>Youth</u>, from <u>Voyage of Life</u>, 1842, courtesy of the National Gallery of Art, Washington D.C.

100. Thomas Cole, <u>Manhood</u>, from <u>Voyage of Life</u>, 1842, courtesy of the National Gallery of Art, Washington D.C.

101. Thomas Cole, <u>Old Age</u>, from <u>Voyage of Life</u>, 1842, courtesy of the National Gallery of Art, Washington D.C.

102. Hough, engraving of <u>Youth</u> from <u>Voyage of Life</u>.

103. Marchant copy of <u>Dance of Death</u> from Innocents' church yard murals.

104. Giotto, <u>The Marriage at Cana</u>, 1303/1305, courtesy of the Scrovegni Chapel, Padua.

105. <u>Last Judgment</u> from Princes' Portal, Bamberg.

106. <u>Last Judgment</u>, west front central porch, courtesy of Notre Dame, Paris.

107. <u>Doom Painting</u>, South Leigh, Oxfordshire.

108. <u>Woman and Dominican Joisting</u>, late thirteenth century.

109. Leonard Baskin, <u>The Prodigal</u>, 1990, courtesy of Leonard Baskin.

110. Kellogg Company, <u>The Return of the Prodigal</u>, 1846-1847.

111. Rembrandt van Rijn, <u>The Return of the Prodigal</u>, 1668-1669, courtesy of the Hermitage, St. Petersburg.

112. Rembrandt van Rijn, detail of father's hands from <u>The Return of the Prodigal</u>, 1668-1669, courtesy of the Hermitage, St. Petersburg.

113. George Segal, detail of Abraham's hands, <u>Abraham's Farewell to Ishmael</u>, 1987, courtesy of George Segal/VAGA.

114. Stephen De Staebler, <u>Archangel</u>, 1987, courtesy of Stephen De Staebler.

115. Tomàs Fernàndez, <u>Crux Gloria</u>, 1991, St. Francis De Sales, Purcellville, Virginia, courtesy of Tomàs Fernàndez.

116. Tomàs Fernàndez, <u>Heaven and Earth</u>, 1984, courtesy of Tomàs Fernàndez.

117. Stephen De Staebler, <u>Winged Figure</u>, 1993, Hewlett Library, Graduate Theological Union, Berkeley. Photograph by Mev Puleo, courtesy of Stephen De Staebler.

118. Stephen De Staebler, <u>Winged Figure</u>, 1993, Hewlett Library, Graduate Theological Union, Berkeley. Photograph by Mev Puleo, courtesy of Stephen De Staebler.

119. Stephen De Staebler, <u>Winged Figure</u>, 1993, Hewlett Library, Graduate Theological Union, Berkeley. Photograph by Mev Puleo, courtesy of Stephen De Staebler.

120. Stephen De Staebler, <u>Winged Figure</u>, 1993, Hewlett Library, Graduate Theological Union, Berkeley. Photograph by Mev Puleo, courtesy of Stephen De Staebler.

PHOTO SECTION

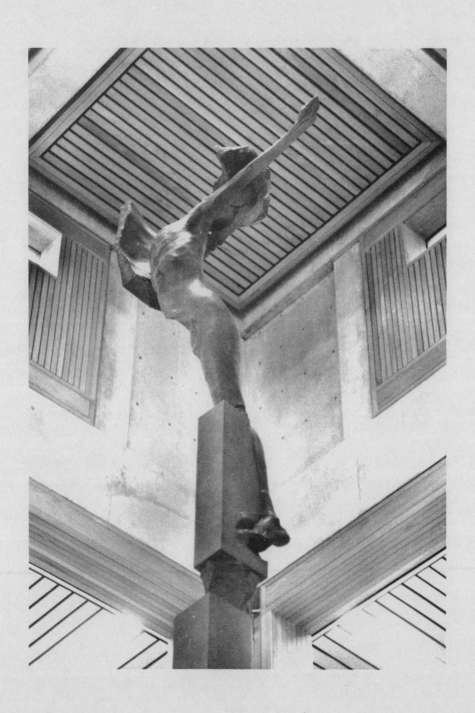

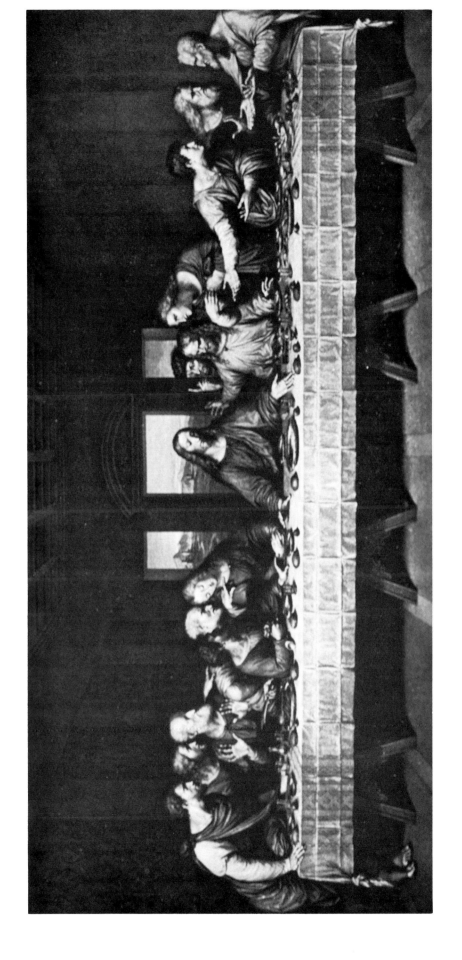

1. Raphael Morghen after Leonardo, The Last Supper, 1800, courtesy of the National Gallery of Art, Washington D.C.

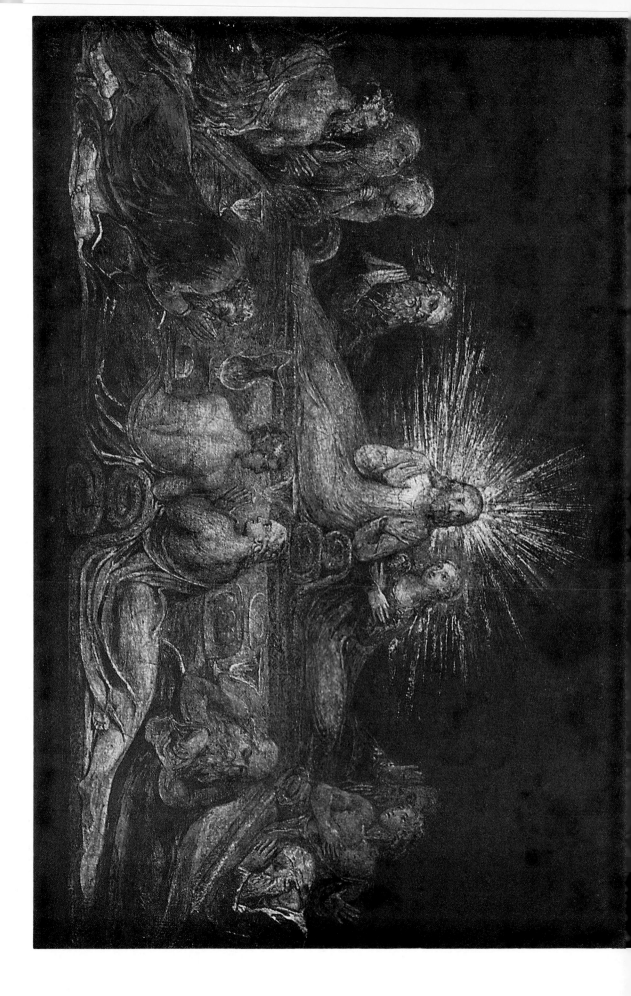

2. William Blake, The Last Supper, 1799, courtesy of the National Gallery of Art, Washington D.C.

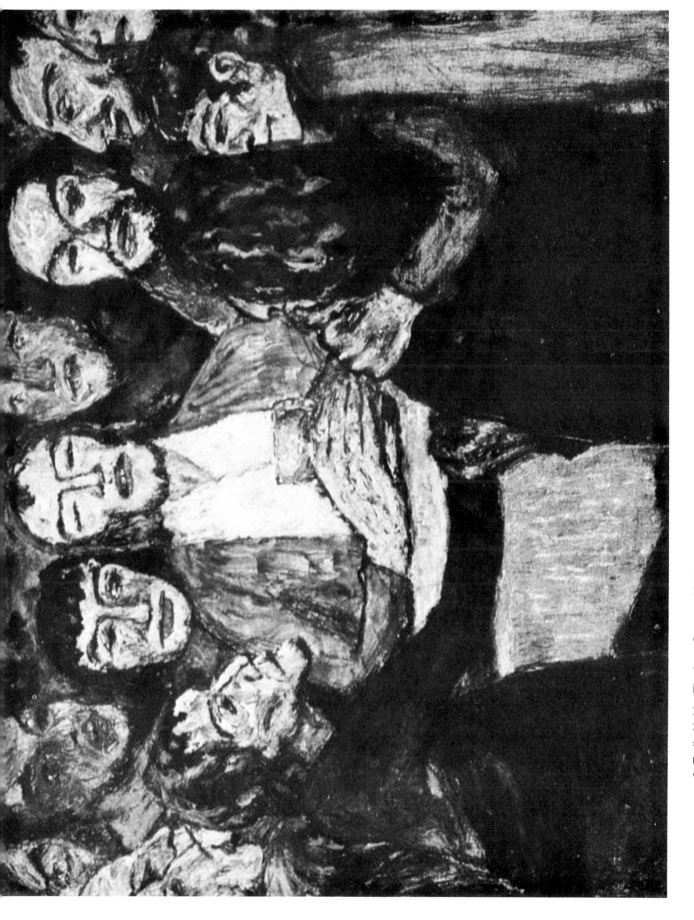

3. Emile Nolde, The Last Supper, 1909, courtesy of the Nolde Foundation, Seebull.

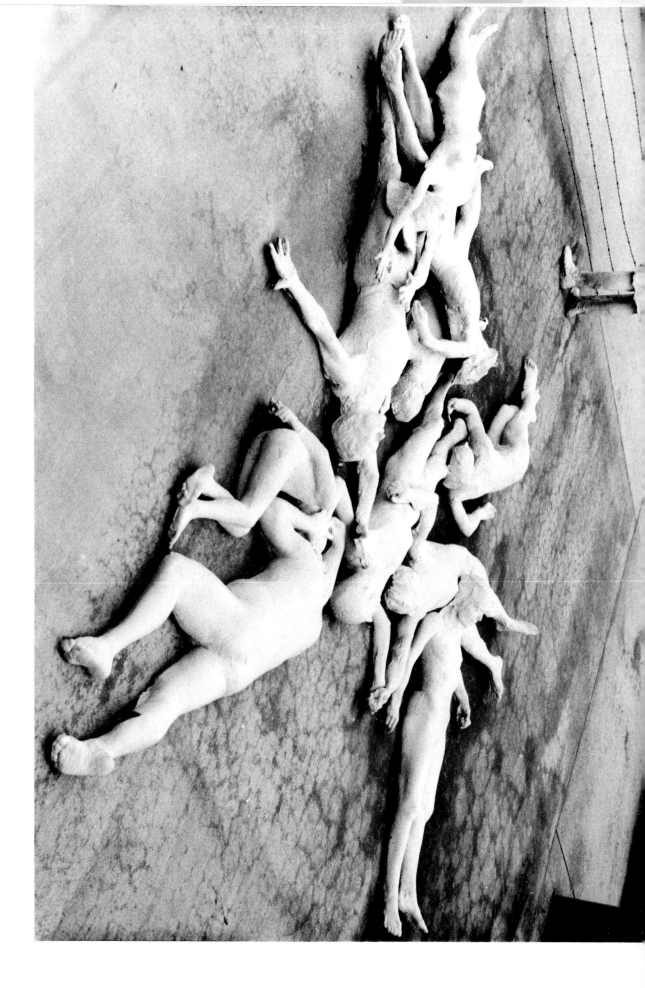

4. George Segal, The Holocaust, 1984, Legion of Honor Museum, San Francisco. Photograph by Doug Adams. c. George Segal/VAGA.

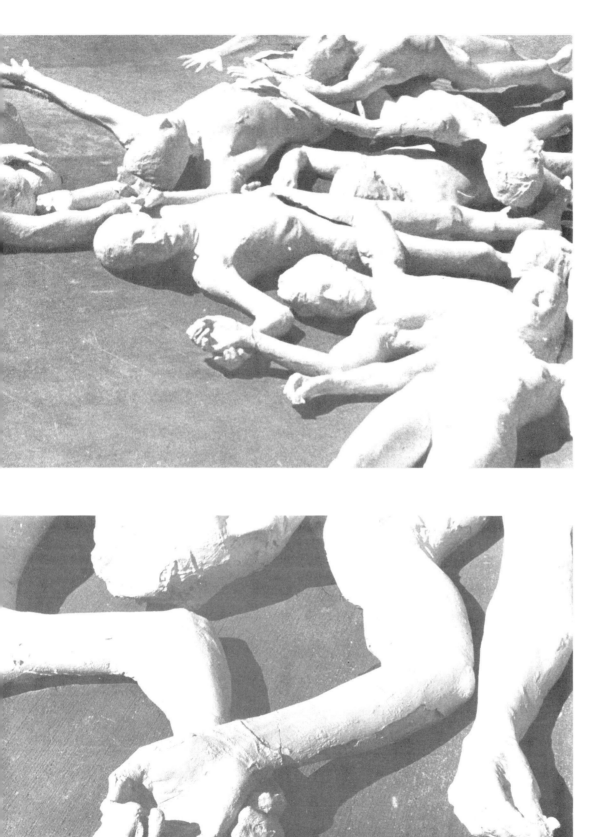

5. George Segal, The Holocaust, 1984, Legion of Honor Museum, San Francisco. Photograph by Doug Adams. c. George Segal/VAGA.

6. George Segal, The Holocaust, 1984, Legion of Honor Museum, San Francisco. Photograph by Doug Adams. c. George Segal/VAGA.

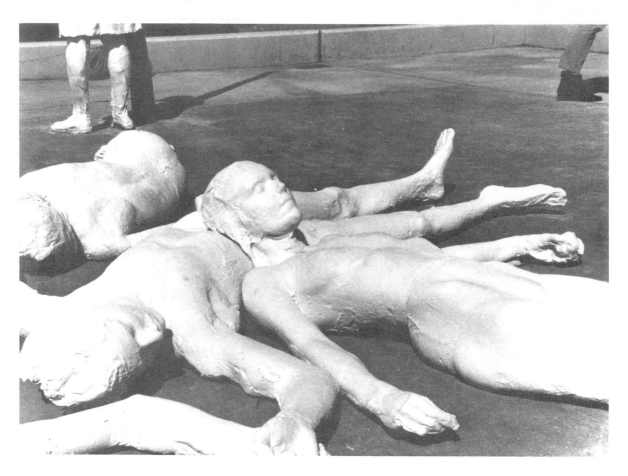

7. George Segal, <u>The Holocaust.</u> 1984, Legion of Honor Museum, San Francisco. Photograph by Doug Adams. c. George Segal/VAGA.

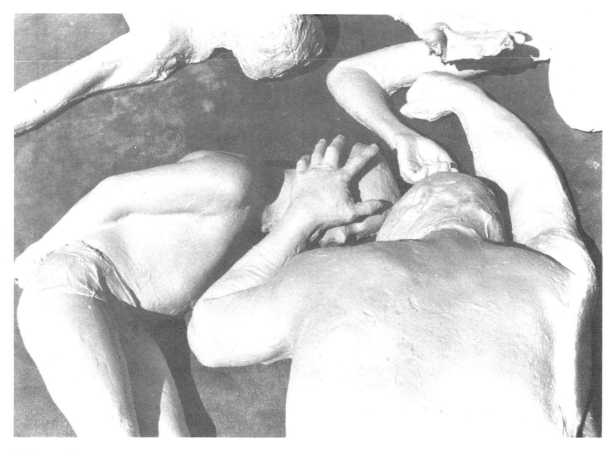

8. George Segal, <u>The Holocaust.</u> 1984, Legion of Honor Museum, San Francisco. Photograph by Doug Adams. c. George Segal/VAGA.

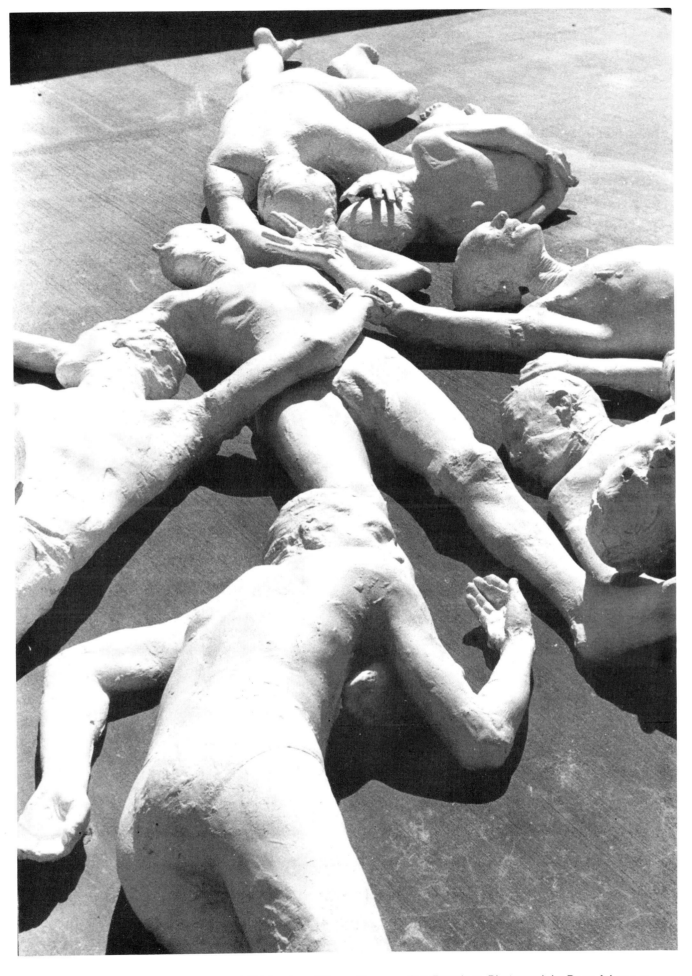

9. George Segal, The Holocaust, 1984, Legion of Honor Museum, San Francisco. Photograph by Doug Adams. c. George Segal/VAGA.

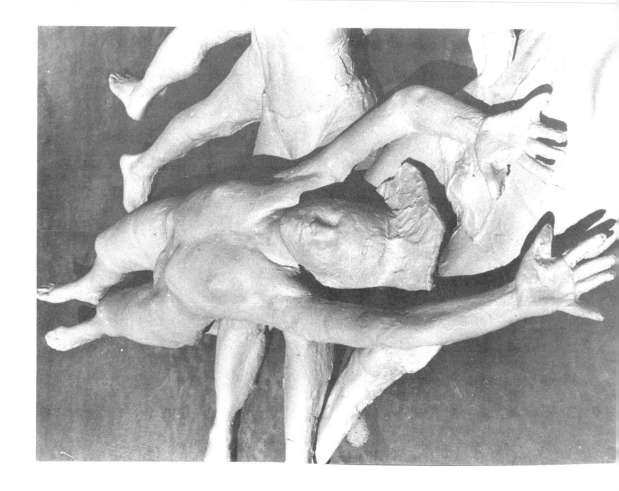

10. George Segal, The Holocaust, 1984, Legion of Honor Museum, San Francisco. Photograph by Doug Adams. c. George Segal/VAGA.

11. George Segal, The Holocaust, 1984, Legion of Honor Museum, San Francisco. Photograph by Doug Adams. c. George Segal/VAGA.

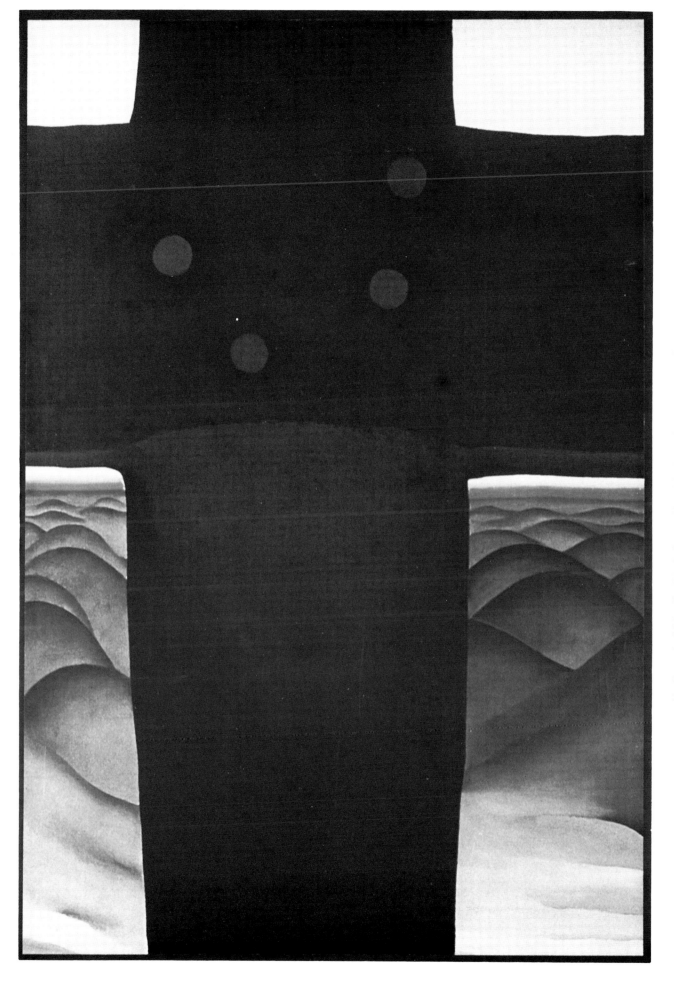

12. Georgia O'Keeffe, <u>Black Cross, New Mexico</u>, 1929, courtesy of The Art Institute of Chicago.

13. Louise Nevelson, <u>Cross of the Good Shepherd,</u> 1976, Erol Beker Chapel, courtesy of St. Peter's Lutheran Church, New York.

14. Barnett Newman, <u>Station #1</u> of <u>Stations of the Cross.</u> 1958, Courtesy of the National Gallery of Art, Washington D.C.

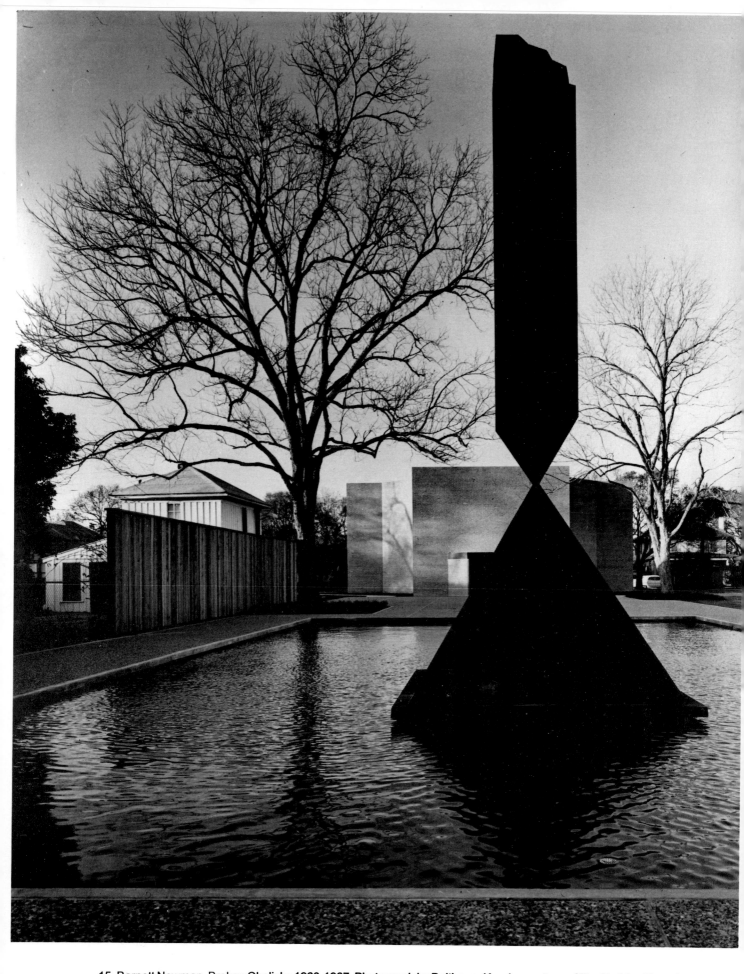

15. Barnett Newman, <u>Broken Obelisks</u> 1963-1967, Photograph by **Balthazar Korab, courtesy of The Rothko Chapel,** Houston.

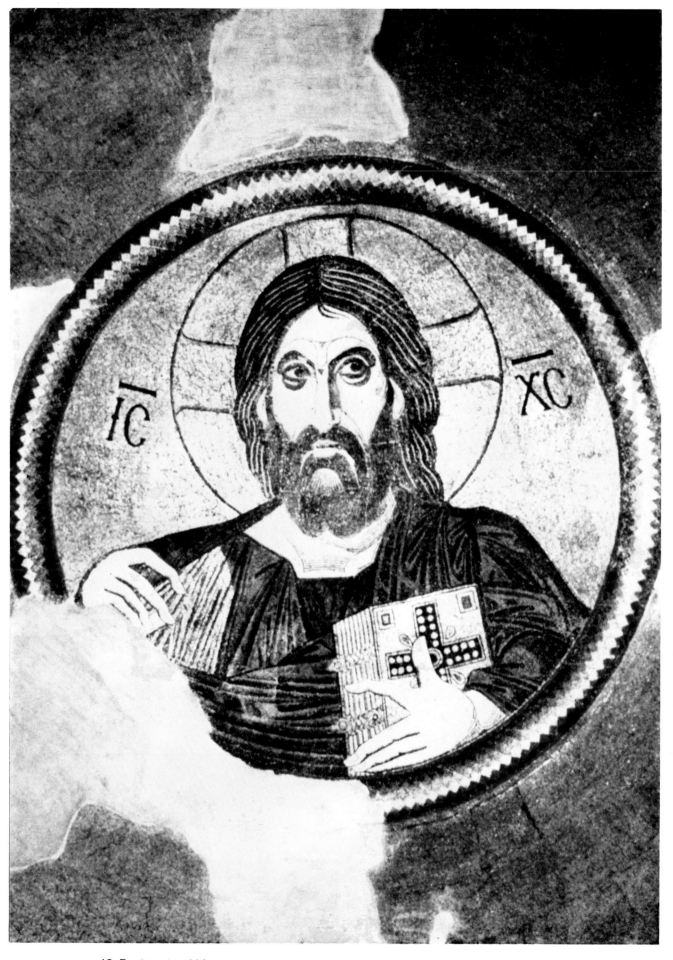

16. Pantocrator, 11th century, courtesy of Monastery at Daphni, Greece.

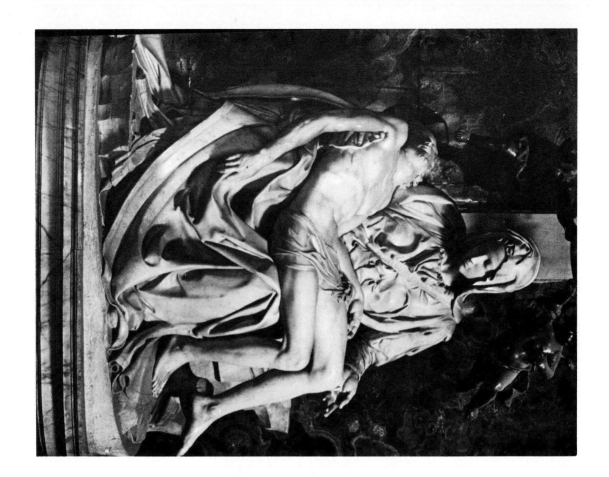

17. Michelangelo, The Roman Pieta, 1500, courtesy of the Basilica Church of St. Peter, Vatican City.

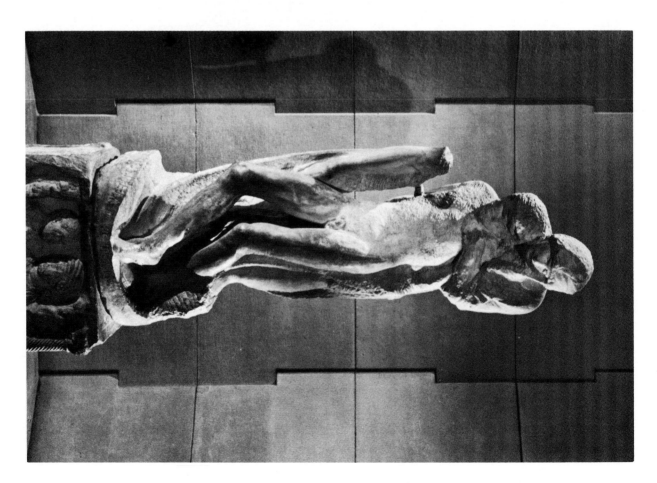

18. Michelangelo, The Rondanini Pieta, 1564, courtesy of Castello Sforesca, Milan.

128

19. Stephen De Staebler, <u>Pietà,</u> 1989, The Roofless Church, New Harmony. Photograph by Scott McCue, courtesy of Stephen De Staebler.

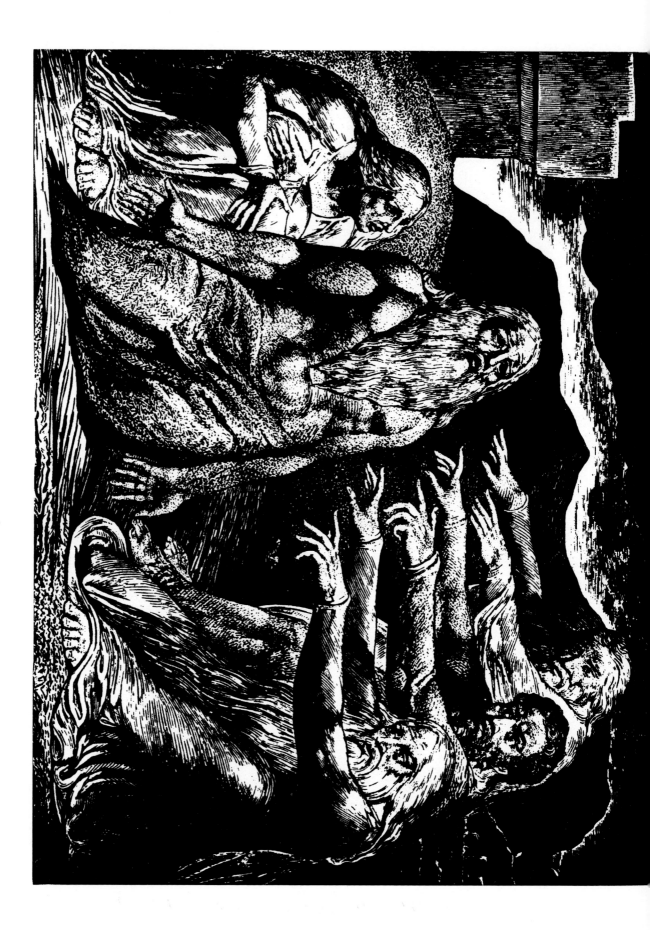

20. William Blake, The Just Upright Man is Laughed to Scorn. #10 from Illustrations for the Book of Job.

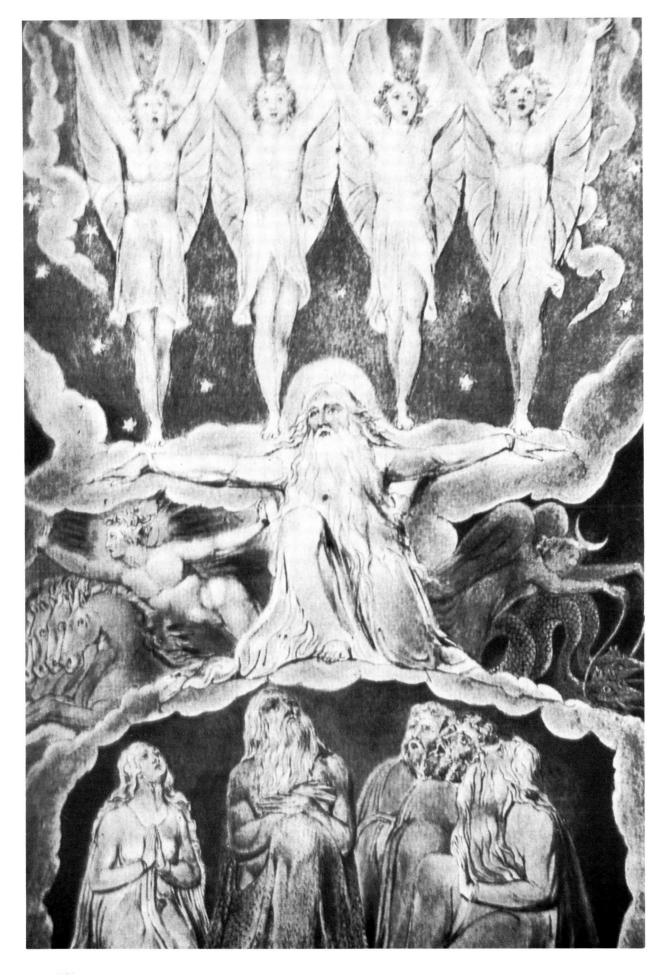

21. William Blake, <u>When the Morning Stars Sang Together & All the Sons of God Shouted for Joy</u>, #10 from <u>Illustrations for the Book of Job</u>.

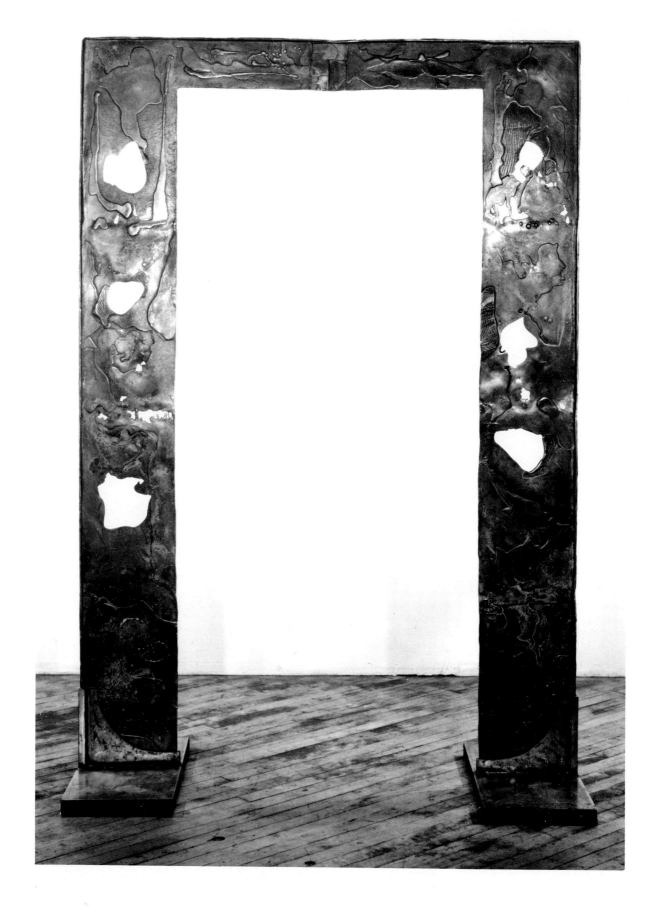

22. Ann Honig Nadel, <u>Soul Catcher,</u> 1985, courtesy of Ann Honig Nadel.

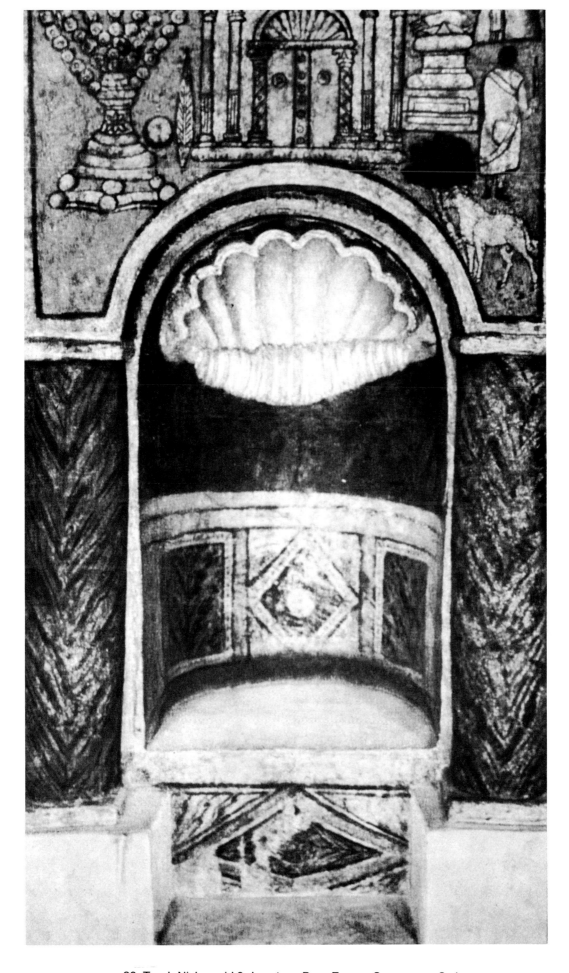

23. <u>Torah Niche</u>, mid 3rd century, Dura-Europa Synagogue, Syria.

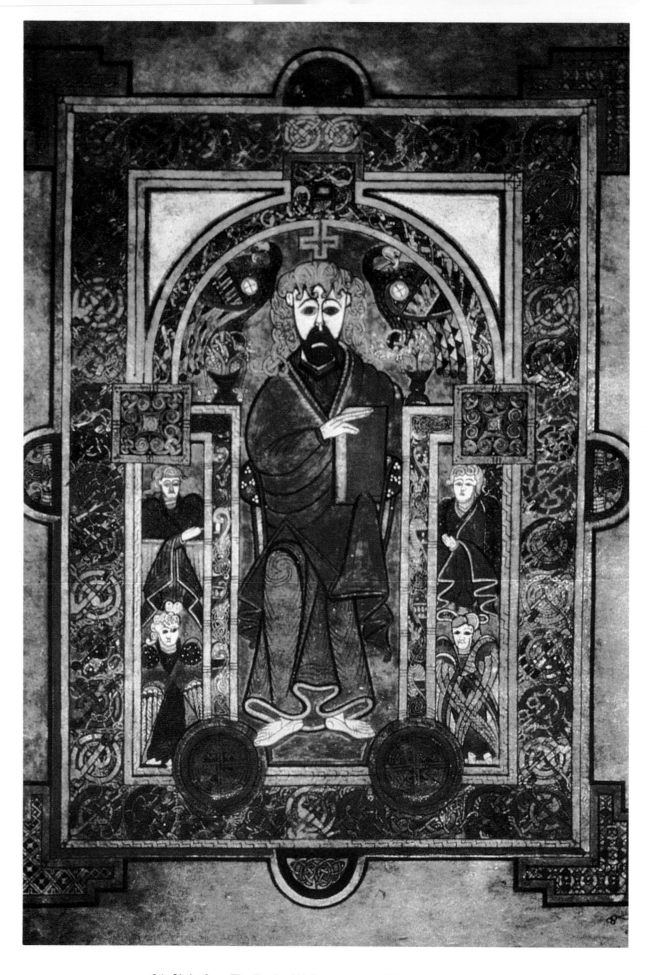

24. <u>Christ</u> from <u>The Book of Kells,</u> courtesy of Trinity College Library, Dublin.

25. Andrea Mantegna, The Agony in the Garden, mid 15th century, courtesy of the National Gallery, London.

135

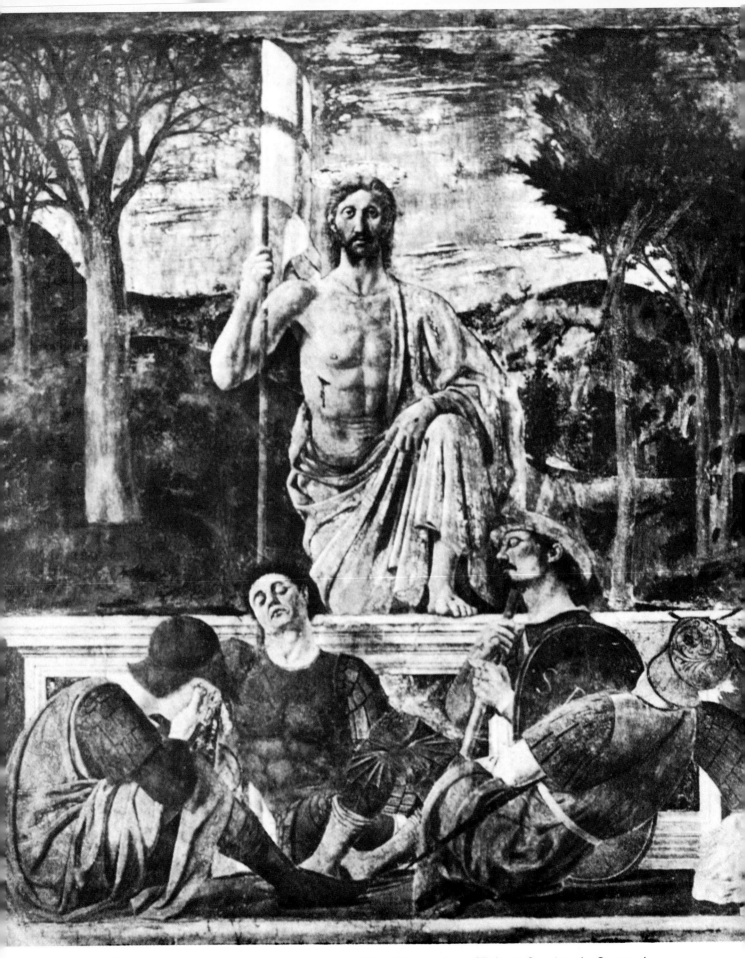

26. Piero della Francesca, <u>The Resurrection,</u> c. 1462-1464, courtesy of Palazzo Communale, Sansepolcro.

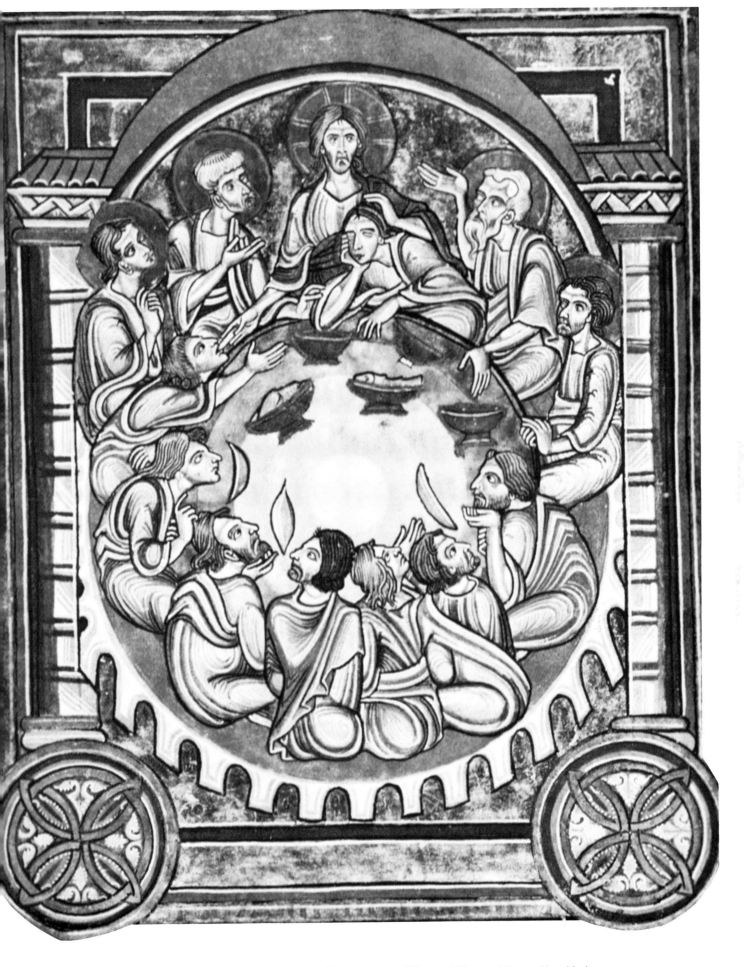

27. <u>Berthold Missal Last Supper.</u> c. 1225, courtesy of Pierpont Morgan Library, New York.

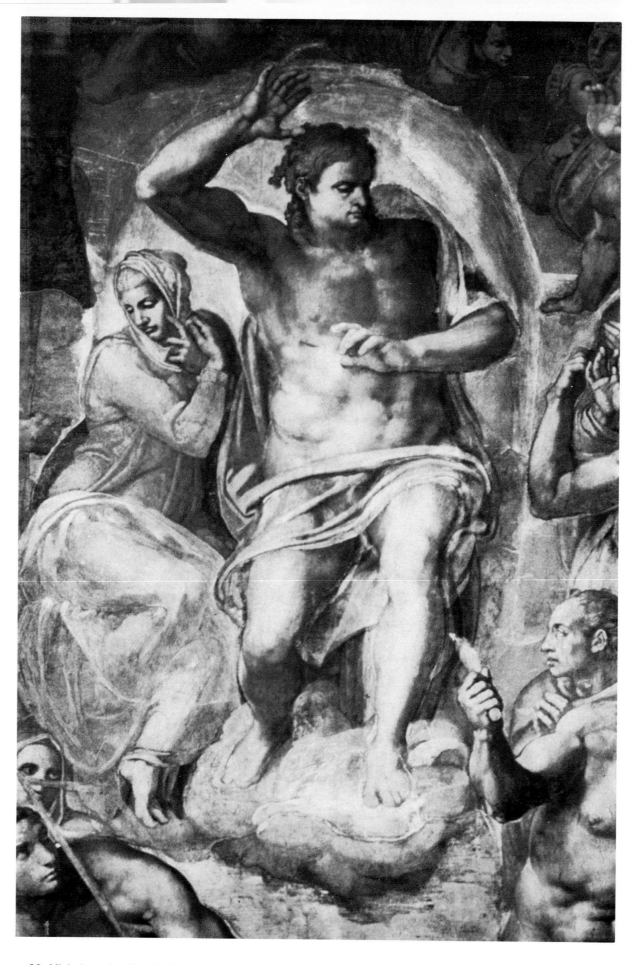

28. Michelangelo, "Detail of Christ in Judgment" from <u>The Last Judgment.</u> 1541, courtesy of the Sistine Chapel, Vatican City.

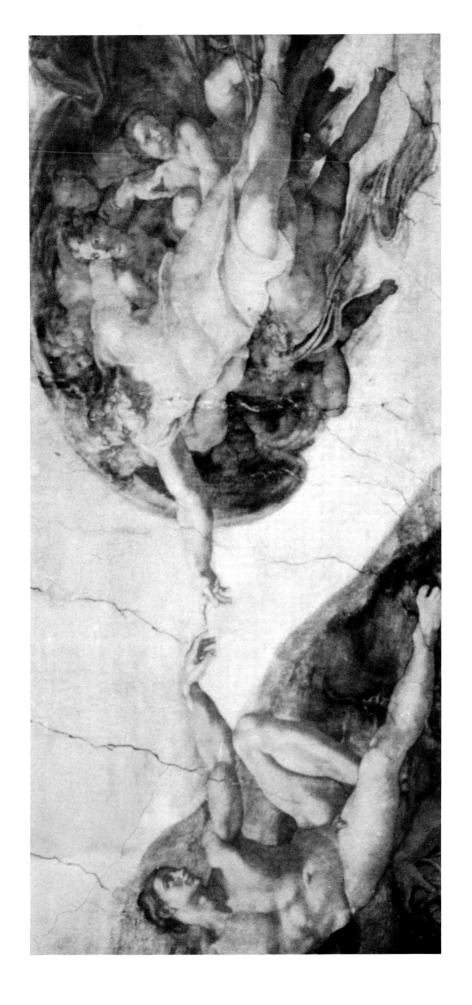

29. Michelangelo, The Creation of Adam, c. 1511, courtesy of the Sistine Chapel, Vatican City.

30. Michelangelo, Temptation and Expulsion, c. 1511, courtesy of the Sistine Chapel, Vatican City.

31. Salvador Dali, The Sacrament of the Lord's Supper. 1955, courtesy of the National Gallery of Art, Washington D.C.

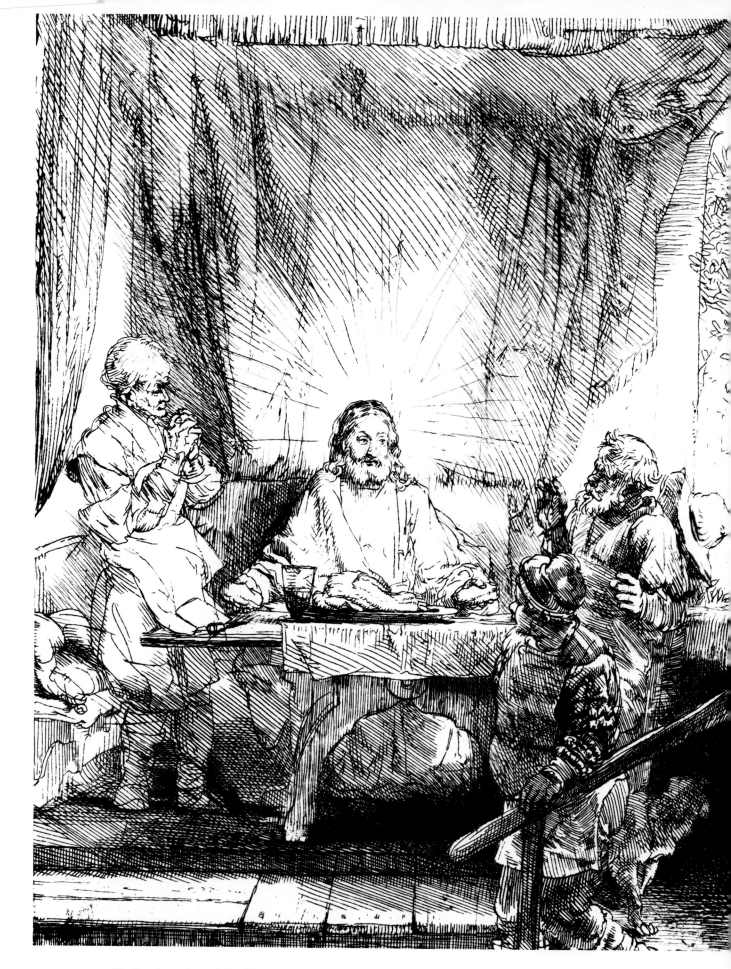

32. Rembrandt van Rijn, <u>Christ at Emmaus,</u> mid 17th century, courtesy of the National Gallery of Art, Washington D.C.

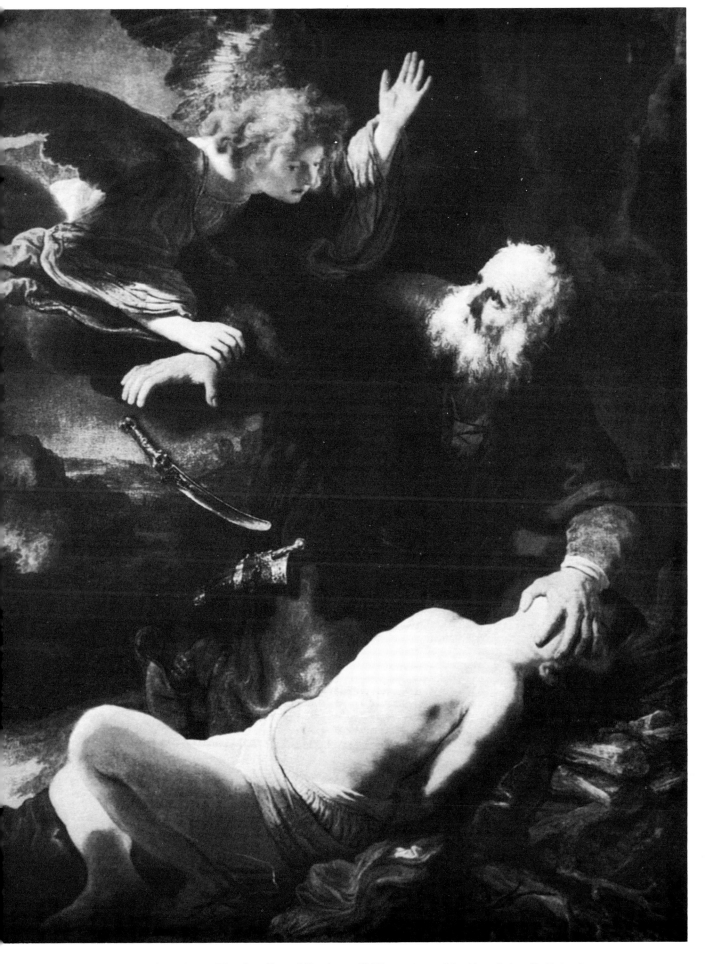

33. Rembrandt van Rijn, <u>Sacrifice of Abraham,</u> 1635, courtesy of the Hermitage, St. Petersburg

143

34. Jack Levine, <u>Sacrifice of Isaac,</u> 1974, courtesy of Jack Levine.

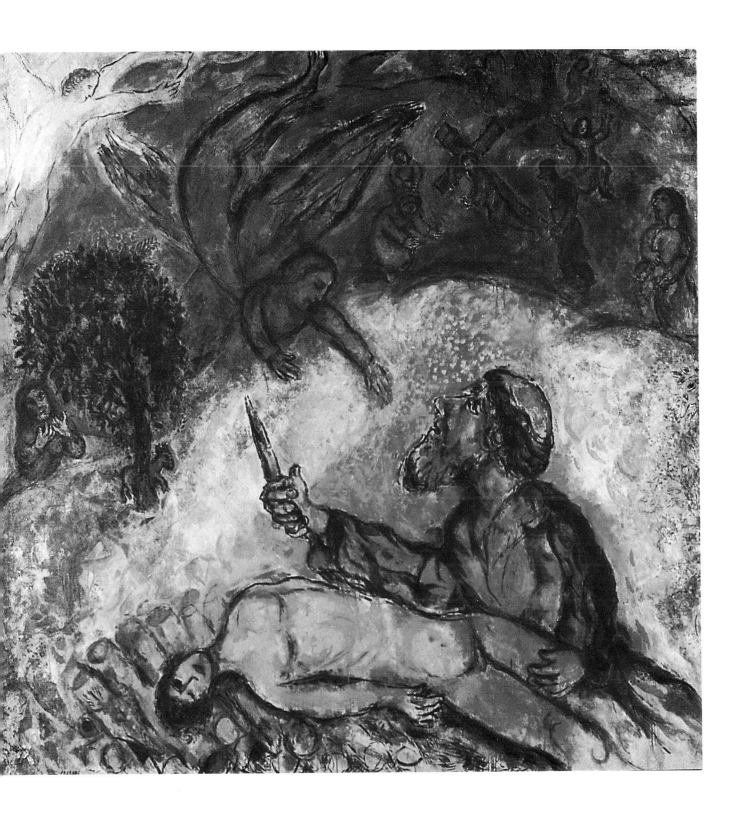

35. Marc Chagall, <u>The Sacrifice of Isaac,</u> 1935, courtesy of Musée National Message Biblique Marc Chagall, Nice.

146

37. Marc Chagall, Moses Before the Burning Bush, n.d., courtesy of the Musée National Message Biblique Marc Chagall, Nice.

38. Mathias Grünewald, <u>Resurrection</u> detail of the <u>Isenheim Altarpiece,</u> 1515, courtesy of the Musée d'Unterlinden, Colmar.

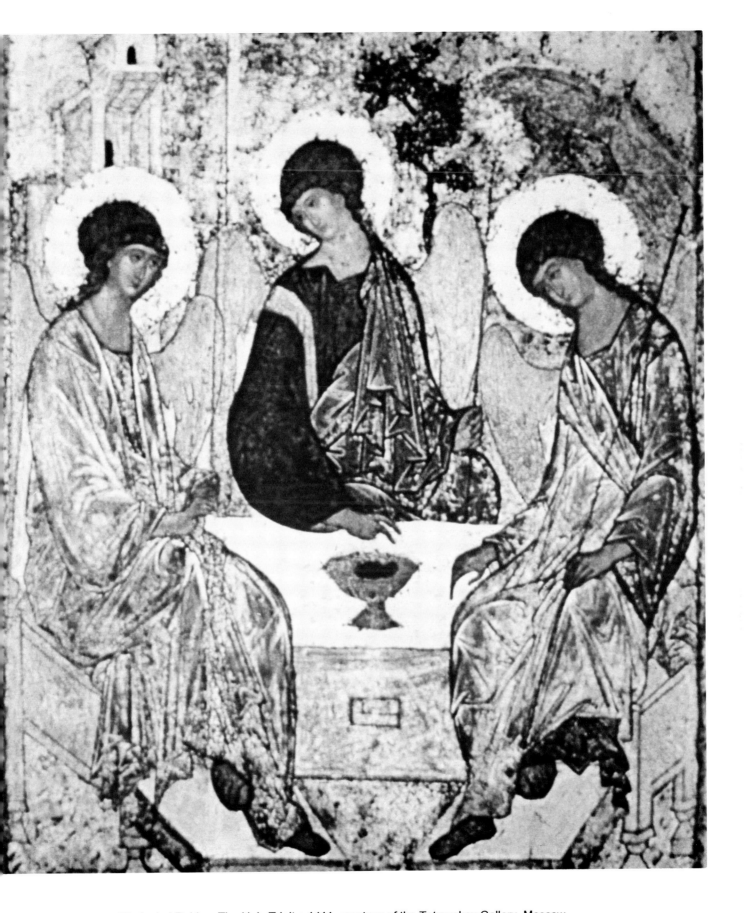

39. Andrei Rublev, The Holy Trinity, 1411, courtesy of the Tetreyekov Gallery, Moscow.

40. <u>Old Testament Trinity,</u> 1410, courtesy of the Russian Museum, St. Petersburg.

41. El Greco, <u>St. Francis,</u> c. 1590-1604, courtesy of The Art Institute of Chicago.

42. Christo, The Running Fence, Sonoma and Marin Counties, California, 1972-1976. Photograph by Gianfranco Gorgoni, courtesy of Christo.

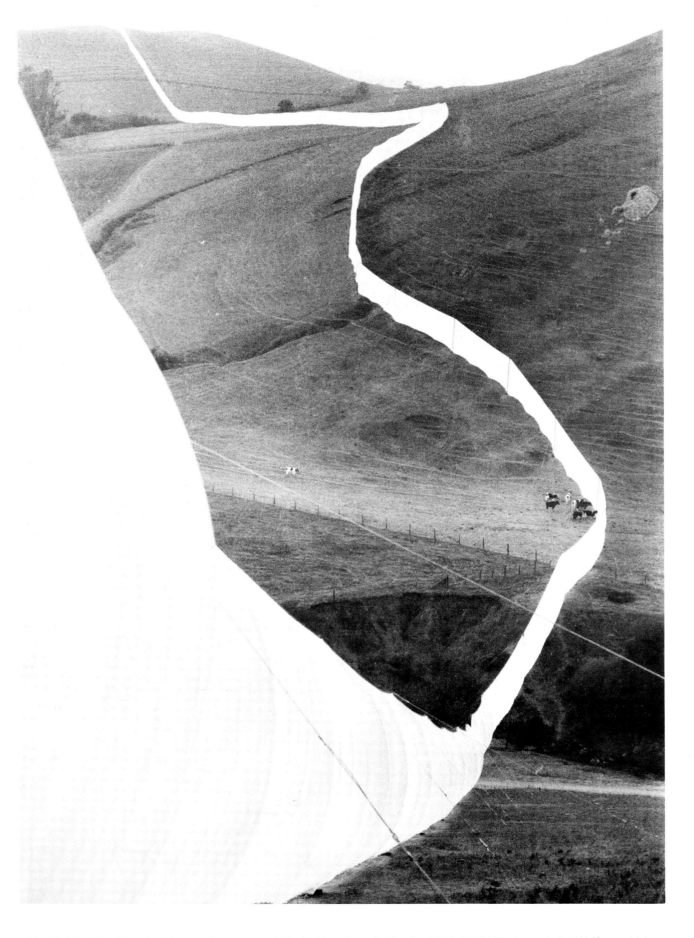

43. Christo, <u>The Running Fence, Sonoma and Marin Counties, California,</u> 1972-1976. Photograph by Wolfgang Volz, ourtesy of Christo.

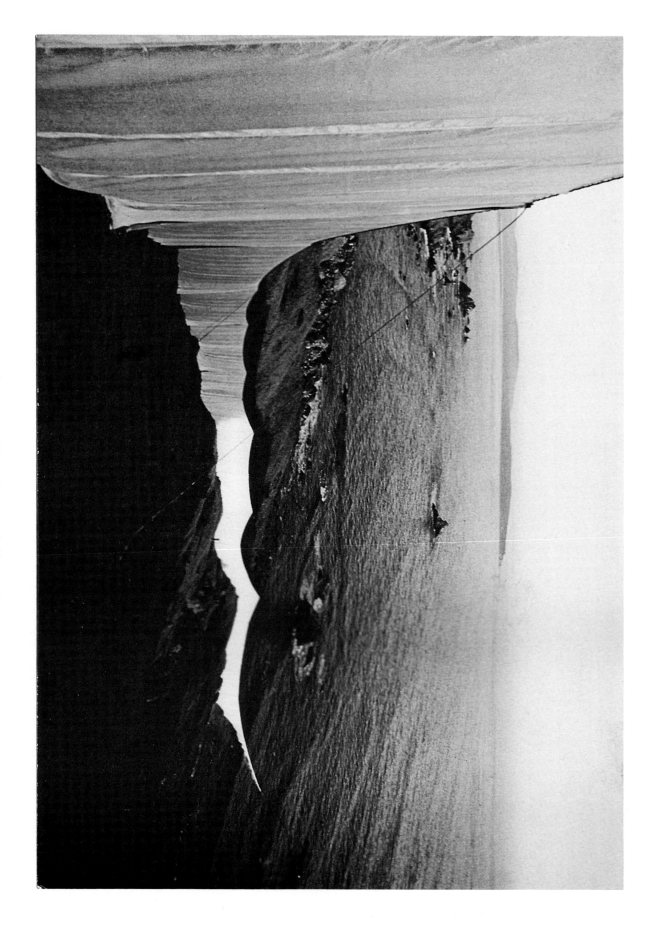

44. Christo, The Running Fence, Sonoma and Marin Counties, California, 1972-1976. Photograph by Wolfgang Volz, courtesy of Christo.

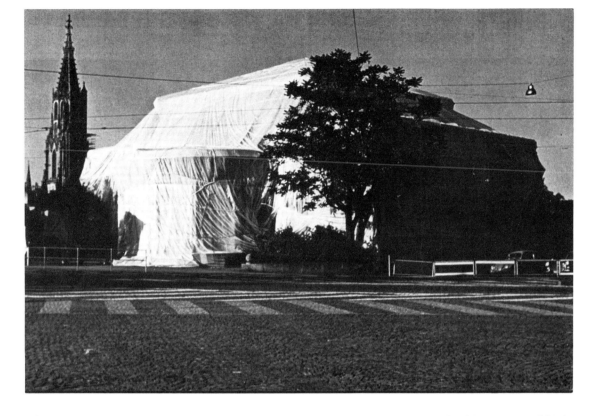

45. Christo, <u>Wrapped Kunsthalle, Bern, Switzerland,</u> 1968. Photograph by Thomas Cugini, courtesy of Christo.

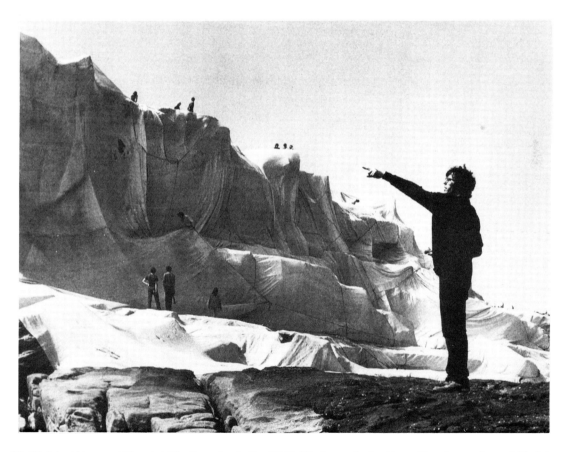

46. Christo, <u>Wrapped Coast, Little Bay, Australia,</u> 1969. Photography by Harry Shunk, courtesy of Christo.

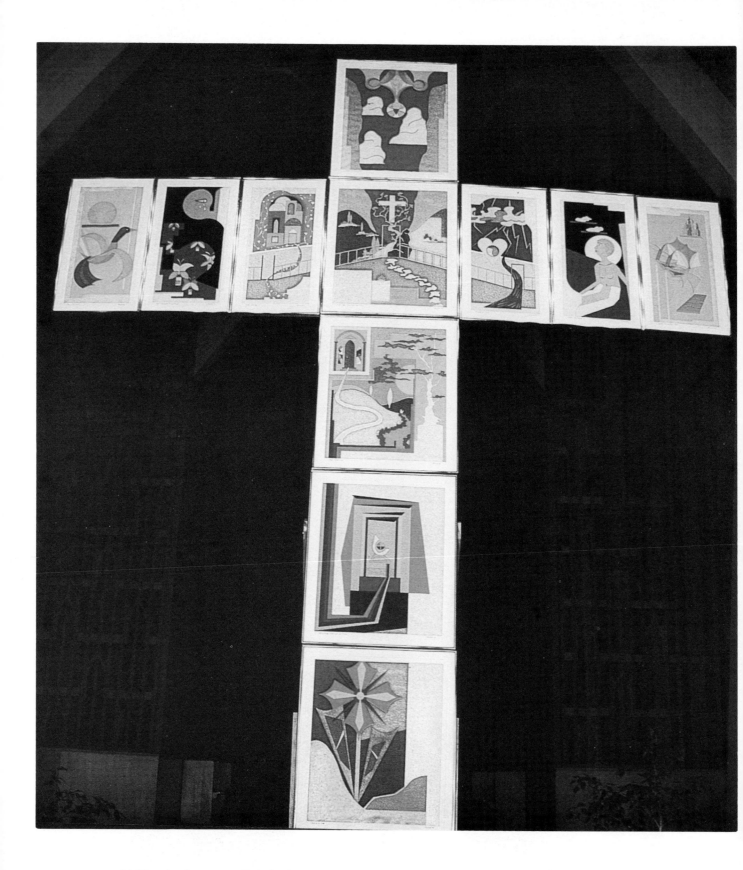

47. Timothy Grummon, <u>Panels of Love,</u> 1988. Photograph by Jann Weaver, courtesy of Timothy Grummon.

48. Jan van Hemessen, <u>Arise. Take Up Thy Bed. and Walk,</u> mid 16th century, courtesy of the National Gallery of Art, Washington D.C.

49. Jacques Callot, <u>Jesus and Saint Peter on the Water,</u> early 17th century, courtesy of the National Gallery of Art, Washington D.C.

50. The Master of the Retable of the Reyes Catolicos, <u>The Marriage at Cana,</u> late 15th century, courtesy of the National Gallery of Art, Washington D.C.

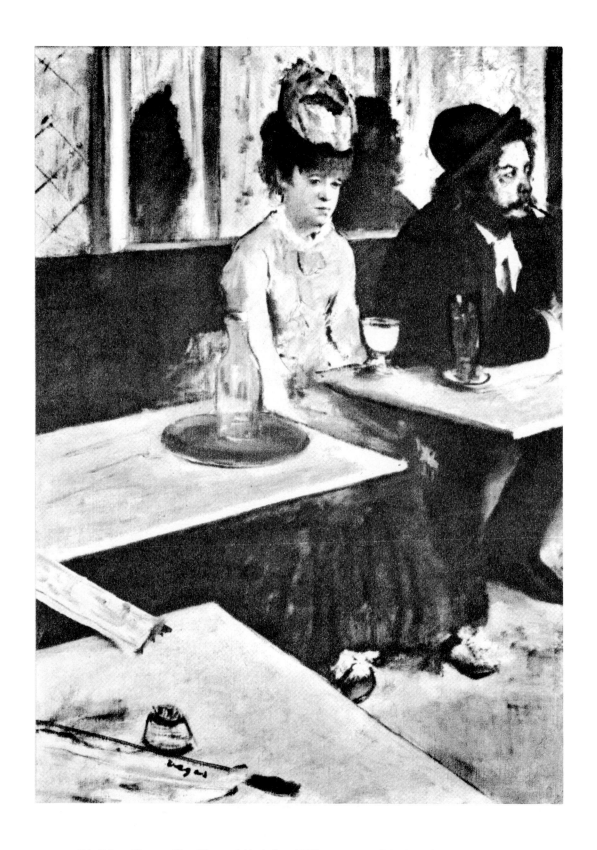

51. Edgar Degas, <u>The Glass of Absinthe,</u> 1878, courtesy of the Musée d'Orsay, Paris.

52. Camille Pissarro, <u>The Corner of Hermitage Garden,</u> 1877, courtesy of the Musée d'Orsay, Paris.

53. Auguste Renoir, Seine at Argenteuil, 1873, courtesy of the Musée d'Orsay, Paris.

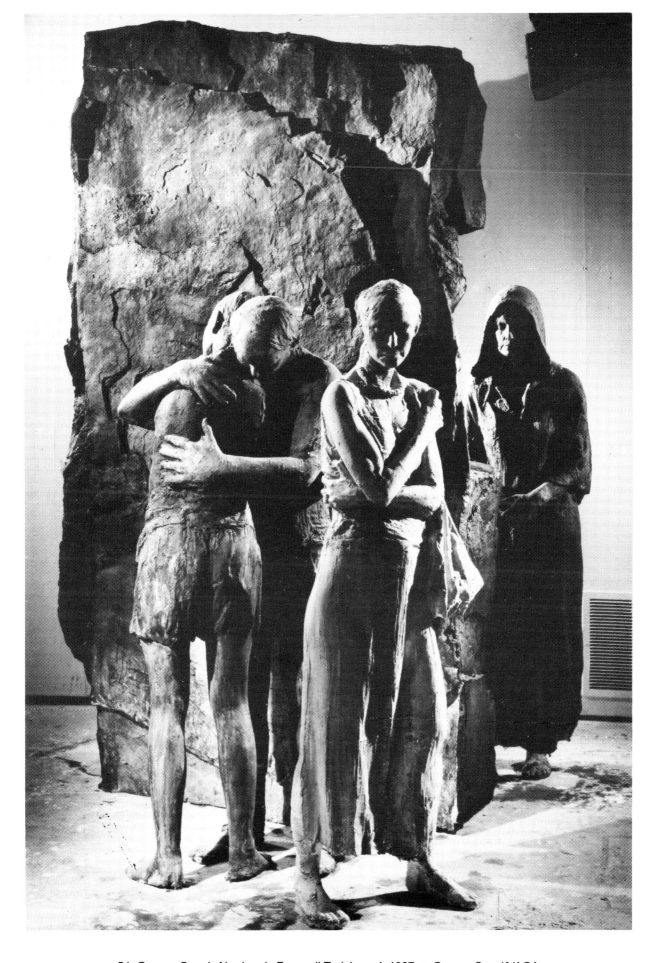

54. George Segal, <u>Abraham's Farewell To Ishmael,</u> 1987, c. George Segal/VAGA.

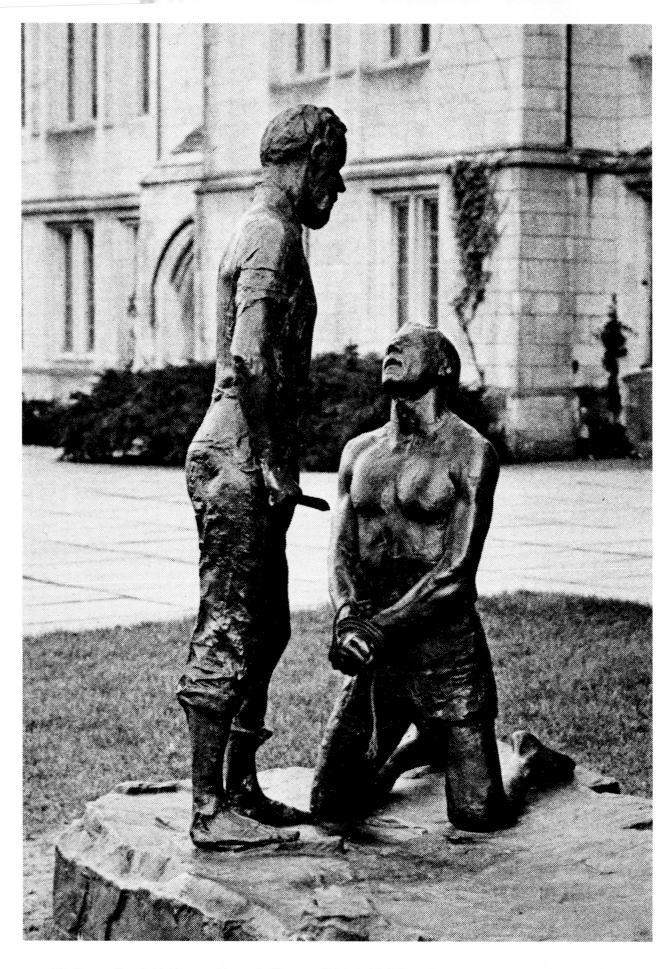

55. George Segal, <u>Abraham and Isaac: In Memory of May 4, 1970, Kent State,</u> 1978, c. George Segal/VAGA.

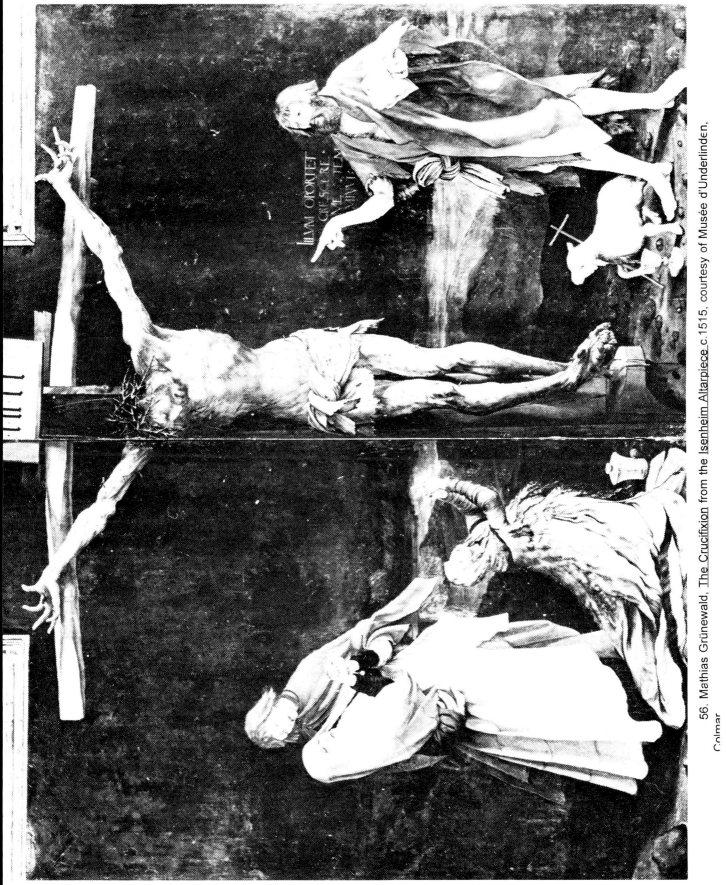

56. Mathias Grünewald, The Crucifixion from the Isenheim Altarpiece c.1515, courtesy of Musée d'Underlinden, Colmar

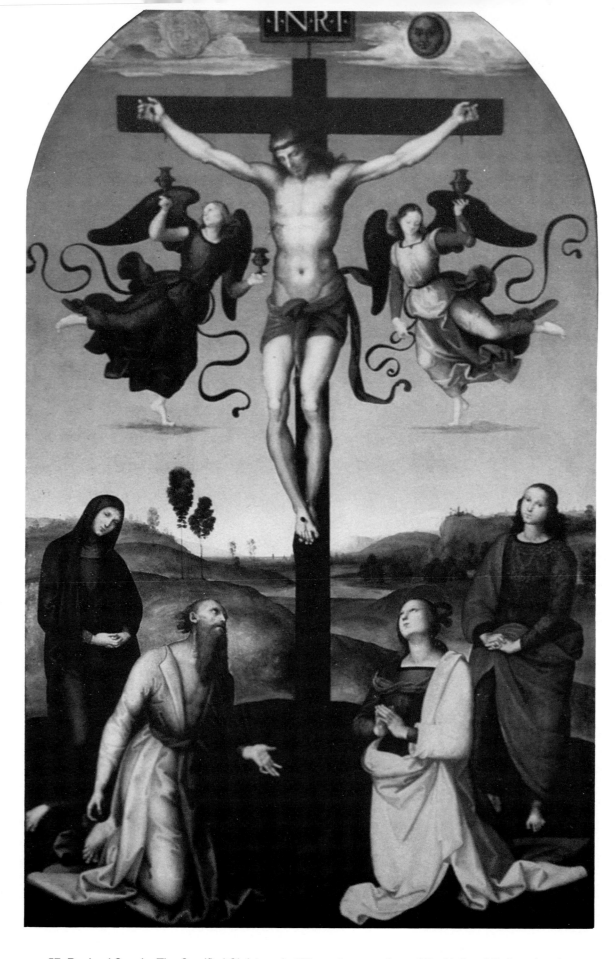

57. Raphael Sanzio, <u>The Crucified Christ,</u> early 16th century, courtesy of the National Gallery, London.

58. Master of Saint Veronica, The Crucifixion, c. 1400-1410, courtesy of the J. Paul Getty Museum, Malibu.

59. Barbara Baumgarten, Two Praying at Temple, 1984, courtesy of Barbara Baumgarten.

60. Barbara Baumgarten, <u>Woman,</u> 1985, courtesy of Barbara Baumgarten.

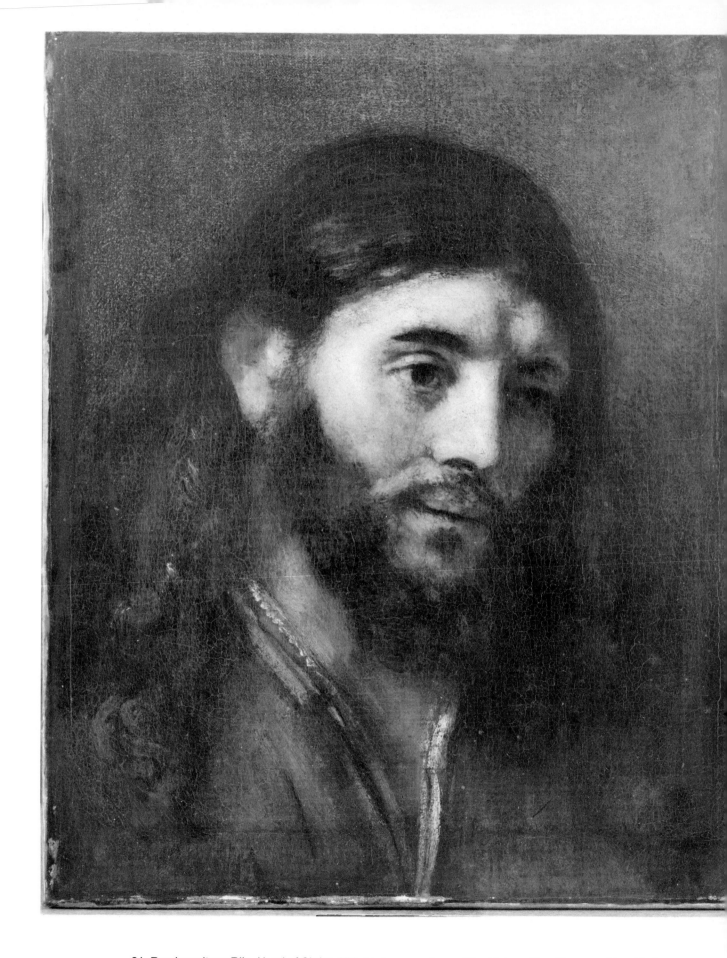

61. Rembrandt vanRijn, <u>Head of Christ,</u> 17th century, courtesy of the Metropolitan Museum, New York.

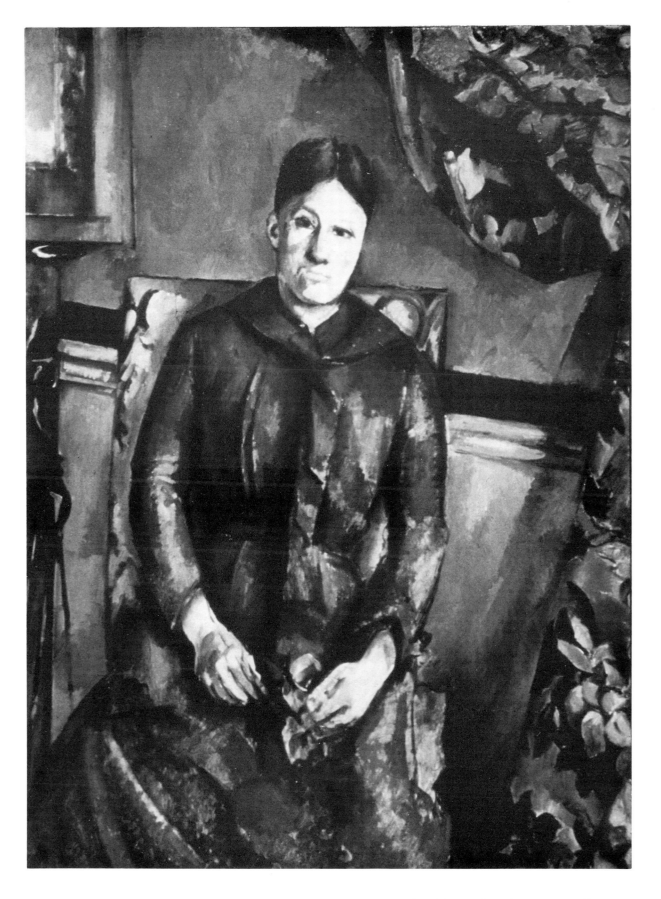

62. Paul Cezanne, <u>Madame Cezanne,</u> late 19th century, courtesy of the Metropolitan Museum, New York.

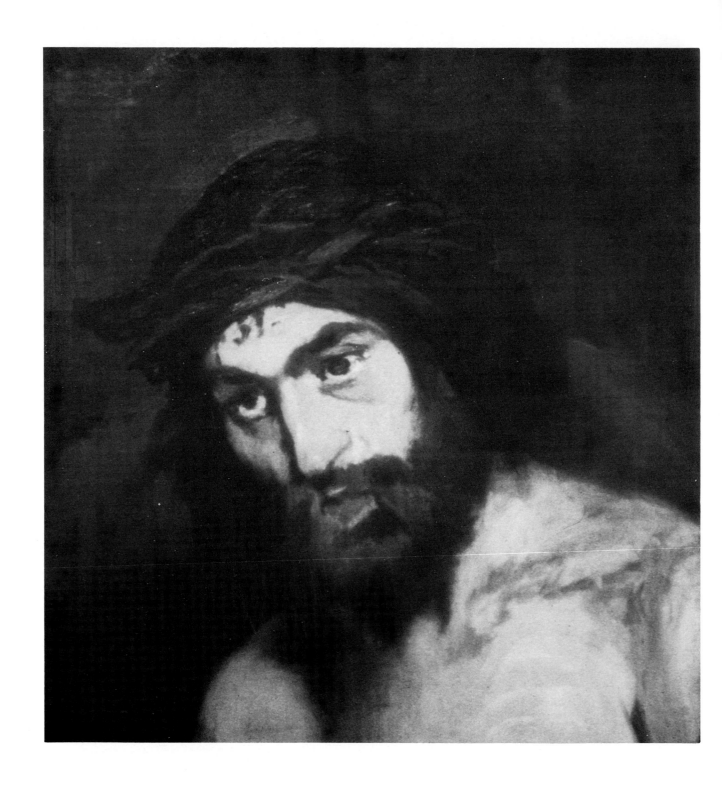

63. Edouard Manet, <u>Christ,</u> l9th century, courtesy of the Legion of Honor Museum, San Francisco.

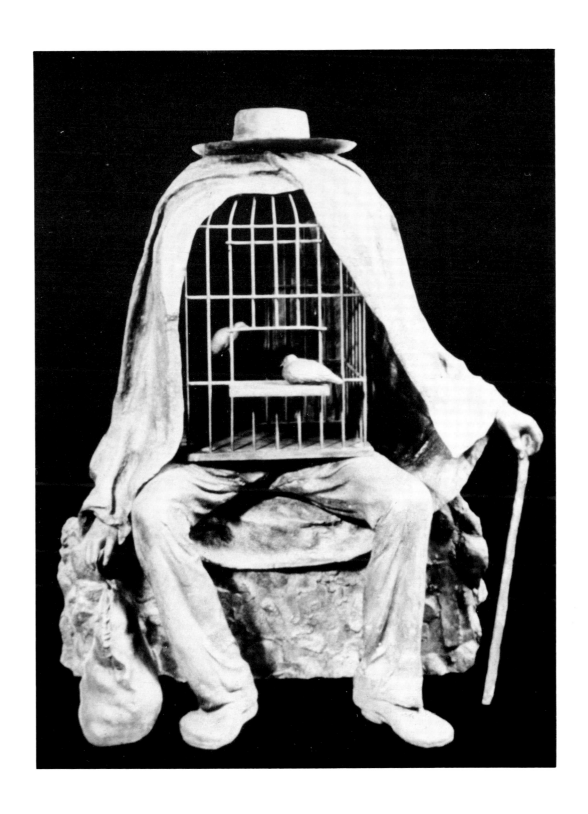

64. Rene Magritte, <u>The Therapeutist,</u> 1967, courtesy of the Hirshhorn Museum, Washington D.C.

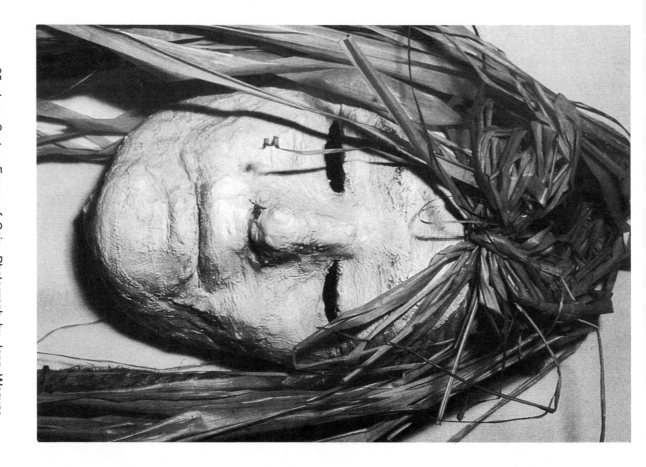

65. Joan Carter, Faces of Cain. Photograph by Jann Weaver, courtesy of Joan Carter.

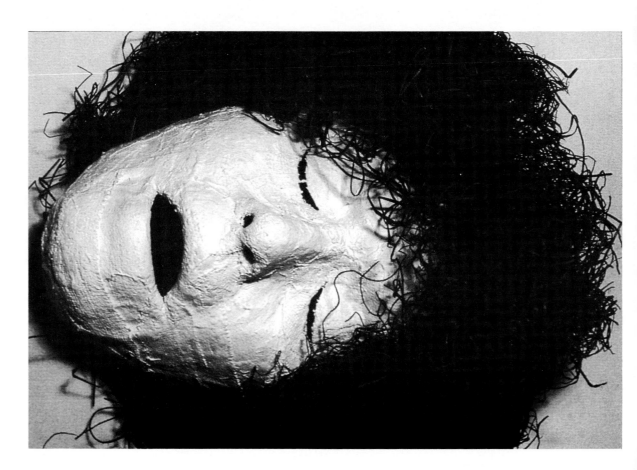

66. Joan Carter, Faces of Cain. Photograph by Jann Weaver, courtesy of Joan Carter.

68. Joan Carter, Faces of Cain. Photograph by Jann Weaver, courtesy of Joan Carter.

67. Joan Carter, Faces of Cain. Photograph by Jann Weaver, courtesy of Joan Carter.

175

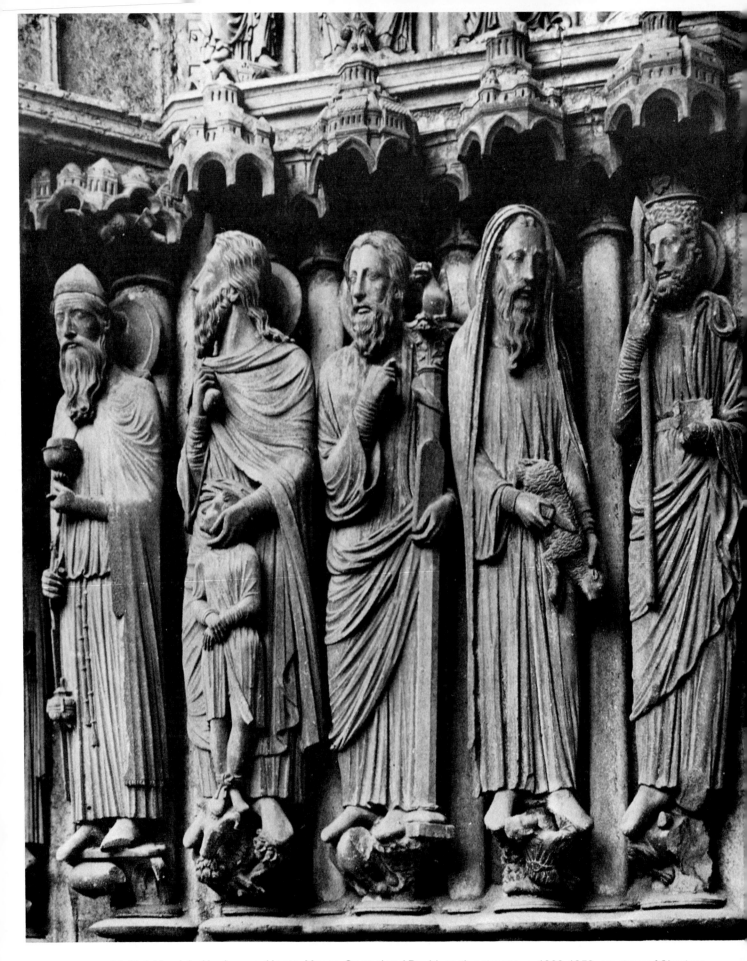

69. <u>Melchizedek, Abraham and Isaac, Moses, Samuel and David,</u> north entrance, c. 1230-1250, courtesy of Chartres Cathedral.

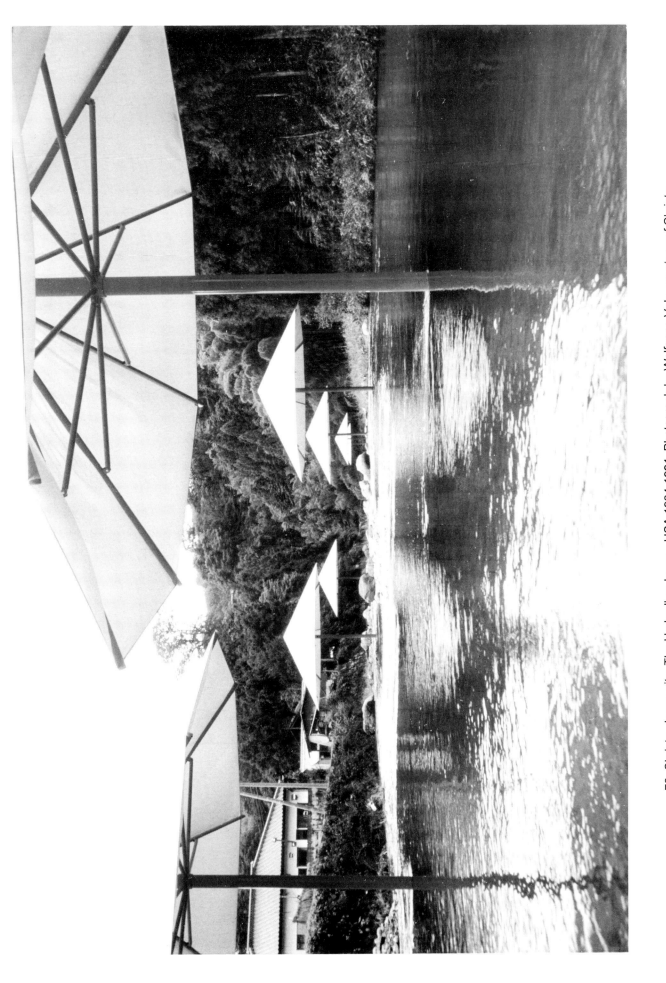

70. Christo, Japan site, The Umbrellas Japan - USA 1984-1991. Photograph by Wolfgang Volz, courtesy of Christo.

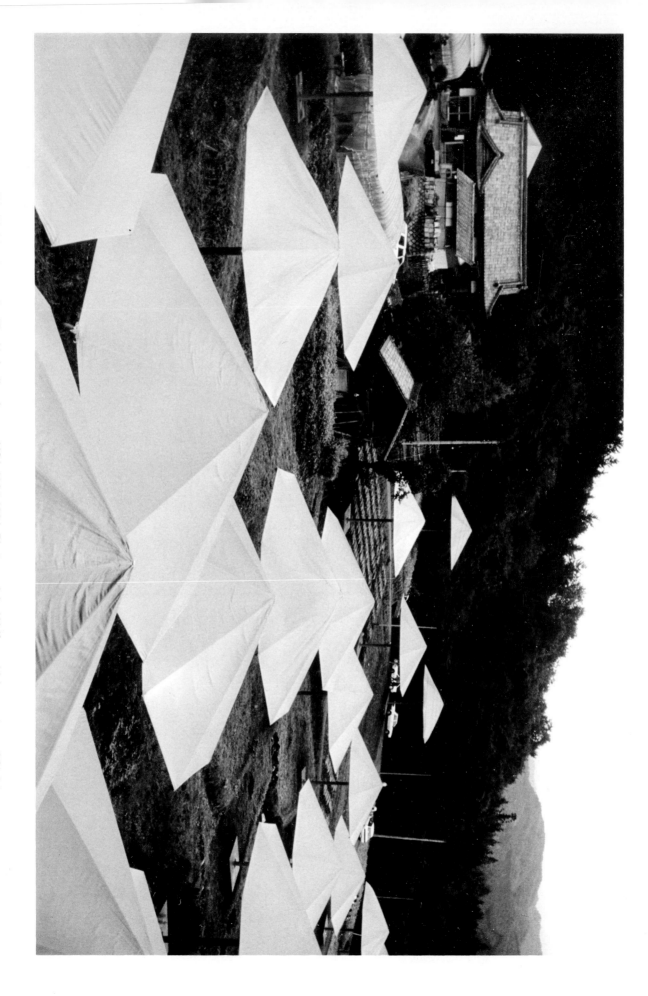

71. Christo, Japan site, The Umbrellas Japan - USA 1984-1991. Photograph by Wolfgang Volz, courtesy of Christo.

178

72. Christo, USA site, The Umbrellas Japan - USA 1984-1991. Photograph by Wolfgang Volz, courtesy of Christo.

179

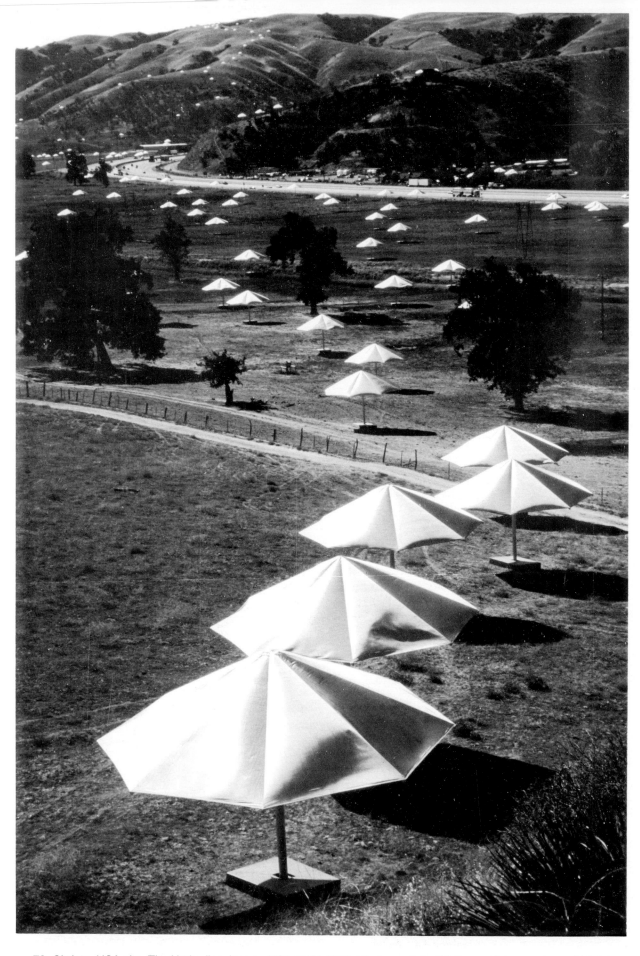

73. Christo, USA site, <u>The Umbrellas Japan - USA 1984-1991</u>. Photograph by Wolfgang Volz, courtesy of Christo.

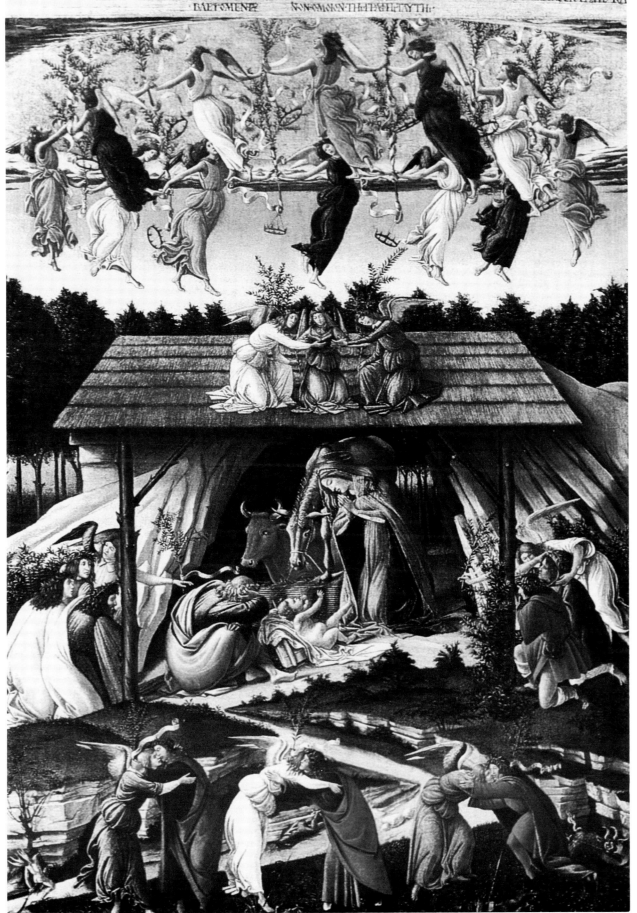

74. Sandro Botticelli, <u>Mystic Nativity,</u> ca. 1500, courtesy of the National Gallery, London.

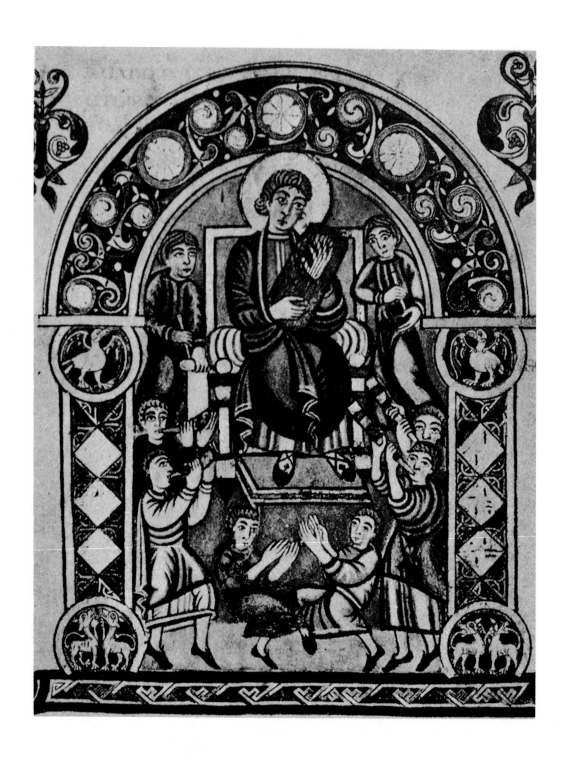

75. <u>David,</u> eighth century, courtesy of the British Museum.

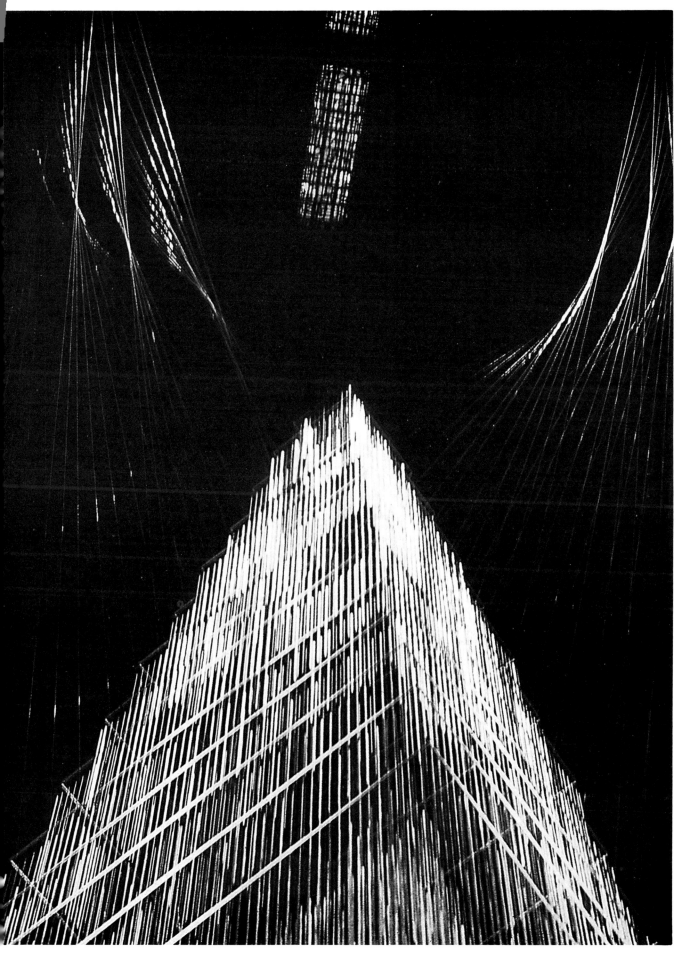

76. Richard Lippold, <u>Baldacchino,</u> 1969-1970, courtesy of St. Mary's Cathedral, San Francisco.

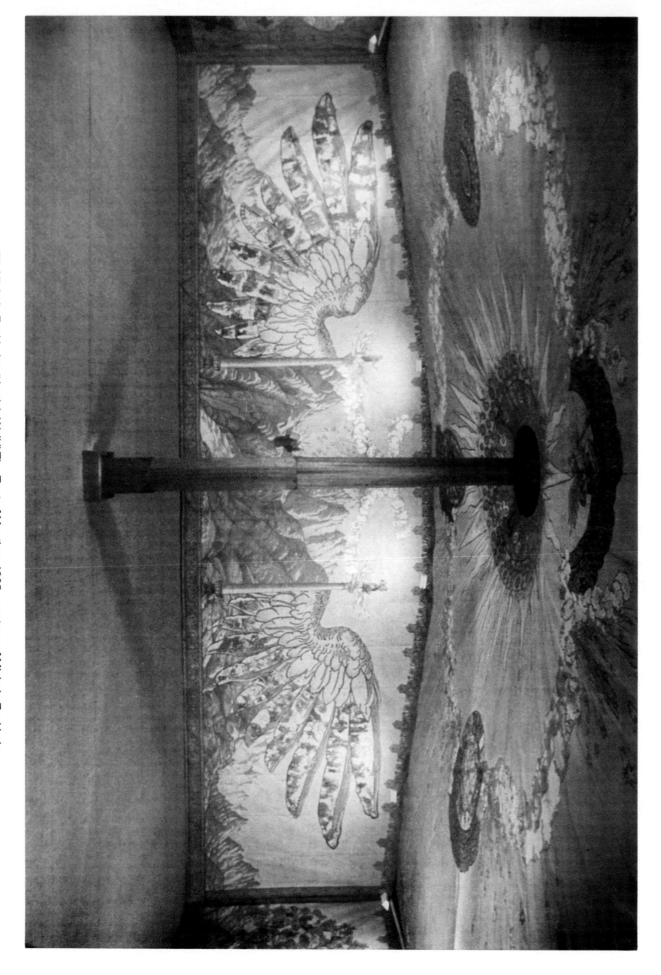

77. Michele Zackheim, "Jewish Wall," The Tent of Meeting, 1985, courtesy of Michele Zackheim.

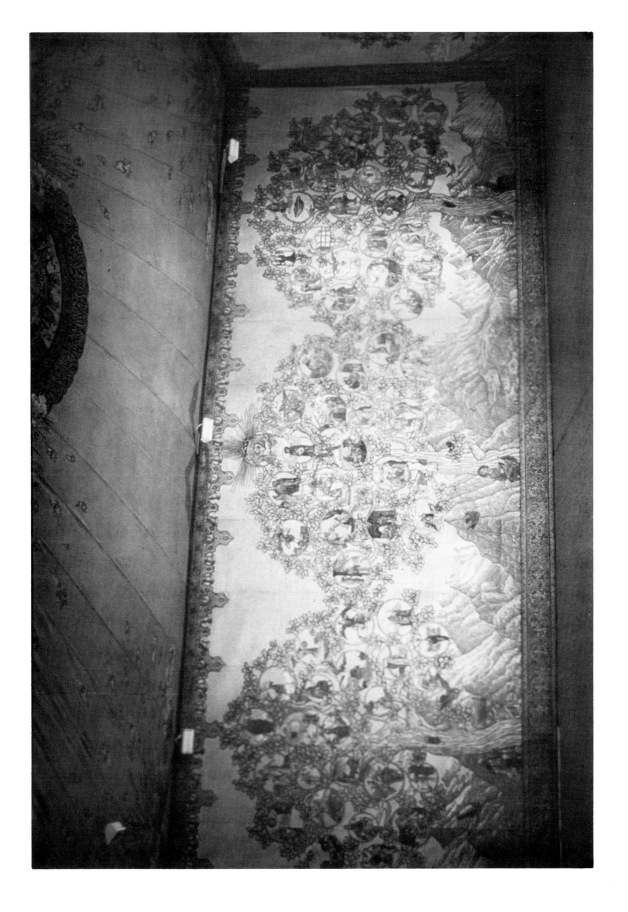

78. Michele Zackheim, "Christian Wall," The Tent of Meeting, 1985, courtesy of Michele Zackheim.

79. Michele Zackheim, "Mary and Elizabeth," The Tent of Meeting, 1985, courtesy of Michele Zackheim.

80. Hugo van der Goes, Portinari Altar~piece, 1475, courtesy of the Uffizi Gallery, Florence.

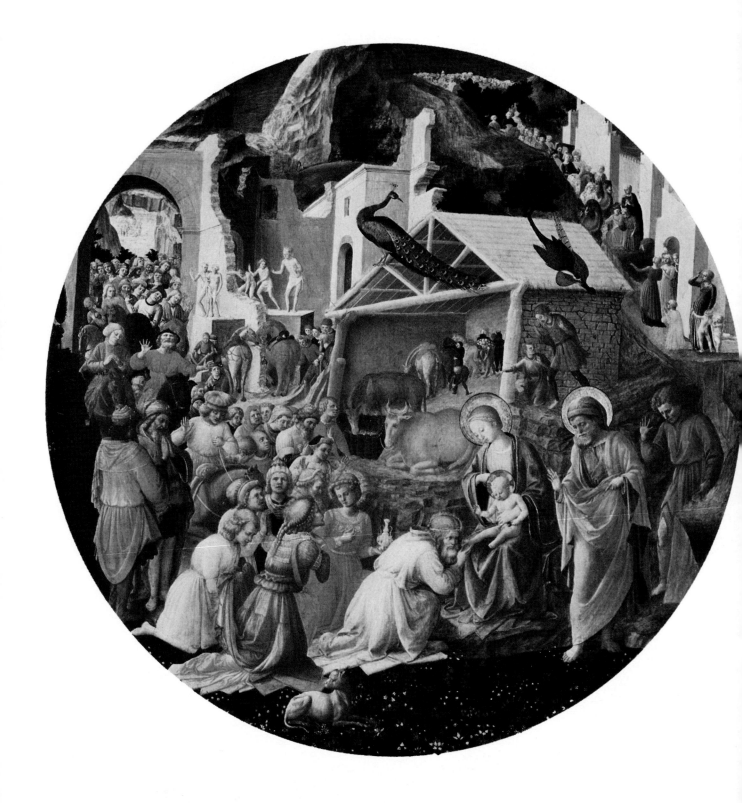

81. Fra Angelico and Fra Lippi, <u>The Adoration of the Magi,</u> fifteenth century, courtesy of the National Gallery of Art, Washington D.C..

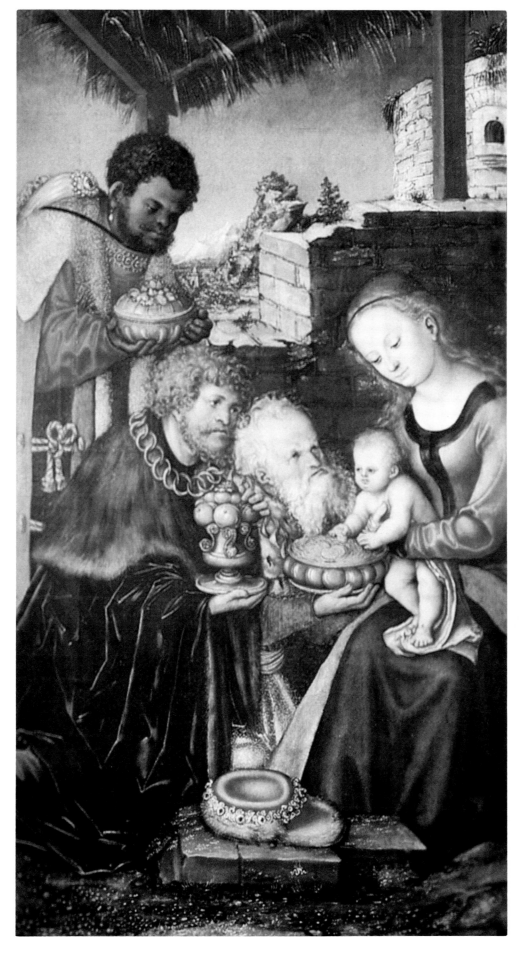

82. Lucas Cranach, <u>Adoration of the Magi,</u> 1514.

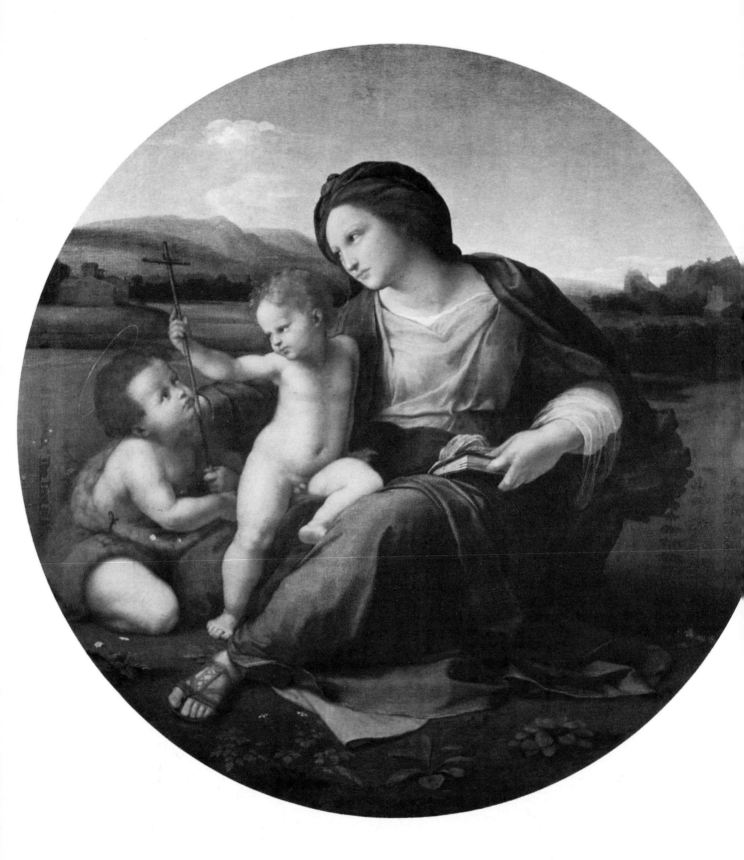

83. Raphael Sanzio, <u>The Alba Madonna,</u> 1508-1511, courtesy of the National Gallery of Art, Washington D.C.

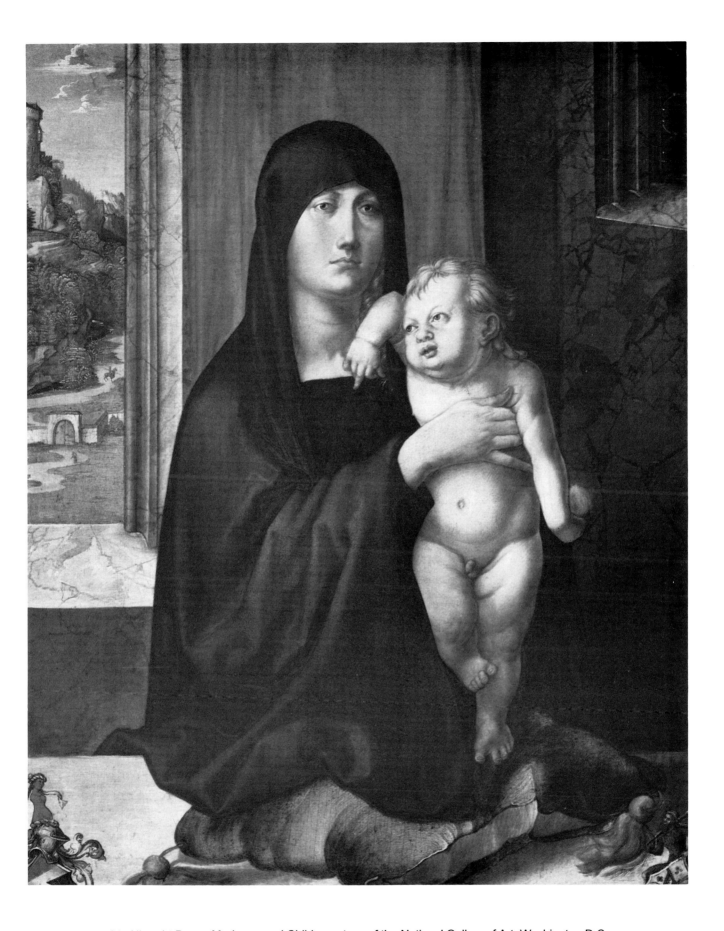

84. Albrecht Durer, <u>Madonna and Child,</u> courtesy of.the National Gallery of Art, Washington D.C.

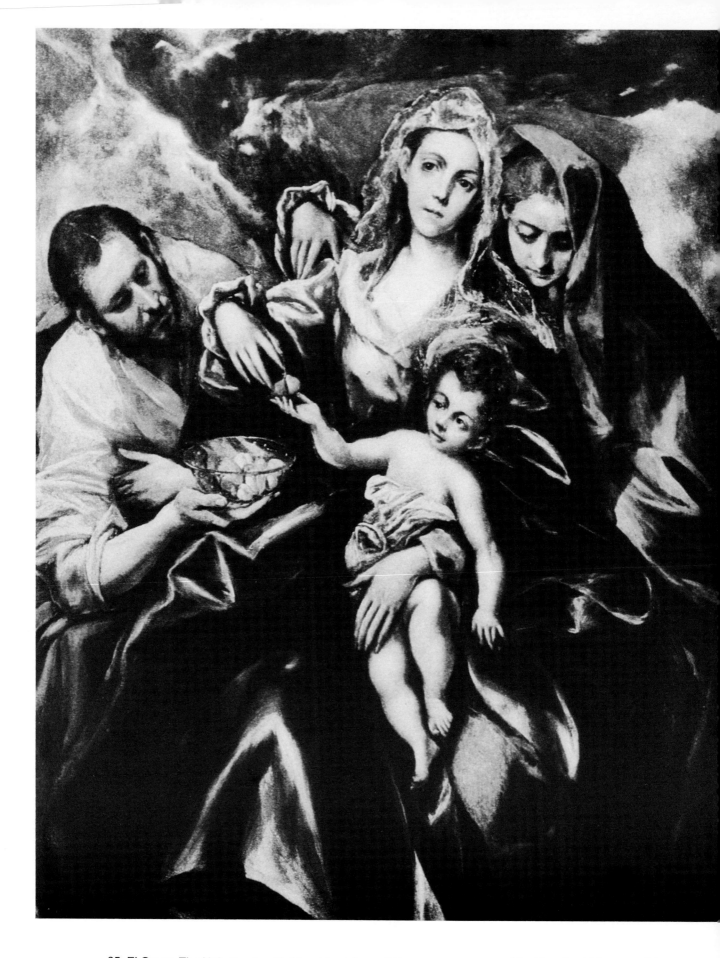

85. El Greco, <u>The Holy Family with Mary Magdalene,</u> 17th century, courtesy of the Cleveland Museum of Art.

86. Audrey Englert, <u>Expectant Madonna.</u> Photograph by Jann Weaver, courtesy of Audrey Englert.

87. Audrey Englert, Shepherd and Three Shepherdesses. Photograph by Jann Weaver, courtesy of Audrey Englert.

88. Audrey Englert, <u>Christa</u>. Photograph by Jann Weaver, courtesy of Audrey Englert.

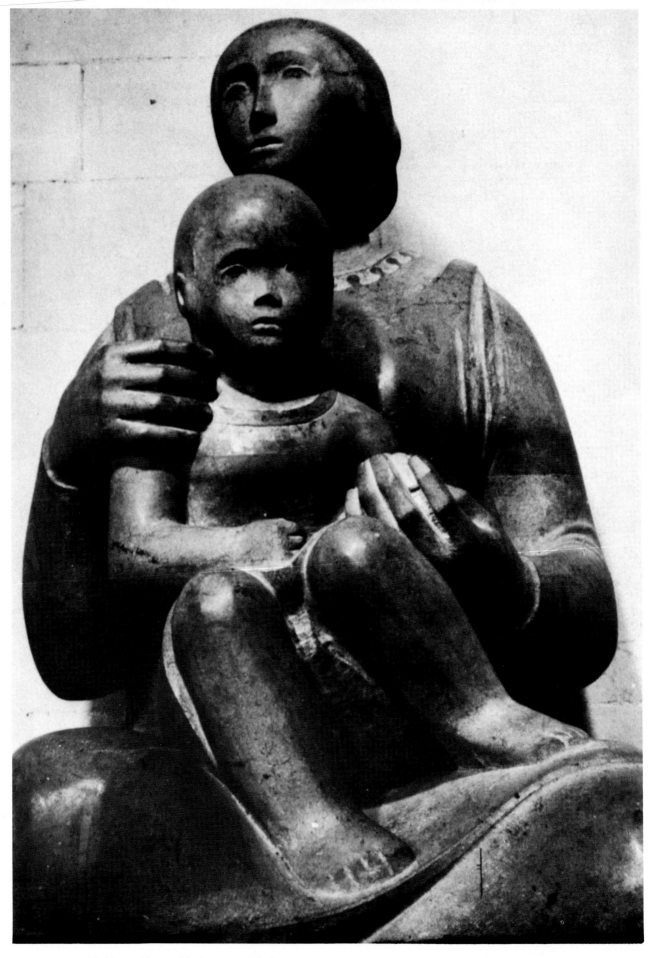

89. Henry Moore, <u>Madonna and Child,</u> 1942, courtesy of St. Matthew's Church, Northampton.

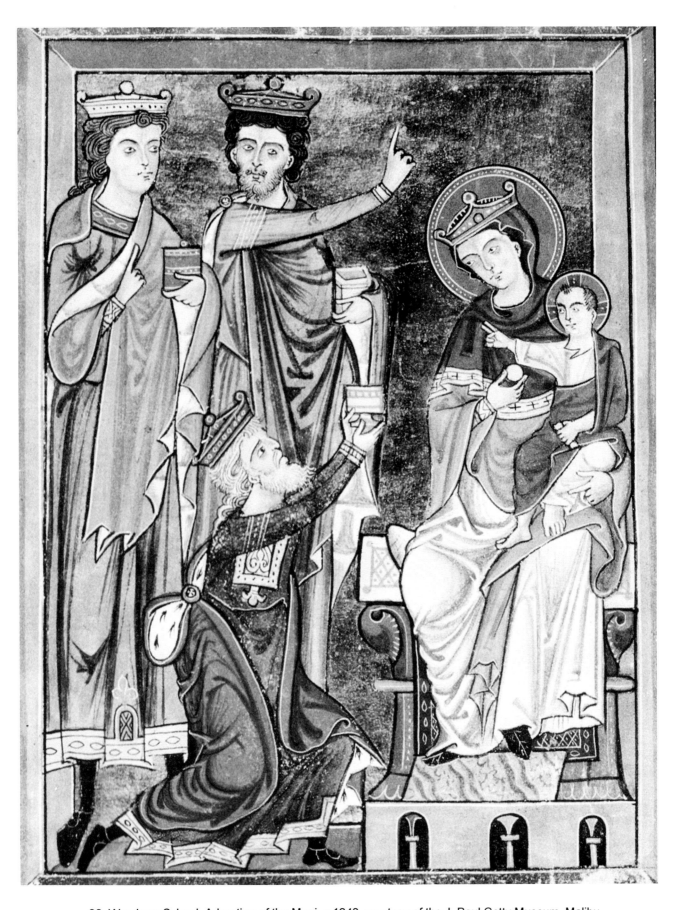

90. Wurzburg School, <u>Adoration of the Magi,</u> c.1240, courtesy of the J. Paul Getty Museum, Malibu.

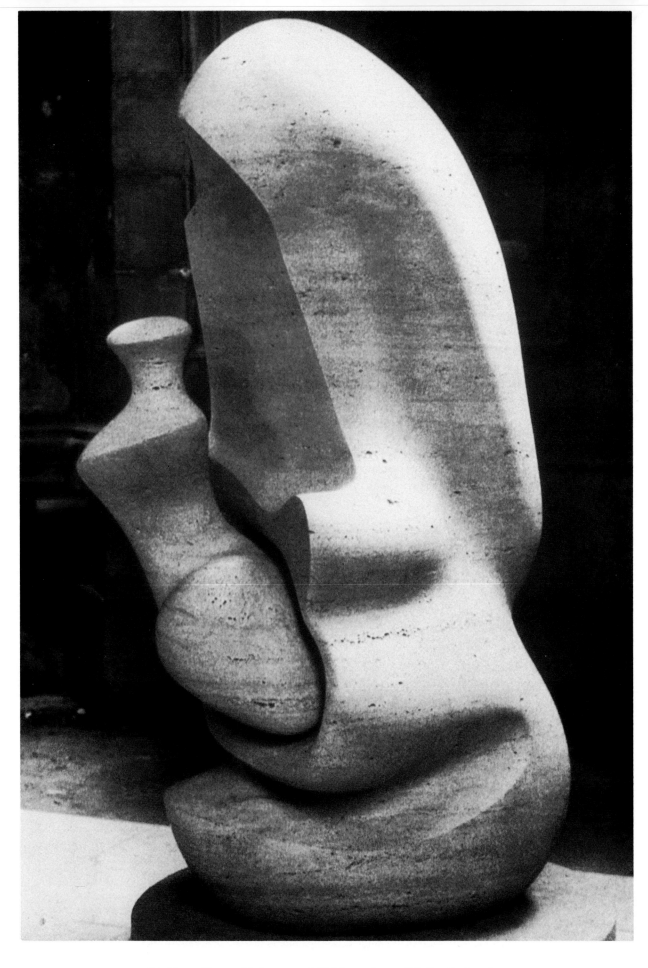

91. Henry Moore, <u>Madonna and Child,</u> courtesy of St. Paul's, London.

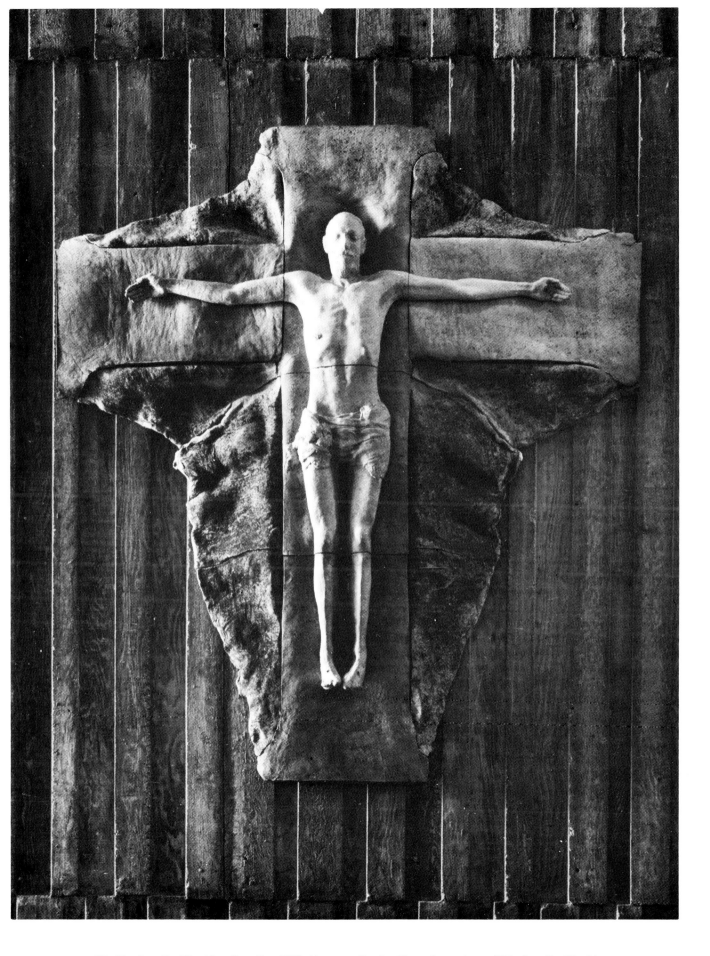

92. Stephen De Staebler, <u>Crucifix,</u> 1968, Newman Center Chapel, courtesy of Stephen De Staebler.

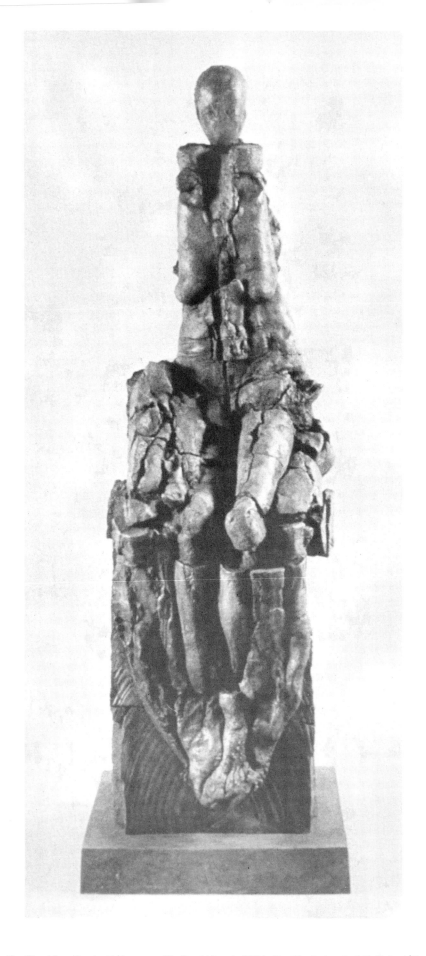

93. Stephen De Staebler, <u>Seated Woman with Oval Head,</u> 1981, Pacific School of Religion, Berkeley, *courtesy of* Stephen De Staebler.

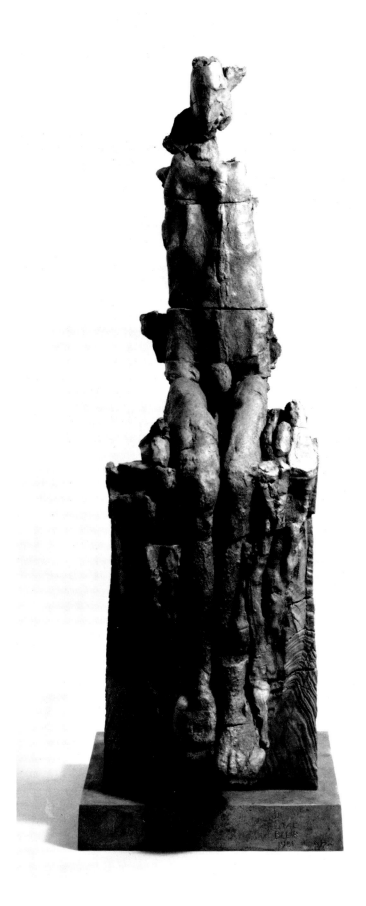

94. Stephen De Staebler, <u>Seated Man with Winged Head,</u> 1981, Pacific School of Religion, Berkeley, courtesy of Stephen De Staebler.

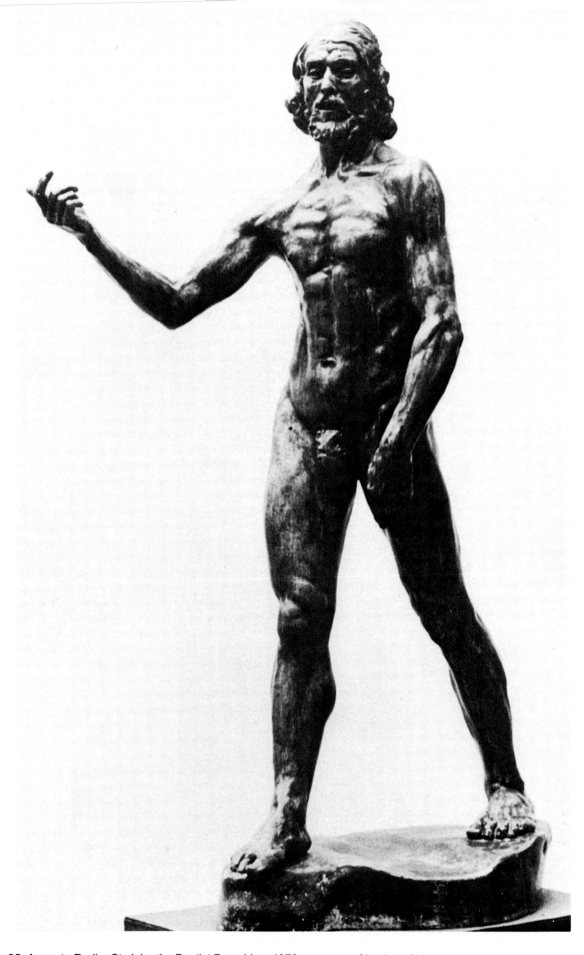

95. Auguste Rodin, <u>St. John the Baptist Preaching</u>, 1878, courtesy of Legion of Honor Museum, San Francisco.

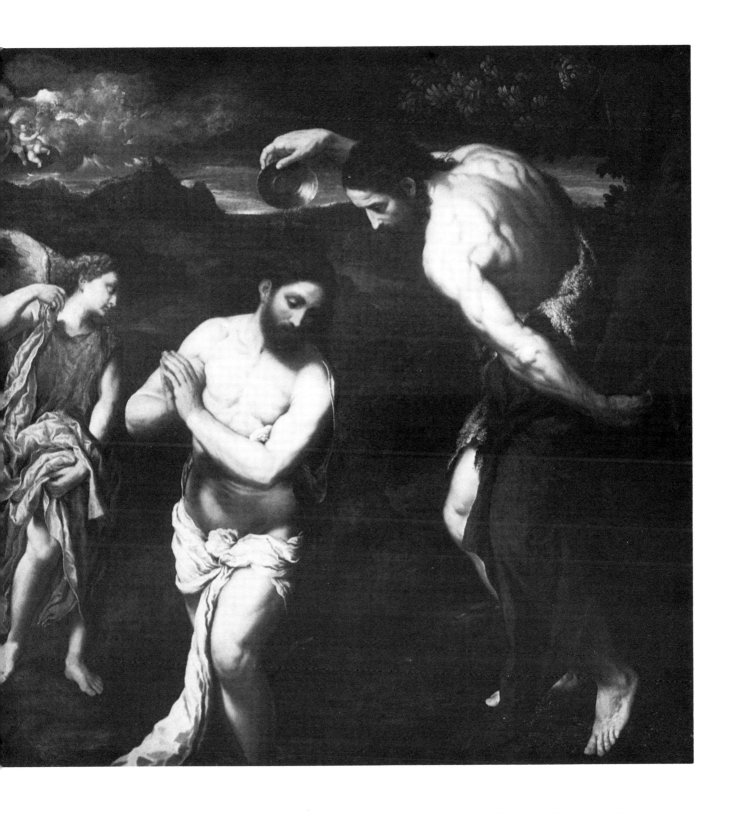

96. Paris Bordonne, <u>The Baptism of Christ.</u> 16th century, courtesy of the National Gallery of Art, Washington D.C.

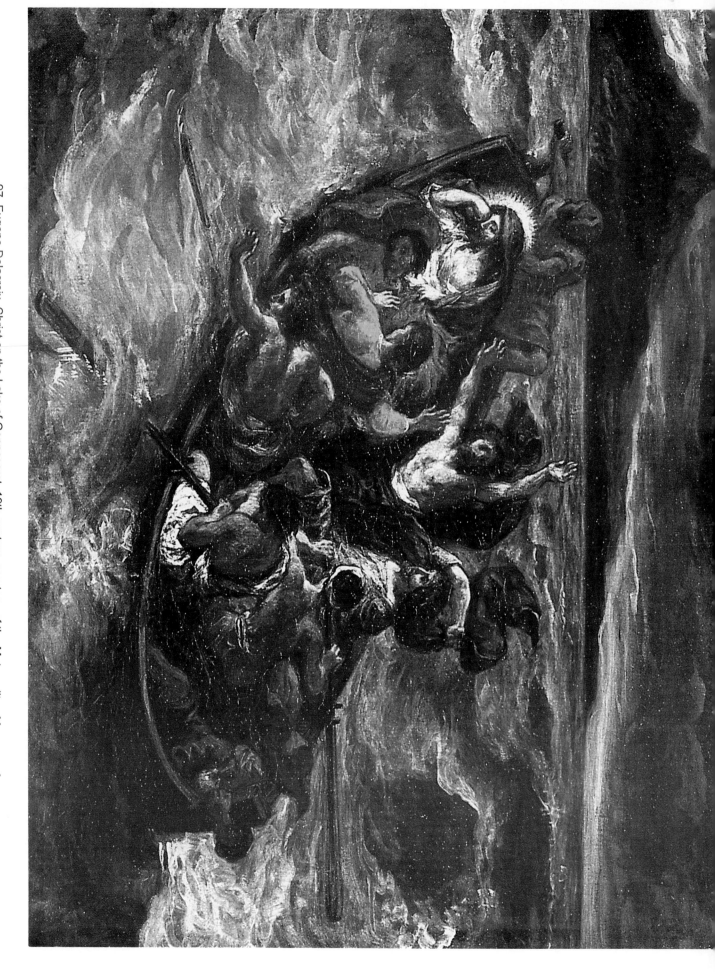

97. Eugene Delacroix, Christ on the Lake of Gennesaret, 19th century, courtesy of the Metropolitan Museum of Art, New York.

98. Thomas Cole, <u>Childhood,</u> from <u>Voyage of Life,</u> 1842, courtesy of the National Gallery of Art, Washington D.C.

99. Thomas Cole, <u>Youth,</u> from <u>Voyage of Life,</u> 1842, courtesy of the National Gallery of Art, Washington D.C.

100. Thomas Cole, <u>Manhood,</u> from <u>Voyage of Life,</u> 1842, courtesy of the National Gallery of Art, Washington D.C.

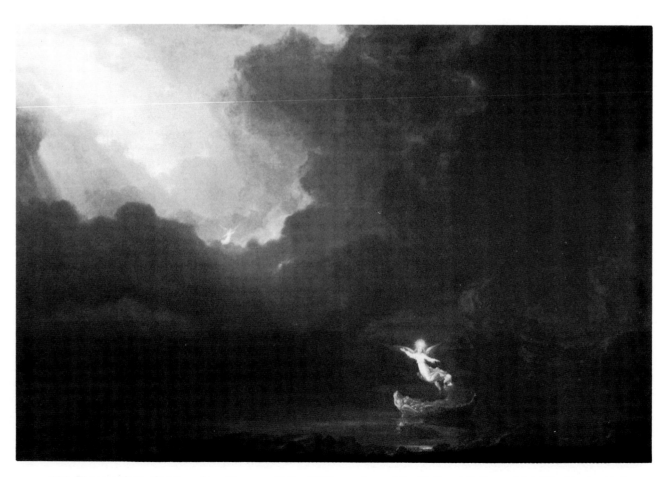

101. Thomas Cole, <u>Old Age,</u> from <u>Voyage of Life,</u> 1842, courtesy of the National Gallery of Art, Washington D.C.

102. Hough, engraving of <u>Youth</u> from <u>Voyage of Life.</u>

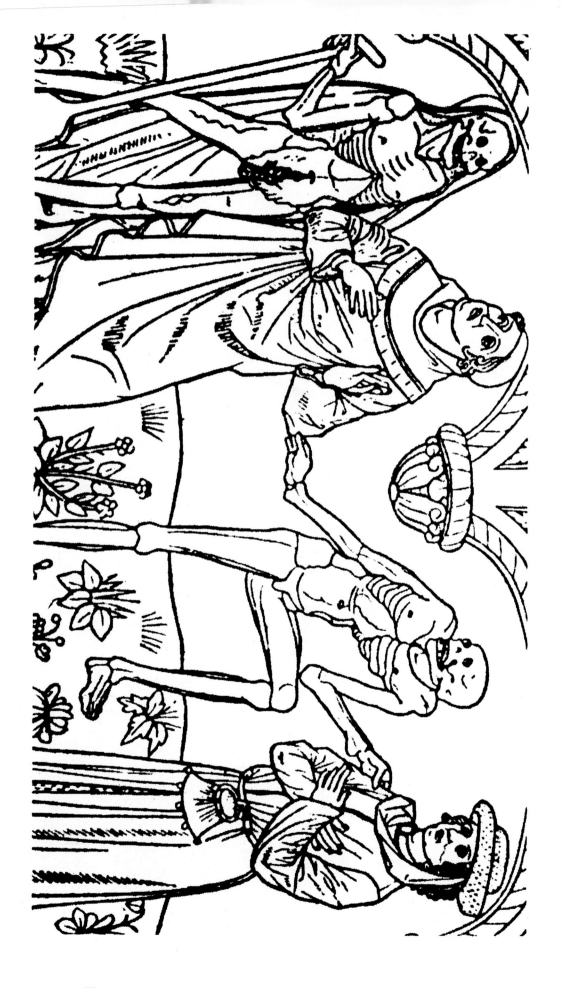

103. Marchant copy of Dance of Death from Innocents' church yard murals.

104. Giotto, <u>The Marriage at Cana</u>, 1303/1305, courtesy of the Scrovegni Chapel, Padua.

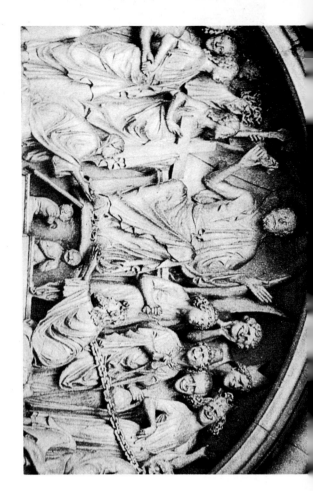

105. Last Judgment from Princes' Portal, Bamberg.

107. Doom Painting, South Leigh, Oxfordshire.

106. Last Judgment, west front central porch, courtesy of Notre Dame, Paris.

108. Woman and Dominican Jousting, late thirteenth century.

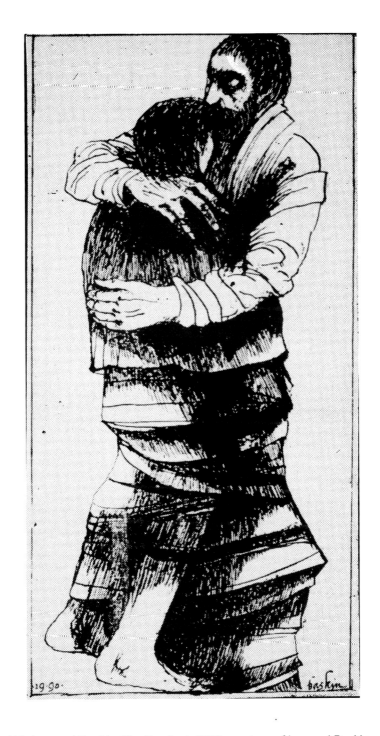

109. Leonard Baskin, The Prodigal, 1990, courtesy of Leonard Baskin.

110. Kellogg Company, <u>The Return of the Prodigal,</u> 1846-1847.

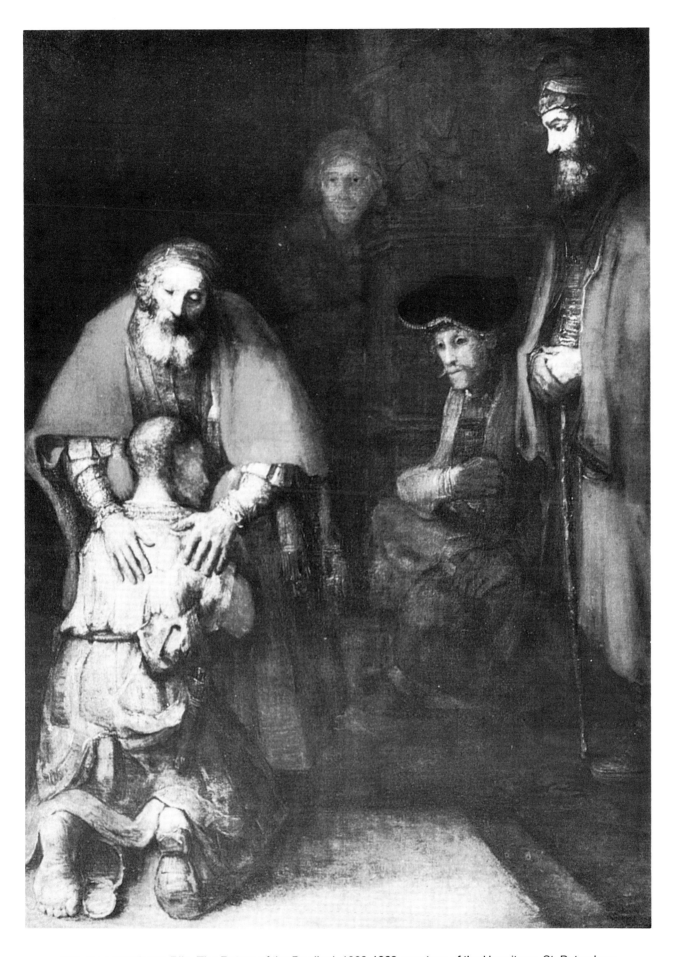

111. Rembrandt van Rijn, <u>The Return of the Prodigal,</u> 1668-1669, courtesy of the Hermitage, St. Petersburg.

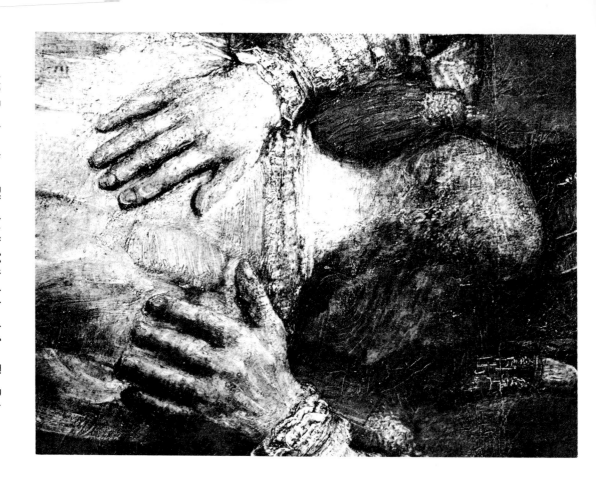

112. Rembrandt van Rijn, detail of father's hands from The Return of the Prodigal, 1668-1669, courtesy of the Hermitage, St. Petersburg.

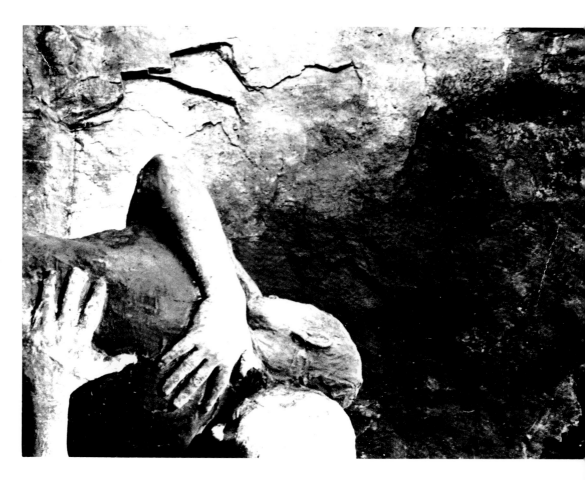

113. George Segal, detail of Abraham's hands, Abraham's Farewell to Ishmael, 1987, courtesy of George Segal/VAGA.

214

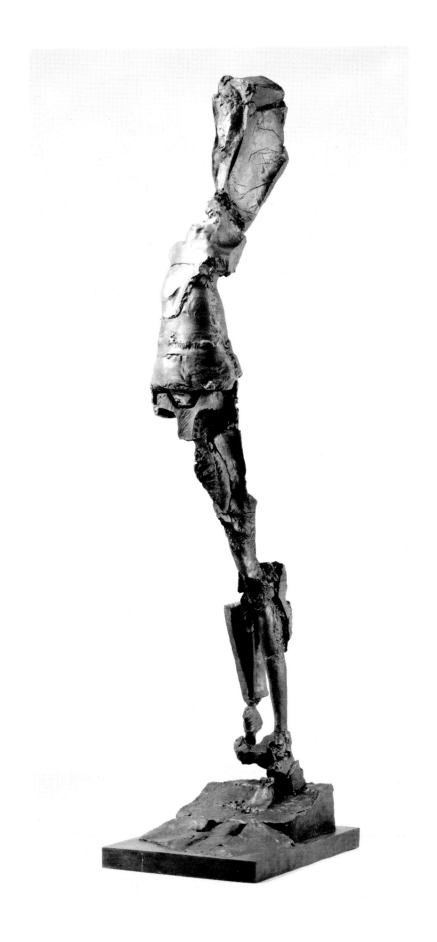

114. Stephen De Staebler, <u>Archangel,</u> 1987, courtesy of Stephen De Staebler.

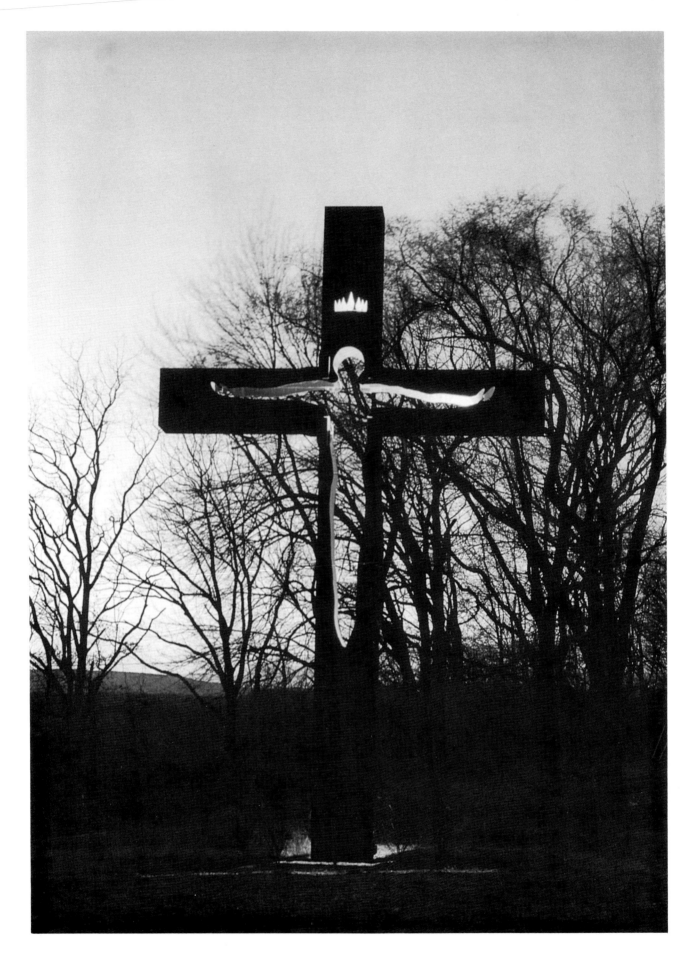

115. Tomàs Fernàndez, <u>Crux Gloria,</u> 1991, St. Francis De Sales, Purcellville, Virginia, courtesy of Tomàs Fernàndez.

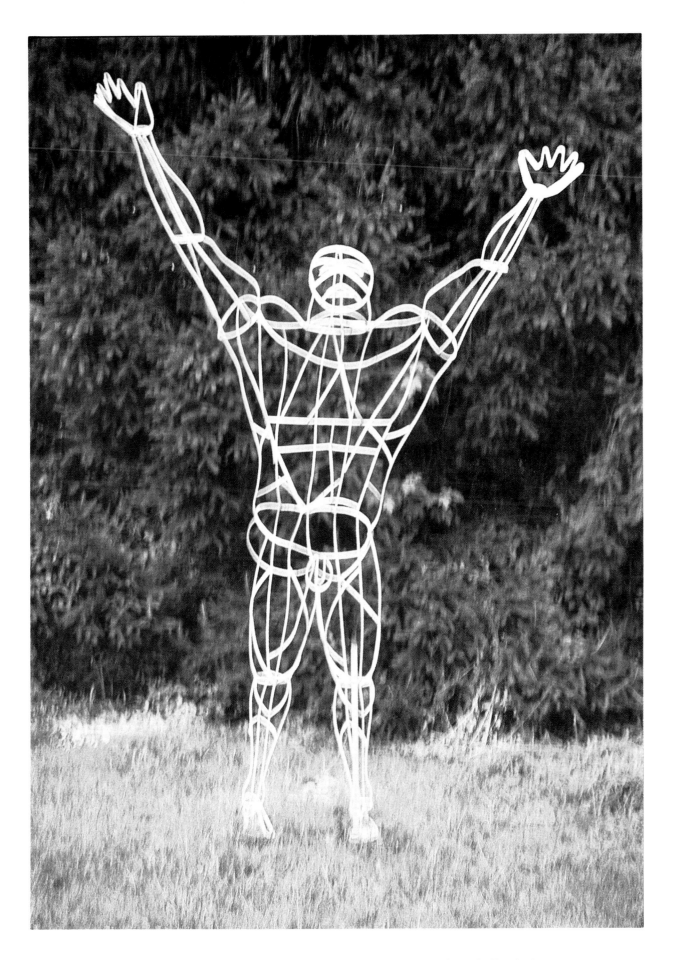

116. Tomàs Fernàndez, <u>Heaven and Earth,</u> 1984, courtesy of Tomàs Fernàndez.

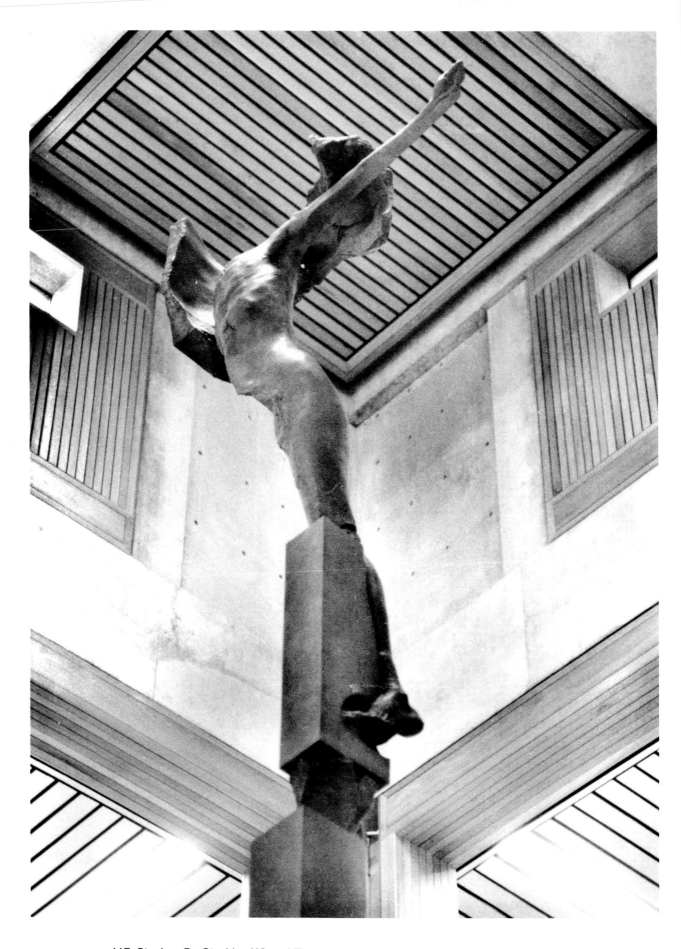

117. Stephen De Staebler, <u>Winged Figure,</u> 1993, Hewlett Library, Graduate Theological Union, Berkeley. Photograph by Mev Puleo, courtesy of Stephen De Staebler.

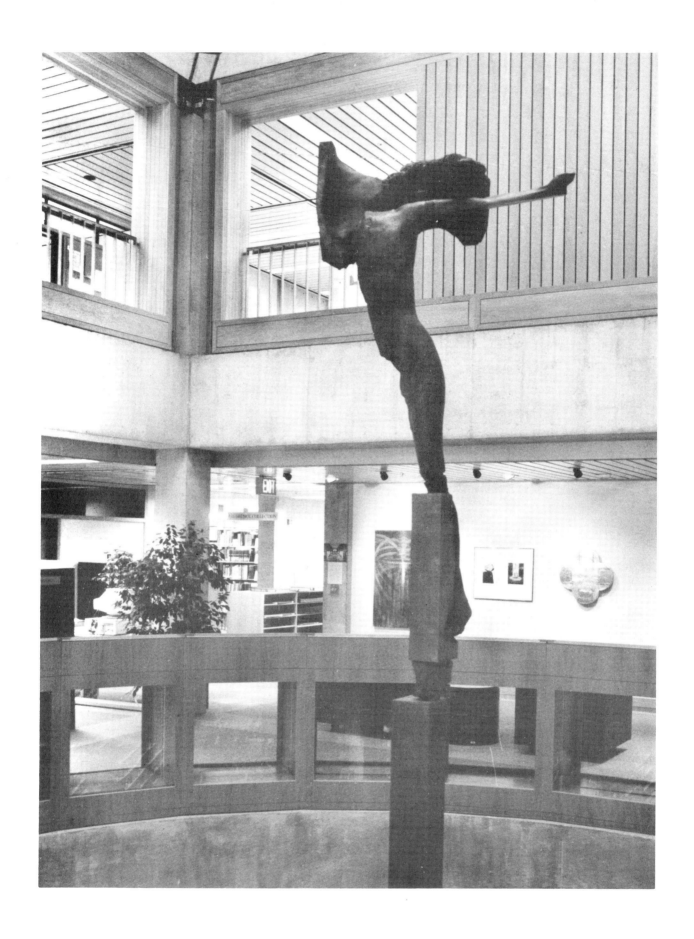

118. Stephen De Staebler, <u>Winged Figure</u>, 1993, Hewlett Library, Graduate Theological Union, Berkeley. Photograph by Mev Puleo, courtesy of Stephen De Staebler.

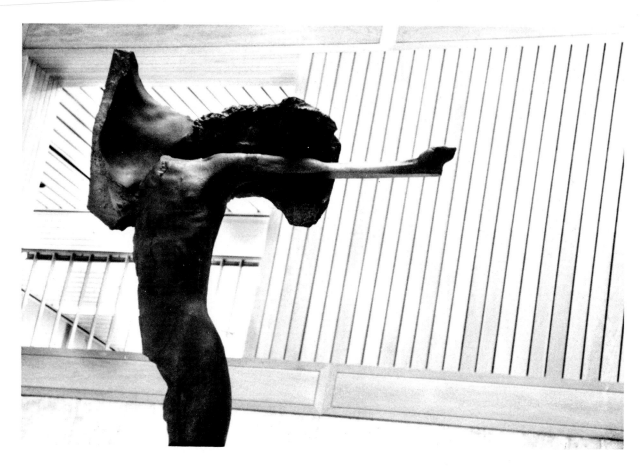

119. Stephen De Staebler, <u>Winged Figure,</u> 1993, Hewlett Library, Graduate Theological Union, Berkeley. Photograph by Mev Puleo, courtesy of Stephen De Staebler.

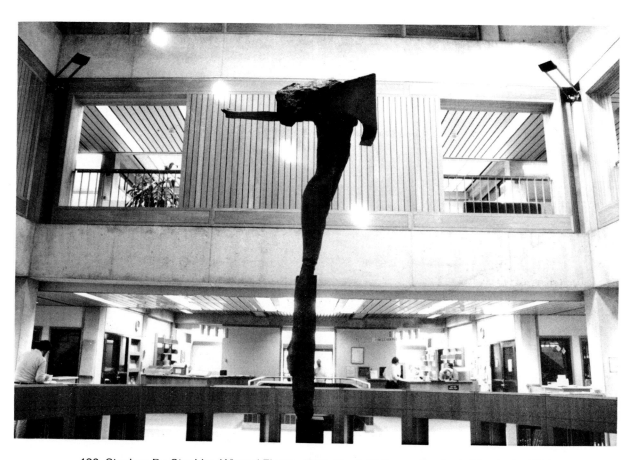

120. Stephen De Staebler, <u>Winged Figure,</u> 1993, Hewlett Library, Graduate Theological Union, Berkeley. Photograph by Mev Puleo, courtesy of Stephen De Staebler.

BIBLICAL INDEX

GENERAL INDEX

Paglia, Camille: 63.
Palm Sunday: 23.
Pantocrator: 13, 85.
parable: 37, 46, 50, 52, 57-8, 67, 74, 94-6, 107.
paralytic: 46-7.
Paul: 4, 5, 14-5, 29, 52, 72, 74, 85, 97-8.
peacock: 21.
Peter: 4, 23, 46-8, 52, 63, 97-8.
Pentecost: 106-7.
Pharisee: 57-8.
Phillip: 4.
Piero della Francesca: 34.
pietà: 15-6, 31, 82-4, 101.
pigs: 33.
pilgrimage: 40-1.
Pontius Pilate: 63, 92.
prayer: 8, 24-5, 29, 47.
priesthood of all: 65.
prodigal: 50, 52, 94, 107.
Rachel: 44.
Reinhardt, Ad: 57.
Rembrant van Rijn: 1, 28-9, 31-2, 57-8, 95.
repentance: 86, 94-5.
resurrection: 1, 2, 4-5, 13, 15-6, 23-6, 28-9, 33-4, 41, 44, 55, 76-7, 100-1, 107.
Rodin, Auguste: 86-7.
Rubinstein, Artur: 10.
Rublev, Andrei: 1, 37-8.
Ruth: 52.
sacrifice: 7, 9, 31-2, 62.
Samaria: 41.
Samuel: 65.
sarcophagus: 23.
Sarah: 20, 37, 53.
Sea of Galilee: 28-30.
second coming: 2, 5.
Segal, George: 2, 7-8, 52, 94.
Sermon on the Mount: 33, 72-3, 86.
shepherd, shepherdess: 74, 79-80, 107.
snake: 77.
soldier: 23-4.
Sophia: 25.
Star of David: 8, 44.
Stations of the Cross: 2, 12-4, 57.

Steinberg, Leo: 1, 5, 25.
tax collector: 57-9.
Taylor, Joshua: 5, 12, 40.
temple: 20, 48.
Ten Commandments: 33, 47.
tomb: 23-4, 33.
Torah: 20-1.
Torah niche: 20.
torn paper method: 32.
Tower of Babel: 23.
transcendence: 20, 38, 84, 101.
transfiguration: 33.
tree: 21, 23, 26, 43, 67, 72-3, 79.
umbrella: 65-7.
unjust steward: 50, 107.
van der Goes, Hugo: 74.
van Hemessen, Jan: 46.
Vietnam: 31.
wedding at Cana: 46, 48, 52, 81, 91.
Wiesel, Elie: 62.
wine: 5, 28, 37, 46-7, 52, 77, 81.
wisemen: 2, 33, 74-6, 81.
woman taken in adultery: 44, 58.
workers in vineyard: 26, 50.
Zackheim, Michele: 72.
Zernov, Nicholas: 50.